D0458172

SKYSHOOTING

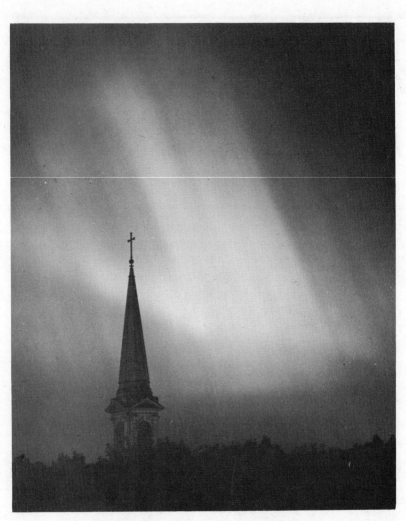

Red Aurora. 1950 E.S.T. September 18, 1941.

Taken at Cambridge, Massachusetts, looking due west, with a 2¼- by 3¼-inch Voigtländer, Skopar *f/4.5* lens, and Ansco Superplenachrome film pack. Exposure 10 seconds. (R. Newton Mayall)

SKYSHOOTING:
PHOTOGRAPHY FOR
AMATEUR
ASTRONOMERS

BY

R. NEWTON MAYALL
Consulting Engineer

AND

MARGARET W. MAYALL
American Association of
Variable Star Observers

DOVER PUBLICATIONS, INC.
NEW YORK

This Dover edition, first published in 1968, is a revised and enlarged
version of the work originally published by The Ronald Press Company
in 1949 under the title *Skyshooting—Hunting the Stars with Your Camera.*

International Standard Book Number: 0-486-21854-6
Library of Congress Catalog Card Number: 67-29410

Manufactured in the United States of America
DOVER PUBLICATIONS, INC.
180 Varick Street
New York, N. Y. 10014

To that great fraternity
of amateur photographers
who look for other fields
to conquer

PREFACE TO THE DOVER EDITION

WHEN THIS book was first published there was practically nothing available to the amateur interested in astrophotography except technical publications. The intent of the book was to make available the basic know-how, and to show that anyone with a camera can photograph the stars.

Since then the rise in camera owners has been phenomenal. In the last decade the amateur has shown what he can do with simple equipment, and also with sophisticated equipment. The high school student of today is showing a much greater interest in astronomy—and so are his elders. But there still is a need for this book.

Over the years the basic intent has not changed. There are many thousands who need a simple approach to get them started, and then they will find it is not difficult.

In this edition we have added a supplementary chapter on cameras, films and developing; a chapter on sophisticated equipment for the more advanced amateur; a chapter on phenomena seen in the sky in daylight; and we have made some changes in the original text.

We are grateful to Dr. Donald H. Menzel for his interest and helpful suggestions, and to the many amateur astronomers whose photographs we have reproduced.

R. NEWTON MAYALL
MARGARET W. MAYALL

Boston, Mass.
January, 1967

PREFACE TO THE FIRST EDITION

THIS BOOK has been written to give information, pleasure, and perhaps even inspiration to amateur astronomers and even just plain stargazers who have wished they knew how to use their cameras to record what they see and enjoy. It has also been written, we'll admit, to entice more and more camera fans into joining us who have found new worlds to conquer by turning our cameras skywards. Our own experience has made us vividly aware of the fact that a would-be skyshooter's sources of information have been woefully limited and much too technical. We think a skyshooter—be he the eager owner of a Brownie or the confident possessor of more exacting equipment like a Contax—deserves a better break.

Here, we feel, is explicit and understandable information which will enable you to photograph the mysterious and beautiful aurorae, the flashing meteors, the uncountable stars, the majestic and inspiring clusters and nebulae, our sister planets, as well as our more familiar sun and moon. We have included a lot of camera know-how, of course, with especial emphasis on the problems which the skyshooter must somehow successfully solve. There is, also, ample background material on astronomy, on telescopes, telescope mountings, and other necessary or desirable equipment. Our aim has been to write a book that will enable anyone to get properly started as a skyshooter, know where he is going, and be reasonably sure of success.

Skyshooting is a lot of fun. Beyond that, it is a richly rewarding hobby. That success is abundantly possible is proved by the illustrations we have used. All of them, except the three stereographs and the broken meteor trail, have been made by skyshooters who were amateurs. We gratefully acknowledge their help and encouragement in generously contributing these examples of their work.

We are grateful, also, to Dr. Harlow Shapley, Director of the Harvard College Observatory, for his continuing interest and many courtesies. To Albert G. Ingalls and the editors of *Scientific Ameri-*

can, and to Charles A. Federer, Jr. and *Sky and Telescope* go our thanks for their cooperation and courtesy in permitting the use of several plates and illustrations. We are deeply indebted to George R. Gonseth, generous friend and good critic, and to James G. Baker for his reading of the manuscript and for checking the optical references, formulas, and other technical details, many of which he has reduced to simple terminology.

<div align="right">

R. Newton Mayall

Margaret L. Mayall

</div>

Boston

June 25, 1949

CONTENTS

ILLUSTRATIONS

Red Aurora, September 18, 1941 . . . *Frontispiece*

TABLES

SKYSHOOTING

Chapter 1

LOOKING IT OVER

SKYSHOOTERS! That's what we call all of you who, to paraphrase Emerson, hitch your camera to a star. Hunting with a camera is a popular pastime. Many hunters have discarded their guns and fishing tackle in favor of the camera after seeing the work of Martin Johnson, William Beebe, and other famous hunters who have made important contributions to knowledge by means of the camera and sensitized film, both in still and moving pictures. As they have brought the wild life of air, land, and sea from the remote corners of the globe to our firesides, so has the astronomer made use of the same equipment to study and describe worlds other than ours.

Do you know that astronomers do some of their work with cameras no better than yours, and with moving pictures as well? One of the most exciting pictures we have seen is of the sun—a moving picture showing great clouds and streaks of luminous gas constantly moving and shooting off from the surface of the sun in innumerable sizes, shapes, and motions. Sometimes these enormous clouds and streamers appear to be sucked into the sun. Without the camera and the advantage of sensitized film, the modern astronomer would be little better off than he was in the eighteenth century.

If you have never trained your camera skywards, perhaps it is because you are familiar with the part photography plays in modern astronomy; therefore you immediately think of our great observatories, telescopes, mountings, and all sorts of expensive equipment that will be required either to photograph the stars or to use the photographs after they are made. But such is not the case.

Strangely enough, the first celestial photographs were not made by astronomers. Henry Draper, a physician in New York, made the first photograph of the moon in 1840, and the first photograph of a star was made in 1850 at the Harvard College Observatory by George W. Whipple (a professional photographer) under the direction of William Cranch Bond, the Director of the Observatory. Today,

3

thanks to these early experimenters and to Professor Edward C. Pickering, who saw the value of photography in astronomy, the Harvard Observatory has a collection of more than half a million photographs of the stars—the largest collection in the world. This gives some idea of the value and importance of the camera to the astronomer. Camera enthusiasts today have better equipment at their command than the astronomer of fifty years ago; yet few of these enthusiasts have thought of using their cameras to photograph the stars. Have you?

To be sure, it is nice to own a good telescope, properly mounted and enclosed by a typical dome. But how many amateur photographers own expensive telephoto lenses and various other equipment often representing an expenditure of hundreds of dollars? Individuals with such equipment are few when compared with the total number who are, day after day, getting excellent results with inexpensive cameras. Neither does the skyshooter have to set up an observatory with all the trappings, in order to have a lot of fun with his camera and do good work; any kind of a camera can be used, from one using 35-millimeter film to the large view and portrait cameras.

Just because you consider yourself an amateur at photography and are perhaps equipped only with a Brownie, that is no reason for you not to try photographing the stars. The late George Ellery Hale (founder and first director of the great Mt. Wilson Observatory) had this to say about the amateur: "The results of amateur observations may not only be useful—they may equal, or even surpass, the best products of the largest institutions." Dr. Hale was not giving idle encouragement in that statement. He knew full well whereof he spoke, because not only was he their mentor, but frequently he had lent a helping hand to amateur astronomers who are today proving themselves worthy of his attention and help.

Astronomy is a field of scientific endeavor in which the amateur shines, and one where the beginner will find the professional ready and willing to help him. Amateur astronomers are contributing valuable observational data to the professional, without doubt equal to the contributions of any other amateur group in any other field of science. This is not by chance, for astronomers have recognized and fostered these amateurs. As a result, many men and women, even boys and girls, throughout the world (particularly in the United

States and the British Empire) devote their spare time to astronomy
for they know their efforts are appreciated, that their work is accept-
able, and that their results are used by the professional who in turn
has been particular to give credit where it is due. Many of our large
observatories provide meeting places for the amateurs, as well as
guidance in their programs.

Harvard College Observatory fostered the AAVSO, one of the
most active amateur astronomical groups in the world, an organiza-
tion of international scope whose members regularly send in their
observations of variable stars (stars whose light varies), from the
farthest corners of the globe. In fifty-five years' time, variable star
observers have made more than 2,250,000 valuable observations.
Director Harlow Shapley's sponsorship of amateur astronomical
activities is sufficient to show his belief in the amateur's work and
ability.

Many observatories throughout the world and particularly in the
United States sponsor amateur astronomical activities, or give such
groups a helping hand, when needed. Many of these groups have
made valuable contributions to the observatories, in the way of equip-
ment. Planetaria also are finding the amateur astronomer a useful
adjunct to their work. They provide optical and telescopic exhibits
and in many other ways are ready to help amateurs. Some plane-
tarium museums provide workshops for the amateur telescope
makers, arranged so the public can see the work in progress. In more
isolated communities the amateur astronomer frequently is the only
source of astronomical information.

Some of you may already know that one of the best equipped
observatories in this country was conceived, built, and operated by
an amateur—the late Gustavus Wynne Cook, who there produced
some of the finest photographs of the sky that have been made. He
loved the stars as they are revealed by the camera. So devoted had
he become to his hobby of shooting the stars that his ambition was
to make a complete photographic atlas of the sky covering both the
Northern and Southern Hemispheres. He had partly accomplished
this ambition for the Northern Hemisphere before his death in 1940.
The Cook Observatory has since become the property of the Univer-
sity of Pennsylvania. A remarkable fact is that many of Mr. Cook's
pictures were made on glass plates measuring 20 by 24 inches, which
are some of the largest plates ever used in astronomical work.

The annals of astronomy contain innumerable similar contributions made by amateurs. Although the work of many, in the past, was wholly unfamiliar to the public, today we are more cognizant of the part such individuals play. John Brashear was an amateur telescope maker who, after many years of mirror making, was commissioned to grind the 72-inch mirror for the then new telescope of the Dominion Astrophysical Observatory, Victoria, B. C. Joel Metcalf, a minister, ground lenses for recreation. He gave a number of these to the Harvard College Observatory where they have been used for many years, and they are still considered the finest lenses of their kind. Other examples are the quiet, unassuming Leslie C. Peltier, well known for his comet discoveries, and Russell W. Porter, an architect by profession, who is in part responsible for the "Giant of Palomar," the greatest telescope of all time. Yes, the amateur has played and is playing an important role in many phases of astronomy.

So too may the skyshooter gain recognition. But even without fame you will discover many interesting facts. You will learn first of all to have greater respect for that piece of sensitized film which, unlike human eyes, is a permanent record of the unseen. The longer it is exposed the more light it gathers, thus enabling you to see on a photograph things you can never see with the unaided eye.

If you are systematic and take pictures of the stars in accordance with a definite program, you can use your own plates to study the variation in the light of certain stars which, because of this peculiarity, are called variable stars. It is also possible for you to carry out other research, either new or of a routine character. And don't let that word "research" frighten you, because high-hat as it may sound, research can be very intriguing and the source of a great deal of fun and pleasure.

Routine observation, or research, is not to be ignored. Regular observations of meteors and variables have brought forth much valuable data, for which the professional is deeply appreciative. Such programs may be carried out individually, or in small local groups, or by joining a national organization. The beginner will be more than repaid by attaching himself to some such group where he will find many others in the same boat and where still others have been through the mill, so to speak, and are ready and willing to lend a helping hand.

When starting something new it is a wise thing to look over the whole field; then you can pick out that which interests you most, or what is best suited to the equipment you have on hand. In this way you can get started with little expense. Therefore let's look at this business of shooting the stars and find out what it's all about.

We have been told there are more than eighty million photographers in the United States alone. Practically everyone has a camera of one sort or another. If you haven't one, a few dollars will provide it. One of the nice things about skyshooting is that any kind of camera can be used. The majority of that eighty million does not own expensive equipment. They may have Brownies, Kodaks, or some other inexpensive types, and tripods.

Let's start right there—with a camera of some sort and a tripod. As you know, the stars appear to rise and set, and if a fixed camera on a tripod is pointed upward to the sky you would expect to get streaks caused by the stars changing their positions during the exposure. That is exactly what you will get. These streaks are called star trails, and such pictures may be pictorial or practical. Star trails may be used for determining the focal length of a lens (distance from lens to sharply focused image), by measuring the length of the trails; or they may be used to check the focus of your camera—that is, the sharpness of the image when the lens is set at infinity as marked on the camera. Sometimes the focusing scale is a little bit "out." There are many other practical reasons for taking star trails, as we shall show you later.

Meteors (or do you call them shooting stars?) are elusive flashes of light in the sky. There is no sense in leading you astray about meteors, however, for although photographing them is a lot of fun and interesting work, you've got to keep your tongue in your cheek. Meteors are enough to try the patience of Job, and you will need a lot of patience!

Did you ever think about photographing the aurora borealis, or northern lights? Next time you see one of these beautiful natural phenomena, try taking a picture. Aurorae are not with us all the time as are the stars, at least not visually; therefore, photographing an aurora takes but little of one's time and the results are well worth the effort (see Frontispiece). This is also an excellent field for the color film fan with a candid camera.

These three things—star trails, meteors, and aurorae—are easily photographed with your present equipment. If you do not own a tripod, mount your camera on a pile of books or in any other manner so that it will "stay put."

The next step requires a simple mounting that anyone can make out of wood. The design of this mounting (see Chapter 5) provides for the movement of the camera in an up and down or north-south direction and also in a sideways or east-west direction. Hence, once your camera is set on a star you can turn the camera slowly toward the west, thus obtaining pinpoint images of the stars with a time exposure, instead of trails as in the case of the fixed camera mentioned above. With such a device you can make a photographic atlas of the sky, whereon many stars will appear that you cannot see by just looking up at the sky.

The motions of the planets among the stars can be traced on photographs made with a camera so mounted. Other objects such as double stars—stars that may appear as single bright images to the eye—will become two pinpoint images very close together on the film. You can also take pictures that show great clusters of stars grouped in odd shapes. It is possible to photograph the moon and show the numerous craters, peaks, and mountain ranges that outline the low, flat, and desolate lunar areas called "seas." All these can be accomplished by building a simple support for your camera, so that you can "follow" the stars, planets, and moon as they appear to march across the sky from east to west. And you can engage in the fascinating pastime of hunting for comets.

If you are bent on doing serious work, then a different kind of mounting will be needed. Even so, suitable equipment can be made out of odds and ends at very little expense. With a good mounting there is virtually no limit to what you can do. Nebulae, variable stars, novae (new stars), sunspots, the moon and planets, all will be within your reach.

Thousands of amateurs have made their own telescopes. Excellent instruments have been made out of gas pipe, stove pipe, a piece of glass, and similar materials. If you have a telescope, by all means use it for shooting the stars with your camera. Those who own telescopes, either homemade or professional, can attach a camera to the mounting, to the telescope itself, or use a camera at the eyepiece. If

you haven't tried this you are missing half the fun to be had with your 'scope.

There is room for everyone, no matter what the equipment may be, even though it is only a camera and reading glass. There's an idea! If you do not own a camera, make one with a reading glass (see Chapter 5). Believe us—try it! We have seen some excellent star pictures made with an ordinary 3-inch reading glass, such as grandma uses. If you still doubt your ability, just glance quickly at some of the illustrations and see for yourself what others have done. Then, perhaps, you will be more eager to try it yourself.

There is a constant opportunity for more skyshooters to co-operate in various nationwide programs, some of them initiated by our large observatories. For example, there is a great need for routine observers, scattered all over the country, to photograph meteors. This is a program that does not require special types of cameras and mountings to obtain excellent results (see Chapter 4). There is also a national program for photographing aurorae both in black and white and in color—again, no special equipment is re-quired. Both of these programs are scientifically worth-while. Neither specifies scientific training, but the results are of scientific value and you can have a lot of fun as well. Perhaps there is some-one near your home who is already engaged in such work.

Shooting the stars offers no dull moments. Frequently it offers thrills and excitement. A casual "run-of-the-mill" photograph may record a new star (nova), or a comet invisible to the unaided eye may make its appearance on your plate. And, by the way, comets are named after the person or persons who first discover them. There are many comets that never attain a brilliance sufficient for them to be seen by the unaided eye, but they are discovered on photographs, often some time after the pictures are taken.

In 1963, hundreds of thousands of people rushed to the New England countryside in Maine, New Hampshire, and Vermont in order to see a total eclipse of the sun. Thanks to the widespread newspaper publicity, many thousands carried their cameras (whether Brownie, Leica, or movie) to take a "pot shot." Dig out that picture you took of that solar eclipse and look at it once again. Not so bad, was it? Has the thought ever occurred to you that just as in-teresting pictures of the sun can be made when it isn't eclipsed?

Photographs of the sun, taken over a period of days, will show the appearance and disappearance of dark blemishes or "spots" as they are called. These spots change from day to day in size, number, position, and shape, as they move across the sun's disk. By constantly "shooting" the sun you can have a lot of fun tracing the paths of the spots, comparing them, and watching them increase and decrease in size and number. These facts about sunspots are generally common knowledge, but it is not so well known that recurrences of a maximum and minimum number of spots at a definite interval, called the sunspot cycle, were discovered by S. H. Schwabe, an amateur. Schwabe determined the sunspot cycle from his own observations, made over a period of twenty years. He found that a maximum of spots recurs at intervals of about eleven years. There is a great fascination in watching sunspots develop from day to day.

The opportunities that lie before you are many and varied. The mechanically minded will find many new outlets in the design and fabrication of mountings. The engineer will find this a fascinating field. New problems in construction present themselves, different enough from everyday structural problems to be of interest.

The mathematically minded will enjoy reducing their own observations, or perhaps "figuring" new lenses will have a greater appeal. The artist will find pleasure in photographing objects of beauty, and the sky is full of such objects.

The chemist may desire to experiment with emulsions and developers. Speedier and speedier emulsions are being made. Some of these have their drawbacks and once the trials have been made it is not always so easy to manufacture in quantities. The creator of new and faster films and plates will find a ready market among astronomers. There is enough room and work for everyone, and a lot of fun besides.

Skyshooting is not hard to do, and there are great opportunities for anyone who answers the knock. Once you get started in this sport and become a skyshooter we do not care to venture any opinion as to how far you may go, for the sky *is* the limit. But we can say that there is enough material in the sky and there are enough different fields of work to keep you interested and busy the rest of your life.

Chapter 2

STAR TRAILS

WHEN YOU LOOK up into the clear night sky there are three things you expect to find—stars, planets, and the moon. Take the moon or the stars away for a long period and you would subconsciously know that something is missing. How light the night when the moon is shining bright, and how dark when it is not visible. Even though they are less familiar to most of us, the planets, too, are welcome. We would miss the reddish glow of Mars and the bright orb of Venus, if they were taken from us. But what would we do if the stars were not there forming their distinctive groups with which we are all a bit familiar, such as Orion who announces winter with his appearance, or the broken-down chair of Cassiopeia which we moderns liken to a badly printed W? Then there are the Big and Little Dippers, and if you don't think you would miss these two famous configurations of the northern sky, just live in the Southern Hemisphere for a short while. It is strange how quickly you can get homesick—not for home, but for stars.

The stars are really as much a part of us as our beautiful rolling countryside, our mountains, rivers, and cities. We take pictures of all these, so why not take pictures of the stars? You haven't taken pictures of the stars for two reasons—one is because you thought you couldn't and the other is because you didn't know what to do with them.

Whenever some celestial phenomenon is due to be observed, such as a rare configuration of the planets or an eclipse of the moon or sun, many persons wonder if they can take pictures of the phenomenon with their cameras. The answer is—yes! We are apt to think of a star as being a very faint point of light, so faint and far away that it cannot be photographed easily; yet it is possible to point your camera skywards, say toward the planets or some bright stars, and take a snapshot. By a snapshot we mean any exposure of one second or less. Don't for a minute think you can't do it, too.

Now let's see just what you can do with these pictures of the stars. Did you ever think of using your camera to make drawings of the constellations? Instead of trying to draw the outlines of different star groups by looking at them, why not photograph them? If you have children you can entertain them by making an accurate drawing, say of the Big Dipper, from something that doesn't seem to resemble this well-known group of stars.

Place your camera on a tripod rigidly fixed in place, or on some other solid object, so that the lens is pointing toward the Big Dipper or another well-known constellation such as Orion or Cassiopeia. If your lens needs setting, set it at infinity (Brownies and other fixed-focus cameras cannot be adjusted, they are already set) and for a time exposure. Use the largest opening for the lens. When ready, using the timestop (not bulb), open the shutter for 5, 10, or 15 minutes, then close it. That's all there is to it. When the film is developed, you will find many short black streaks on the negative. These streaks represent the bright stars.

Now you can do either of two things—mark your negative, or mark a print. The fainter stars will have narrower streaks than the brighter ones. If you place an ink dot of proper relative size at one end of each streak (use the same end of each streak) you will reproduce the stars and their grouping as you see them in the sky. Not hard, is it? In this manner, you can draw all the well-known constellations and make an interesting album for the children, or for your own use.

This sort of album can be made of great value to the blind. We know of one person who has made star charts of this type by punching holes of various sizes so that the blind could be taught the configurations in the sky. Also, for this purpose the stars could be delineated in any manner that would enable the blind to see them with their fingertips. Isn't this worth-while?

Most persons think of astronomy as a science with no practical value. Yet astronomers discovered the vital gas helium, in the sun, and determined its properties many years before it was found on the earth. It was their discovery of the peculiar properties of this gas that caused a worldwide search to be made for it. Then, too, the need for bigger and better telescopes stimulated years of research in the glass industry. As a result, today cooking can be done in a glass

dish placed on top of the stove or over a gas flame, without fear of breakage. No, astronomy is far from being wholly impractical.

Making star trails will also give you an idea of the length of exposure required to obtain an image of a star on the film. Let's try another exposure and then see what it all means. This time set the camera as before, and point it at the North Star and expose for half an hour. When the film is developed you will notice a great many streaks that are definitely curved and that vary in intensity from very faint to very bright. These streaks are star trails and they are more vivid in this negative than the one in the experiment above. They are much longer and easier to see, because in the former experiment your eye reacts quickly to the short trails of only the brighter stars.

Long ago you learned that the stars actually do not move across the sky; instead, the earth turns on its own axis, thereby making the stars appear to move. Well, just look at your negative. Something moved! And we must believe the astronomers that it was the earth. Therefore the trails reveal the earth's motion.

We suggested taking a picture of the North Star because it proves another well-known fact. Polaris is not at the true pole. As you can see, the trails are curved and the North Star is very prominent. If the camera could be exposed continuously for 24 hours, the trail of Polaris (and all the other stars on the film) would be a complete circle and the center of that circle would mark the true pole, or the celestial pole as the astronomer calls it. If the North Star were located right at the celestial pole, it would show no trail.

There is another fact about the earth's motion that is helpful to know if you contemplate shooting the stars. The astronomer tells us the earth rotates upon its axis at the rate of about 1,000 miles per hour at the equator. You can check this quickly, for if you stand somewhere on the equator, with the sun directly overhead, 24 hours later the sun will again be overhead, and in that time you will have moved through space a distance of about 25,000 miles (the approximate circumference of the earth). There are 24 hours in a day, which if divided into 25,000 will give roughly 1,000 miles per hour as the rate you traveled. This speed is equivalent to about one quarter of a mile per second. Likewise your rigid camera moved at the same rate of a quarter of a mile per second or a distance of

approximately 1,320 feet. Therefore, a star trail is a continuous series of exposures all of the same length of time and of very short duration.

Before we get down to the more practical uses of star trails, we should like to prove something which still may seem fantastic to you—that the stars can be photographed with a snapshot exposure.

Set up your camera as before, and point it to any part of the sky, preferably toward a region where there are a few bright stars. Open the shutter of the lens for 5 seconds, close it for 5 seconds, then open it again for 15 minutes.

Now examine the negative with a low-power magnifying glass, and you will notice a definite break near one end of each star trail. This break is caused by the closing of the shutter for only 5 seconds. This is a point worth remembering. But more important is the fact that in a 5-second exposure there is a decided trail, long enough to be measured. Therefore, in order to get a pinpoint image of light on the film, resembling a star as you see it with the eye, only a very short exposure is required, for no part of a star trail has a longer exposure than any other part.

You can easily determine from this picture the exposure required to make an image as long as it is wide; that is, one that shows no trailing. Suppose in 5 seconds' exposure you obtain a trail 2 mm.— about $\frac{1}{16}$ inch—long and $\frac{1}{10}$ mm. thick. (The closer divisions on a millimeter scale are more convenient for measuring distances than the ordinary ruler marked off on the inch scale.) Then, in order to show no motion the trail would also have to be $\frac{1}{10}$ mm. long, thus giving a sharp image.

A 1-second exposure would give a trail $\frac{4}{10}$ mm. long (2 mm. divided by 5 sec. = 0.4 mm.); therefore the exposure required to give a trail $\frac{1}{10}$ mm. long would be only $\frac{1}{4}$ second (1 sec. divided by 4 = 0.25 or $\frac{1}{4}$ sec.).

Further examination of your negative will show that a snapshot (exposure of 1 second or less) will record all the stars that can be seen on a star trail plate with the exception of a few of the fainter stars. This is because the faintness of the single image on the film in such a short exposure makes it hard to recognize, whereas the longer exposures produce a streak that can readily be seen.

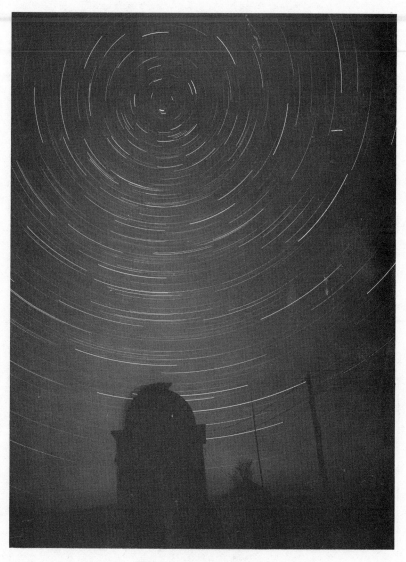

Figure 1. Polar Star Trails

Taken with a homemade camera fitted with an *f/4.5* Eastman Kodak lens, 8 inches focal length. An 8- by 10-inch W & W Panchromatic plate was used. (Edward A. Halbach)

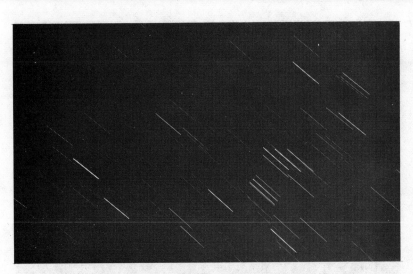

Figure 2. Equatorial Star Trails

Region of Orion. You can pick out the stars that form the "Belt" and "Sword." Taken with 20 minutes' exposure on Eastman Super XX film. (D. C. Wysor)

Figure 3. Tracing of Figure 2

A direct tracing made by marking the position of the left end of each trail, thereby making a picture of the constellation of Orion as you see it in the sky.

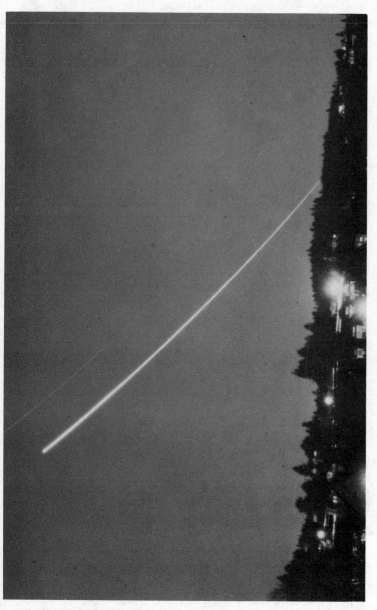

Figure 4. Trail of Venus

Taken with a 620 Folding Kodak, fitted with an *f/4.5* Kodak Anastigmat lens. The camera was mounted on a tripod. Exposure time: 1ʰ35ᵐ at *f/8*, using Kodak Super XX roll film (2¼ by 3¼ inches). (Carl P. Richards)

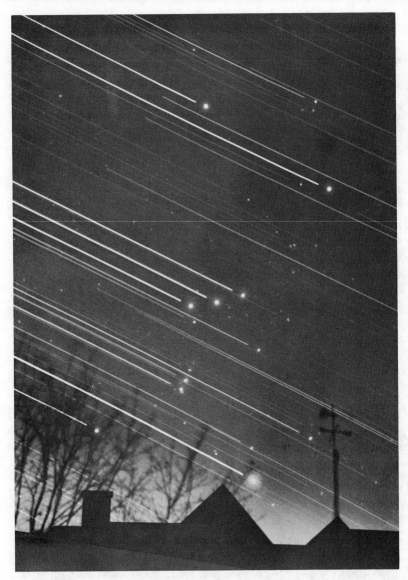

Figure 5. Tricks and Trails

Ingenuity can produce interesting results. This is a genuine star trail photograph, taken with an equatorially mounted 3¼- by 4¼-inch Graflex fitted with $f/4.5$ lens, used at full aperture with Super XX film. Film developed in D-19 developer. The stars were allowed to trail for 2½ hours, then the lens was capped for 5 minutes, after which the stars were "followed" for 30 minutes with a small guiding telescope on the same mount. The following was done manually with a slow-motion screw. A diffusion disk was placed over the lens to produce the hazy effect of the individual stars. The appearance of the trails in front of the trees is caused by swaying of the branches during the long exposure. (John Stofan)

In this experiment we left it up to you to pick the portion of the sky to photograph. Most persons would pick a spot toward the south and about halfway between the horizon and a point nearly overhead. If you did this you could not but notice the trails were quite different from those obtained by photographing the stars in the polar region. The polar trails were distinctly curved, whereas those in the last picture were more nearly straight. That is as it should be, for the celestial pole is also that point in the sky toward which the axis of the earth points.

The celestial equator is an imaginary line corresponding to our earthly equator, and it bears the same relation to the celestial pole that the terrestrial equator bears to the poles of the earth. Therefore, because the earth turns upon its axis, photographs of stars on the celestial equator will show trails that are straight. The farther away from the celestial equator the camera is pointed the more curved the lines become, until the pole is reached, where the lines will become arcs of circles with small radii.

It may be advantageous to complete the foregoing simple experiments in one evening, especially if you have had to wait for a clear night. No particular type of film or developer has been mentioned because that unused film in your camera is good enough to produce excellent trails. No special developer is needed, but a slow contrasty developer suitable for use with your particular film will give the best results. If you do not do your own developing, be sure to tell whoever does it for you what to expect. Most commercial films designed for general use are perfectly satisfactory, but a fast plate or film with a medium fine grain emulsion will give the best results. This is a good rule to adhere to in taking any pictures of the stars.

Dark as the night may seem, a lens shade of one sort or another should be used to shield the lens from as much extraneous light as possible. Although the sky may look dark, it is often brighter than you think—bright enough at times to produce an appreciable amount of fogging on the film, called "sky fog." This is particularly true on a bright moonlight night. However, as a general rule a moderate amount of sky fog is not detrimental.

You can get more fun out of photography of any kind if you do your own developing and printing. Developing star pictures is an

easy job, and complete instructions are given in Chapter 12. Practically all the pictures you take can be developed by rule and by one type of developer.

If you have tried the above experiments the whys and wherefores come next. We have shown how it is possible to take snapshots and how, by measuring a star trail, it is possible to determine the length of exposure necessary to show no trail when a fixed camera is used. Star trails can be used to learn a few things about your camera. But first let's find out how you can determine the length of a trail that will be produced by a given lens in a given time.

When you take a picture of a landscape, only a portion of what you see is recorded. That is because the lens of your camera is designed to do certain things—one of these is to see all things within a certain area or angle and bring them to a focus on the film. The amount of space observed by the lens is expressed as an angle and we speak of a lens as covering so many degrees, such as 60°; or we may say that it is a 60° lens. In other words, if a line is drawn straight out from the center of such a lens, then everything within an angle of 30° either side of that line will be recorded on the film. This area is also called the "field" or "field of view."

Suppose your lens does cover an angle of 60°. We can use that figure to find out how long a trail will be for a given exposure, because we know how far a star will have to travel in the sky to make a trail across the film. Since one hour of time is equal to 15°, 60° equal 4 hours. Motion is fastest at the equator. If, therefore, an equatorial star, or one nearly on the celestial equator, is focused on one edge of your film it will take 4 hours for it to reach the other edge. Technically, the "angle of the lens" would refer to coverage from one corner of the plate to the corner diagonally opposite, so the time from side to side would actually be a little less than 4 hours.

In 1 hour the star will make a trail $\frac{1}{4}$ the distance across the film; in $\frac{1}{4}$ hour, $\frac{1}{16}$ the distance, and so on. If the film is 4 inches across, the trail will be 1 inch long in a 1-hour exposure, $\frac{1}{4}$ inch long in $\frac{1}{4}$ hour. A 1-minute exposure will produce a trail $\frac{1}{60}$ inch long. In this way you can determine a close approximation of the length of exposure to be given with such a camera in order to show no motion, by using $\frac{1}{250}$ inch or 0.1 mm. in diameter as the normal size of the image.

But lenses differ, and under the same conditions as above a lens covering an angle of only 15° (measured from side to side of plate) would produce a trail across the plate in 1 hour. In 15 minutes the trail would be 1 inch long; in 1 minute, $\frac{1}{15}$ inch; and in 1 second the trail would be $\frac{1}{900}$ inch long, which is a negligible amount. If your lens is not marked and you are in doubt as to the angle of coverage of your lens, ask the nearest photographic dealer. He will either know offhand or he can find out for you.

We hesitate to inject this bit of mental arithmetic, but it is fundamental and knowing how to do it right now will put you one-up on the fellow who doesn't know. Star trails are a little more important than you think and by them you can learn something about your camera.

In the two examples above we found the length of the trail by mental arithmetic. This can be done much more easily by using a simple formula. If we let

T = length of the trail of an equatorial star
F = focal length of the lens
t = length of exposure, in seconds, minutes, or hours
N = number of seconds, minutes, or hours in one day,

the formula is:

$$T = 2\pi F \frac{t}{N} \qquad (2\pi = 6.28 \text{ or roughly } 6)$$

In other words, the length of the trail can be found by multiplying the focal length of the lens by 6 and then multiplying the result by the length of exposure in minutes divided by the number of minutes in the day. The values for N and t must always be expressed in the same units; that is, if t is in seconds, N must also be expressed in seconds. Likewise, T and F must be expressed in the same units—that is, in millimeters or inches. For your convenience the time conversion is given here (see also Table XVII in the Appendix):

1 day = 24 hours = 1,440 minutes = 86,400 seconds.

From the same formula you can easily find the focal length of the lens or the time of exposure as follows:

$$F = \frac{TN}{2\pi t} \text{ and } t = \frac{N}{2\pi F} T.$$

Therefore, by using equatorial star trails you can find the focal length of your lens if the length of the trail and exposure are known; the amount of exposure necessary to produce a given length of trail with a given focal length lens; or the length of a trail produced by a given lens in a given time. Why not try this on the trails you have made?

Furthermore, it can readily be seen that there is a variation in the length of trails made by two different lenses with the same length of exposure. Referring again to the examples: in 1 hour a 60° lens will give a trail 1 inch long whereas a 15° lens will give a trail 4 inches long. This variation is proportional to the focal length of the lens; and the greater the focal length, the faster the motion across the film; which also shows that the greater the magnification the greater the speed of motion of the image.

Did you ever test various films for speed? In nine cases out of ten you are guided by what the salesman says and probably think it is necessary to have complicated equipment to make such tests. But any clear night the stars will serve you for testing the speed of various plates and films. Here is how to do it:

Point your camera toward the North Star. Expose two different films under the same conditions. A comparison of the number of trails and the density of the trails on the negatives will immediately show the greater sensitiveness or speed of one emulsion over another. For many years the astronomer has tested the speed of his films by the stars.

Another stunt that can be used to test for speed, and one that also proves snapshots of the stars can be made, is to point your camera to a group of fairly bright stars, preferably a group that has one star quite a lot brighter than the rest. Vega, one of the brightest stars in the sky and nearly overhead during the summer months, would be a good star to have in the center of the plate. Then expose the film with the lens at full aperture, using all the exposures your camera allows, such as $\frac{1}{50}$, $\frac{1}{25}$, $\frac{1}{10}$, $\frac{1}{5}$, $\frac{1}{2}$, and 1 second. Make the last exposure 5 minutes or more. Wait 1 minute between exposures. In this manner each image will be clearly separated on the film; the long trail at the end will enable you to count back easily to determine the fastest or shortest exposure used to record each star. You will notice that the brighter stars can be caught with an exposure of

⅟₅₀ second. The fainter ones will require about ⅕ second, and some of them will require a full second, using ordinary film. If two different films are used, the images may be recorded at ⅟₅₀ for the brighter stars, on both films; but the densities of the images may vary. The emulsion of a film showing the densest images, say at ⅟₅₀ or ⅟₂₅ second, will be the faster.

We tried this one night just for fun. We used a 2¼ by 3¼ Voigtländer, fitted with a Skopar lens of 10.5 cm. focal length and working wide open at $f/4.5$, with a Superplenachrome film pack. Extremely sharp trails and well defined images were obtained throughout the range of exposures mentioned above.

The same camera was then stopped down to $f/22$ (the smallest opening) and the bright stars were recorded clearly at ⅕ second exposure. As you probably know, lenses are referred to as $f/4.5$, $f/3.5$, and so forth. This simply means that the focal length of the lens is 4.5 or 3.5 times the diameter of the largest aperture. In a given lens, the smaller the f-number, the larger is the aperture in relation to the focal length, and the faster is the speed of the lens. In our first experiment we used the lens wide open and the focal length was 4½ times the diameter of the opening. The second group of exposures, however, was made with an opening so small that the focal length was 22 times as large, thus greatly cutting down the speed of the lens. Yet snapshots *were* made of the brighter stars!

By this time you will have noticed two characteristics of star trails: stars of different brightnesses give trails of different intensities; and longer exposures give longer trails but do not show fainter stars. This second characteristic is because trails are nothing but a series of very short exposures of equal length.

With these two characteristics in mind you can use star trails to keep track of the weather while you are asleep; that is, if you want to. A small camera pointed to the North Star will give trails that will show the number of hours of clear sky. (A Brownie camera is admirably suited for this job.) A break in the trails gives the length of time clouds were in the vicinity of the north and if no trails are recorded, it was cloudy all night. The density of these trails is also an indication of the transparency of the air. In order to use polar trails for this purpose, the time of starting and stopping the exposure should be recorded. Because the trails are arcs of circles the celestial

pole can be found easily; then by using a small protractor the amount
of clear or cloudy weather, when it occurred and how long it lasted,
can be determined quickly. Of course you must provide some
arrangement for closing the shutter before dawn, such as attaching
an alarm clock to it!

If you set your camera on the region of the constellation Perseus
(in the sky during fall and winter) you may be lucky enough to
photograph a strange phenomenon. The star Beta Persei, which the
ancients called Algol or the Demon Star, is not a single star. It has
a companion that travels about it in much the same manner as the
moon travels about the earth. At regular intervals of about 2 days
21 hours this companion star passes in front of Algol, thus coming
between us and the star, in which position it partially eclipses Algol,
cutting off much of its light. Within the short space of about 10
hours, Algol will nearly disappear from naked eye visibility and then
reappear with all its former brilliance. If you make a star trail plate
of this region at the proper time, you will see one trail that is bright
at one end, fading almost to nothingness in the middle, then gradu-
ally getting brighter and brighter toward the other end. More
about these interesting stars that vary in light will be found in
Chapter 6.

When you look at a map and want to know how far it is from
one town to another, there is a scale of miles that enables you to
determine the distance. Similarly, star pictures need a scale, but
instead of referring to so many miles per inch, it is usually written
or drawn as so many seconds of arc per millimeter. Of course if you
want to make a scale of so many degrees per inch, there is no law to
say you can't do it; but the astronomer uses seconds of arc per milli-
meter and you might as well learn to use the same scale, then we'll
all be talking the same language and can understand each other
better.

If the scale of a plate is 90 seconds of arc per mm. it is written
thus: 90″/mm., which means that each millimeter of distance on
the plate is equal to 90 seconds of arc in the sky. By simply measur-
ing the distance in millimeters and multiplying it by 90, the distance
between two stars is obtained in seconds, which can then be reduced
to degrees. There are 360 degrees (360°) in a circle, 60 minutes
(60′) in 1 degree, and 60 seconds (60″) in 1 minute. It is also

useful to know the scale of a plate if enlargements are to be made. If the scale of the plate is 90″/mm., a 10-times enlargement would have a scale of 90″/10mm., or 9″/mm. If you want to enlarge to a certain scale, such as 10″/mm., divide 90 by 10 and the number of times the original has to be enlarged will be found, in this case 90/10 = 9 times. Star trails can be used to find the scale of the pictures taken with your camera. Once you determine the scale of your plate, all pictures taken with that camera and lens will have the same scale.

The method of determining the scale of a plate is just the reverse of finding the distance when the scale is known. In other words, you must know the distance between two points. The question is, how shall you go about finding the distance between two stars? Every good skyshooter should have a good star atlas, such as Norton, Schurig, or Skalnate Pleso. These charts show all the naked eye stars, together with many other objects such as nebulae, variable stars, double stars, and so forth. Each chart is marked off in latitude and longitude just as any map of the earth would be; but the astronomer calls the lines "declination" and "right ascension," respectively. The declination of a star refers to the number of degrees it is north or south of the celestial equator. The right ascension of a star is usually given in hours, minutes, and seconds, instead of degrees, although some star charts give both.

The zero hour, or degree of right ascension, is comparable to the zero meridian of Greenwich. It is the point from which all distances in the sky are measured east or west; and it is fixed in this way: the Vernal Equinox marks the beginning of spring and it also marks the zero hour of right ascension. That is, when the sun crosses the celestial equator from the south to the north, the instant of its crossing is referred to as the Vernal Equinox and the point along the equator at which the sun is located at that time is the zero hour of right ascension. But for now you do not have to worry your head about it. Just think of declination as latitude and right ascension as longitude.

Now look at that polar trail plate you made and lay it beside a star chart. Identify a few stars by comparing your picture with the chart. Mark the celestial pole if you have not already done so. Then determine the declination of the selected stars. The degrees of

declination are marked on the right and left sides of the chart in exactly the same manner as latitude is marked on a map.

Now measure the distance in millimeters from the pole to the trail of one of the stars selected. The pole will have a declination of 90° (just like latitude), and the equator, 0°. All you have to do now is to subtract the declination of the star from 90° and divide the result by the distance (in millimeters) of the trail from the pole, and your answer will be the scale of your plate.

Here is an example. Suppose the distance of the trail from the pole is 20 mm., and the declination of the selected star is 80°. Then 90° minus 80° = 10°. If we then divide 10° by 20 mm. our answer will be 0°.5 or 1,800 seconds, which is the scale of the plate and it should be written this way: 0°.5/mm. or 1800″/mm.

It matters little whether the conversion to seconds is made first or last. Using the same figures as above, 10° = 36,000″; then 36,000″ divided by 20 mm. = 1,800″. Remember, there are 60 seconds (″) in one minute (′), 60 minutes in 1 degree (°), in circular measure; and that 360° = 1 circle. Also remember that, in time measurement, hours, minutes, and seconds are distinguished from circular measure by noting the first letter of each word, thus—h, m, s. For example, $1^h30^m10^s$.

Again we can reduce this rule to a more simple form, if we let

D = declination of the star
d = distance of the trail from the pole, in millimeters
S = Scale of plate

then

$$S = \frac{90° - D}{d}$$

One important thing about these star trails is that they can be used for so many different purposes, if you know what it's all about. Did you ever wonder why they made you struggle through trigonometry in school? The teacher always said it made it easier to figure complicated problems. There is a lot of truth in that and we can give you an example right here; and if you have wanted to show off your knowledge of trigonometry or logarithms, or the slide rule, try this:

In the above example you can find the distance of the trail from the pole (d) by simply multiplying the focal length (F) of your lens, in millimeters, by the cotangent of the declination (D) of the selected star. (The formula is: $d = F \cot D$.)

Then if you take the distance of the trail from the pole and divide it by the cotangent of the declination of the selected star, you will obtain the focal length of your lens. (The formula is: $F = \dfrac{d}{\cot D}$.)

Similar information can be derived from trails made of stars near the celestial equator. Because the pole does not appear on these plates, the perpendicular distance between the trails of two stars (d') is used, and instead of subtracting the declination of a star from 90°, the difference between the declinations of the two stars is used (D is the declination of one star, D' of the other). Hence, the scale (S) of an equatorial plate may be obtained by subtracting the declination of one star from the declination of another and dividing the result by the perpendicular distance between them. This is more simply stated by the formula

$$S = \frac{D - D'}{d'}$$

If the declination of a star is north of the equator, it is called "plus" ($+$), if it is south of the equator, it is called "minus" ($-$). Therefore, if one of the two trails you select happens to be north of the equator and the other south, the difference between their declinations ($D - D'$) will be found by adding the values for each declination.

Likewise, the focal length of the lens (F) may also be found by making a trail plate of an equatorial star. Without going into the mathematics of the formula, all you have to do is expose the film for 10 minutes, then multiply the length of the trail (T) by 22.9, which will give the focal length.

We hope you are convinced that making star trails is not quite so useless an occupation as at first it may seem. Try some of the experiments we have suggested. If the focal length of your lens is marked on the barrel, see how close you can come to the manufacturer's value. Study the trails and you can learn a lot about the film you are using. Try other films and compare them.

After you have made a few star trail plates and studied them, new subjects will be needed to keep you going. Aurorae and meteors fill the bill, for no matter how many pictures you take there is always something new. So let's leave the star trails and watch for the next aurora.

SUMMARY

Star Trails

Instrument	Any camera.
Mounting	Tripod or rigid support.
Setting	Infinity.
Aperture	Full.
Plates	Fast and panchromatic; see Chapter 17.
Exposure	Up to 30 minutes or more, depending on sky conditions and location.

Chapter 3

AURORAE

ONE OF THE MOST beautiful spectacles of the night is the aurora borealis (northern lights) or the aurora australis (southern lights). This interesting and peculiar phenomenon gained great prominence around Easter time in 1940 and in September 1941, when scientists correlated the failure of communications systems and radio with the spectacular displays generally visible throughout the United States at that time. So widespread and magnificent were the aurorae, both in color and intensity, that many photographers forgot to set up their cameras! Yet so brilliant were the streamers that a snapshot of ⅟₂₅ second with a lens working at $f/4.5$ would have been sufficient to record them.

Exquisite displays full of color and of many forms are seen at times, and they may be bright enough to be seen easily in the well-lighted large cities. So magnificent are these displays that when one occurs observatories receive a bombardment of telephone calls asking what the weird light in the north means. You may laugh, but some persons become hysterical about it and think it is the sign of the end of the world.

We assume that most of you have seen the northern lights, but what do you know about them? Do you know that they vary greatly in form, intensity, color, height, and so forth? Do you know that in some places the same display may be brighter and more colorful than in other places some distance away? If you do not know these things, or have not seen them, you probably do not recognize the northern lights except when they are so brilliant you can't help but notice them.

If you have a candid camera, such as a Nikon, Leica, or Contaflex, aurora photography is an ideal field for you, particularly if color film is used. Direct photographs in black and white are perfectly good and many times they are spectacular, but in color the whole aspect of the pictures changes. Some of the most beautiful color pictures we

have seen were of aurorae. The effect is at times weird, and with color pictures it is easy to understand how primitive man was held spellbound by this unearthly light which he could not explain but which he tried to connect with human events. Like the number 13, aurorae stood for both good and evil.

Like many other natural phenomena, no one knows exactly what causes aurorae, but astronomers are hard at work trying to find out. There are many theories as to their origin, but the latest seems to be the most plausible. It is briefly this: that the upper atmosphere is bombarded by electrified particles emitted from the sun. The best analogy is the neon tube, full of a gas which is made to glow by the passage of an electric current through it. The new theory is more understandable if we think of the earth and sun as the two ends of a tube and the atmosphere as the gas within the tube. Under normal conditions there is no apparent glow, but when the "switch" is turned there is a concentrated electrical charge which causes particles in the upper atmosphere to glow. But a great deal of observational data must be gathered and studied carefully before any theory will be accepted as a fact.

Although it is generally thought that aurorae are not visible except in the north, this is untrue, because they have been observed in New Orleans, Palm Beach, North Africa, the southern part of Europe, and other equally southern points. Another misconception is that northern lights appear only in the winter. On the contrary, they may be seen at any time of year, at any time of night, anywhere in the United States.

A friend of ours, while on convoy escort duty in the North Atlantic, was called up from below decks one night by nearly terrified men who wanted to know what to do to combat a new "secret weapon." Arriving on deck he was startled by a fantastic display of northern lights! Fortunately he recognized the phenomenon and was able to convince his men that there was no danger. Actually this was no laughing matter, for after many days at sea and near enemy territory it was not surprising that these men, who had never seen an aurora, should be somewhat jittery.

It is true that the northern lights vary in accordance with the latitude and longitude from which you observe them. Much better displays are generally seen in New York or Ohio than will be ob-

served in Florida, and in Canada they will be better than in Ohio.

Many stories have been told of hissing, crackling, or rustling sounds heard at the time of a brilliant auroral display. Most of these tales have come from parts of Alaska and Canada. They have always been taken with a grain of salt, but evidence obtained in the past few years has made skilled observers feel there may be some truth in them. At any rate, these noises, whatever they are, are still listed in the mystery file. If you live in high latitudes it is barely possible you have heard strange noises accompanying an aurora. If you have and the detective instinct in you is strong enough, there is a problem for you to try to solve. *Are* there noises? If so, what are they? Where do they come from? Are they actually connected with aurorae? Some investigators feel the sounds could not be caused by the aurora itself. What do you think about it? Keep your ears open.

You have probably read accounts of aurorae that gave the impression of fantasy. The photographic plate has proved these accounts not so fantastic as they sounded. They were more or less true accounts, notwithstanding the exotic verbiage.

In the study of aurorae there are two phases of the work that require attention, the visual and the photographic. One of the most important observations you can make is the time one form changes to another. This is usually done visually but "types" can be photographed unless the changes are too rapid.

To most of us, auroral displays are just a mass of light having no particular form, but Professor C. Störmer of Norway has spent many years studying the forms of aurorae. The results of his work have been published, wherein he treats of a dozen different forms, in great detail. With the hope that a better idea of the various forms will add to your enjoyment of the northern lights, we outline briefly Professor Störmer's classification. How many of these types can you identify from the auroral displays you have seen?

GLOW—A faint glow near the horizon, usually white or greenish, but sometimes red.

HOMOGENEOUS ARC—Diffuse above, sharply defined below. May be near horizon or high in the sky. Often climbs up in the sky. May later break up into rays. Frequently only parts of arcs can be seen.

HOMOGENEOUS BAND—More irregular in form than the homogeneous arc. Varies from very narrow to very wide. May have folds and resemble a huge curtain, which usually changes into bands with ray structure.

PULSATING ARC—Arcs or parts of arcs that flash up and disappear regularly, with a period of 10 to 30 seconds.

DIFFUSE SURFACE—A veil or glow covering large portions of the sky. May look like clouds. Frequently appears after rays or curtains. Color may range from white or greenish to red.

PULSATING SURFACE—A diffuse patch that appears and disappears at regular intervals.

RAYED ARC—An arc with ray structure.

RAYED BAND—A band with ray structure.

DRAPERIES—Bundles of long rays form a curtain or drapery. The lower border is more luminous. Fan-like form or partial corona near zenith.

RAYS—Look like searchlight beams of various colors, usually green, sometimes red.

CORONA—Rays appear to converge to a point. May be formed by long or short rays, or by bands and draperies.

FLAMING AURORA—Quickly moving waves of luminosity moving toward the zenith. Causes parts of arcs, bands, or patches to appear and disappear regularly. Often seen after strong rays and curtains, and frequently followed by formation of corona.

The next time you witness or photograph an aurora, consult the above list of types and notes concerning them. See if you can pick out the type you are looking at and try to predict its outcome and changes. If it happens to be bright, don't worry about what type it is; just set up your camera on a tripod as quickly as you can. Point it toward the brightest part of the display. Never mind whether you have regular film or color film in the camera. Open your lens wide, set it at infinity. Take a snapshot at $\frac{1}{25}$ second; make another exposure at 1 second; and still another at from 5 to 30 seconds, or even 1 minute. If it is a bright display, that will probably be enough, provided your lens works at $f/4.5$ or faster. Unfortunately, no set rules can be laid down. Familiarity with your own equipment (its speed and the film used) is the best guide to the proper exposure. For that reason it is common practice to make two or three exposures differing in time. Experience will teach the proper exposure to be given any particular condition.

Dr. C. W. Gartlein of Cornell University was one of the greatest authorities on aurorae in this country. He very kindly gave us a few tips which we pass on to you.

Generally speaking, all colors are visible in the northern lights, therefore fast panchromatic film will be found satisfactory as will certain other brands of commercial film that can be obtained easily, such as Eastman Tri-X Panchromatic and Super XX, and Ansco Superpan Press and Ultra Speed. Because aurorae usually move about in the sky, it is desirable to give relatively short exposures of from 1 second to 3 minutes. And of course the faster the lens the better.

Candid cameras using 35-mm. film are ideally suited to this type of work, and many of the thousands of fans who own such cameras will find them equipped with very fast lenses working wide open at $f/2$ and $f/3.5$. Excellent photographs have been made with an $f/4.5$ lens, on Super XX film, at an exposure of 1 minute, and some with an exposure as short as 5 or 10 seconds.

Better luck will be obtained with color film if you confine its use to bright aurorae, because medium bright and fairly faint displays require a longer exposure; the color is constantly moving and the fainter displays are apt to give blurred pictures.

If you do your own developing, Dr. Gartlein recommends following the manufacturer's instructions to give maximum speed. Because of the nature of the work, instructions for developing star pictures, given elsewhere in this book, should not be used.

The results of Dr. Gartlein's work have created a great deal of interest. A group of amateur astronomers in the Midwest has worked out an observational program that makes use of two-way short wave radio communication whereby two persons or more, in widely separated areas, confer with each other during the time an aurora is visible. In this way instantaneous comparisons and checks of visual observations can be made. For this purpose the Federal Communications Commission allotted a special band for the use of these amateurs who took upon themselves an extremely valuable and extensive scientific program. Their work was also supplemented by photographs. We have talked with these young men and can assure you they were having more fun with their cameras than they ever had before they began photographing aurorae.

So little is known about the northern lights that the professional astronomer is eager to receive any help you camera fans can give him. Permanent photographic records, either in black and white or in color, are of great value. Such photographs, together with accompanying data about the exposure, place, and time, are used to classify the various types, check up on visual observations, and to determine the height of the display observed. If you own a candid camera with a fairly fast lens, you are exceptionally well fitted for this type of scientific research.

Many amateurs are correlating and studying their own observations, whether visual or photographic. They are also trying to find better methods for making observations, and devising new instruments. Most of this work is carried out in cooperation with the professional. And as in many other fields of endeavor, the women have got into this one, too.

Here, then, is something you can do with limited equipment and it takes but little of your time. Here you will find a new interest in your primary hobby. No duplication will exist between your work and that of the professional in the same field, because he cannot obtain the data he needs over so widespread an area as can the amateur.

SUMMARY

Aurorae

Instrument	Any camera, but especially Leicas and other similar cameras.
Mounting	Tripod, rigid.
Setting	Infinity.
Aperture	Full. $f/6.3$ or better; $f/4.5$ or better preferred.
Plates	Fast and panchromatic; also color film and plates. See Chapter 17.
Exposure	$\frac{1}{25}$ second up to 30 minutes, depending upon the brilliance of aurora, camera and film used.

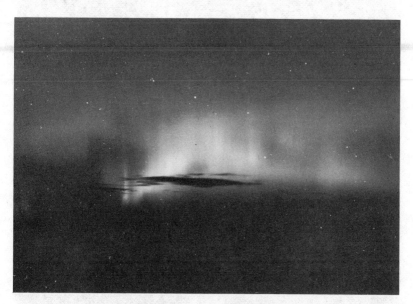

Figure 6. Aurora. September 26, 1940, 2210 E.S.T.

Here is a series (Figures 6, 7, and 8) of pictures of one aurora. All were taken with a Voigtländer "Superb" (reflex-type) camera, fitted with an *f/3.5* Heliar lens. Eastman Super XX film was used. Original negatives were 2¼ by 2¼ inches. Exposure: 10 seconds with lens wide open. As you look at the succeeding pictures note the changes in the form. Note how clearly the stars in the Big Dipper shine through the aurora. These pictures were a first attempt. Location: Hudson, New York. (George V. Plachy)

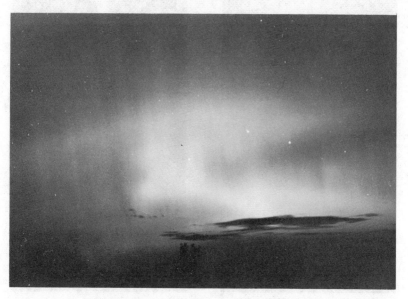

Figure 7. Aurora. September 26, 1940, 2220 E.S.T.

Ten minutes later than Figure 6, the aurora is spread over a larger area and it has become more diffuse. Exposure: 10 seconds at *f/3.5*. (George V. Plachy)

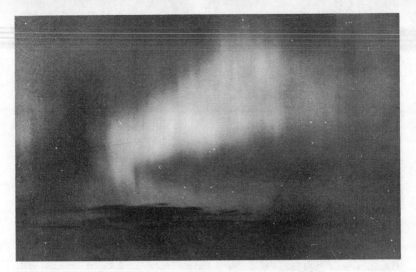

Figure 8. Aurora. September 26, 1940, 2230 E.S.T.

Here the display (compare with Figures 6 and 7) has diminished in intensity and changed its form to a drapery. Note that the rayed structure visible at 2210 and 2220 has almost disappeared. Exposure: 15 seconds at *f/3.5*. (George V. Plachy)

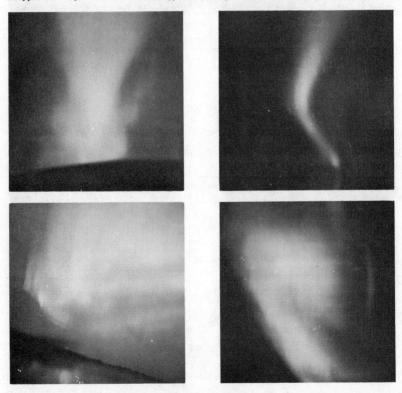

Figure 9. Aurora. September 26, 1940, 2200 to 2230 E.S.T.

These pictures were taken at the same time, by chance, as those in Figures 6, 7, and 8, but about 300 miles north of Toronto. The display as seen from New York appeared normal but very brilliant, whereas farther north the weird forms shown above were visible. Exposure: 5 seconds at *f/2.8*, on Eastman Super XX film. (Charles A. Federer, Jr.)

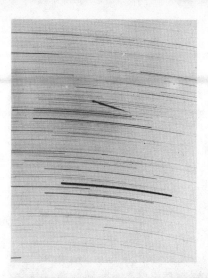

Figure 10. Meteor Trail. 0327 E.S.T., April 21, 1933

The meteor is the black streak, varying in thickness, cutting across the star trails. It was caught when the Texas Observers were photographing the Lyrids. Two explosions can be noted at the left of the trail. The thick black star trail, just below the center, is that of Vega, one of the brightest stars in the sky; directly beneath Vega is the double trail of the double star Epsilon Lyrae. This picture is really a negative; that *is*, the trails appear here just as they do in the original film negative. Photographed with a Graflex camera. Aperture $f/4.5$. Cramer Hi-Speed Plate used. (Oscar E. Monnig)

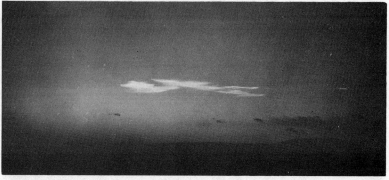

Figure 11. Great Meteor Train. March 24, 1933

This unusual photograph of a meteor "train" shows the luminous trail that is often visible for several minutes after a fireball has spent its life. In this case Mr. Allen saw the meteor at 0501 M.S.T. and at 0524 (23 minutes later) he took the picture reproduced here. He states that "one observer told me he counted 16 explosions or puffs of smoke. The last explosion was much larger than the preceding ones, although its size was nothing to compare with the large main cloud shown in the photograph. I did not get the exact time this train remained visible, but it was over two hours." (Photo copyright by A. R. Allen. Used by permission)

Figure 12.

Multiple Meteor Camera

This is one way to be more or less sure of catching a meteor during a "shower." Note the use of candid cameras using 35mm. film. The cameras are pointing to many different points of the sky. A rotary shutter is placed in front of the cameras, which covers the lenses 25 times per second. (Peter W. Millman)

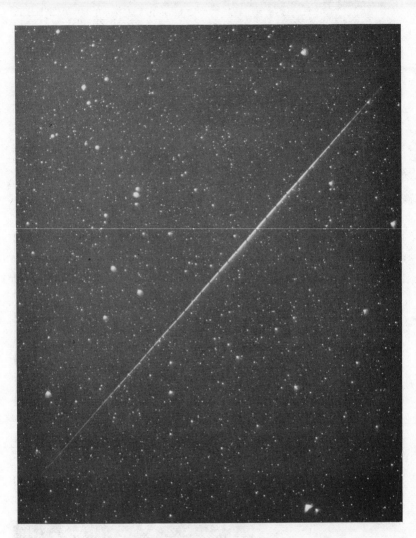

Figure 13. Broken Meteor Trail

This shows what happens to a meteor trail when you use a rotary shutter in front of your lens. Such a picture is used to determine the position of the meteor at short intervals of time, and thus its speed. (Courtesy Harvard College Observatory)

Chapter 4

METEORS

EVEN THOUGH you no longer consider yourself a child, can you refrain from showing emotion when you see a sudden streak of light cut across the night sky? Don't you point quickly and say "Look!" in a loud voice, so those with you can also enjoy the sight? If you are a normal person you probably do jerk your head and draw the attention of anyone within reach of your voice to what most persons call a "shooting star."

Of course, these star-like objects that shoot across the sky are not stars at all, because stars are self-luminous bodies that shine by their own light. Rather, these fleeting visitors to our world are meteors, which are formed by small particles of matter that hit our dense atmosphere with great force. As they continue on their way through the earth's envelope of air, friction occurs which creates sufficient heat to cause the particle to glow.

Probably you have noticed that meteors vary in brightness (sometimes dim, at other times extremely bright), in speed, and in color. You can easily figure out why they may vary in color, brightness, and speed—or at least you could make a good guess and probably be right. This is elementary knowledge, but there are many mysteries connected with meteors that the astronomer wants to solve, and anyone with an ordinary camera can be of great help. Even those star trail pictures may be quite valuable if a meteor has been photographed on them. We say such pictures *may* be valuable, because if you have kept no record of what you did and how you did it, nothing much will be gained.

Right here, we should like to impress upon you the need for keeping a systematic record of the things you do with your camera. It makes no difference what kind of picture you are taking, a complete record of the conditions and method of taking the picture may come in handy at some later date. Just look at all the photographic contests you can enter, if you have all the data required—lens stop

(the f-number) at which the picture was taken, exposure, time of exposure, film used, camera used, the f-number of the lens when used wide open, where the picture was taken, and so forth. All these facts are valuable.

Meteors are interesting objects and there are several things you should know about them. One of the first things to know is the difference between a meteor, a fireball, a bolide, and a meteorite.

When you see a dim or fairly bright streak (called a meteor trail), it is just a meteor. A fireball is a meteor that is as bright as or brighter than Venus. Sometimes it makes a noise as it rushes through our atmosphere, and frequently it is bright enough to be seen in broad daylight. The greater brightness, and noise if any, are generally caused by the large size of the object hurtling through space. An ordinary meteor is probably only as large as a grain of sand or a pea, and it is quickly burned out or consumed, whereas a fireball may leave a trail that will remain visible for a few minutes or even half an hour. Sometimes a fireball will explode when its course is run, or there may be a series of explosions. A fireball which explodes is called a bolide. A meteoroid is a small solid body which becomes a meteor on entering the earth's atmosphere.

A meteor seldom falls to earth, but when it does it is called a meteorite. Therefore meteors are of particular interest because they are our only connection with space beyond our own atmosphere.

Now that you know the difference between the general types of meteors, what good does that do you as a skyshooter? Well, first of all, the definitions may give you a clue as to what you could expect if you photograph meteors; secondly, you can readily see that there is enough difference to make the hunt a worth-while sport. Speaking of sports, you have about one chance in a hundred of actually catching a meteor with your camera. But there is a way to lessen the odds, which we will describe a little later.

But suppose you have made that one-in-a-hundred shot and there is a nicely defined streak on your film. The meteor trail can be picked out easily from amongst the star trails because of certain characteristics. Note how evenly wide the star trails are, how they all run in the same general direction. It would only be mere chance if the meteor ran parallel to the star trails, and even then you would be able to pick it out because its trail would probably be much longer

than any star trail, or for that matter it might be shorter than the star trails. Also note the thickening along the meteor trail and the tapering off at the ends. Of course, it is possible the whole trail will not be recorded on your film. For some unaccountable reason meteors seem to prefer cutting across the corner of the film! Length, shape, and direction are three means of distinguishing a meteor from a star trail. One end of the trail represents the meteor's entrance into our atmosphere, the other end its consumption, and somewhere along the trail the height of its luminosity. If that is what is on your film it is probably just an ordinary meteor. Your picture then shows a small particle of matter getting hotter and hotter, finally burning up.

Suppose, however, that you see a fireball and luck is with you and your camera. The picture you take will differ greatly from that of an ordinary meteor. The trail may be similar in actual structure, but of course it will be much brighter. When the fireball explodes (a bolide), the picture may indicate the end of it. The explosion makes a bulge in the trail on the film, but on the other hand the first explosion may not be the end, because particles are thrown off and they in turn may continue on their paths. If the original meteor is big enough, the particles thrown off first may be large enough to also throw off still more particles and you will see a continuation by a third trail. In other words, a fireball or bolide may be consumed entirely in a single trail, or it may continue in two, three, or more separate trails, sometimes resembling forked lightning.

Why are meteors so hard to photograph? In the first place, before meteors enter our atmosphere and become luminous, they have been flying through outer space at the rate of about 26 miles per second, and we must take the astronomer's word for that. Furthermore, meteors seldom become visible until they are within 50 to 70 miles of the earth's surface. Link these two facts together and what do you get? Yes, fast moving bodies which may appear in any part of the sky, at any time, and visible for only a fraction of a second or a few seconds at the most (somewhat longer for fireballs)! Therefore, it is impossible to set up your camera in any one position so you will be sure to have a meteor cross its path.

Photographing meteors is a really sporting proposition. Although you may be accustomed to seeing at least one meteor on

practically every clear night, it is rarely that one crosses in front of a camera. Even a battery of cameras set to cover a large portion of the sky will not record them night after night. On the thousands, yes, hundreds of thousands of plates filed in our large observatories, meteors will be found on relatively few. At the Harvard College Observatory alone, several hundred thousand plates have been examined, and after fifty years the thousandth meteor trail was found in 1940. In the following eight years 600 more were found. At Harvard there are many cameras in use every clear night. They are pointed to different parts of the sky and in one winter's night more than a hundred exposures will be made (a little less on summer nights). Yet night after night no meteors will be recorded. Therefore, if you happen to be photographing the stars some evening and you find a white streak (black on the negative) cutting across the plate, it is probably a meteor! But do not forget that the lights of an airplane, or an artificial satellite also may be recorded on the film.

We do want you to try this kind of skyshooting, notwithstanding the fact we seem to be discouraging your efforts. But rather than have you disappointed not only with your results, but with us as well, we have only tried to give you a true picture of what you are up against. We said your chances of photographing a meteor are about one in a hundred, but here is a way you can cut those odds down to a point where you can be reasonably sure of catching at least one meteor in an evening.

Meteor photography is a haphazard catch-as-catch-can business. However, there are certain periods during the year that should be more profitable in so far as the chances of photographing a meteor are concerned. The reason for this is that, as the earth moves in its orbit about the sun, every now and then it enters a swarm of particles that may be a disintegrated comet. At such times more meteors are likely to be seen than at other times. As a general rule these showers, as they are called, seem to emanate from specific points in the sky. Because of this, such showers have been given the names of the stars or constellations from which they appear to radiate. For instance, the Lyrids appear to radiate from a point within the constellation of Lyra; the Eta Aquarids appear to radiate from a point at or near the bright star known as Eta Aquarii in the constellation of Aquarius.

These showers usually last for several days and sometimes weeks. Some showers have produced more meteors per hour than others. Therefore, instead of going out night after night with the hope of picking up, let us say, a stray meteor, why don't you wait until the next shower is due and try photographing them then? Table I shows the well-known showers that have been observed over a period of many years, and when they occur we can reasonably assure you that your camera will produce results. We have also shown the dates of the appearance of these showers, the number of days they may be expected to be seen, the number of meteors you can expect to see in an hour, and the coordinates of the points from which they appear to radiate. The coordinates are given in right ascension and declination so that you can find the point easily on a star atlas.

TABLE I

METEOR SHOWERS

Name	Date of Maximum	Duration in Days	No. per Hour	Radiant Point	
				R.A.	Decl.
Quadrantids	Jan. 3	4	28	15h28m	+52°
Lyrids	April 21	4	8	18 04	+33
Eta Aquarids	May 4	8	7	22 24	—01
Delta Aquarids	July 28	3	27	22 40	—17
Perseids	Aug. 11	25	69	3 00	+57
Orionids	Oct. 19	14	21	6 08	+15
Leonids	Nov. 15	7	21	10 00	+22
Geminids	Dec. 12	14	23	7 12	+33

Note: The above table was compiled from various authentic sources, but the data are approximate only, based on the best available information.

The predicted appearance of these showers may be off by several days and sometimes no shower occurs at all. Of the showers listed, the Perseids and Geminids have been the most satisfactory photographically, because they are slower and bluer. At any rate, it is well worth your while to turn your camera toward the points in the sky shown in the table, on the days indicated. Many of the showers last for several days, therefore it is not necessary to wait for the date of maximum, which is given in the table. Start photographing several days before maximum and keep it up several days after maximum.

Now, here is something about meteors you probably don't know, unless you have better than a layman's acquaintance with them. The best time to see or photograph meteors is after midnight. This is another way to cut down those odds we have mentioned, and the reason is simply this: the earth travels in its orbit around the sun at the rate of about 18 miles per second and meteors are flying through outer space at the rate of about 26 miles per second. Therefore, a meteor coming toward the earth will have an apparent rate of about 44 miles per second when we see it. On the other hand, if the meteor overtakes the earth, it will be seen traveling at the rate of about 8 miles per second.

In the morning hours, the earth runs into the meteor, head-on, whereas those meteors seen in the early evening hours are overtaking the earth, and they will be fewer and slower than those in the morning. Also the morning meteors are much hotter and bluer than those of early evening.

Although the cards are stacked against you, photographing meteors is a game as good to play as any other that requires patience, perseverance, and taking advantage of every opportunity. No great effort is required to obtain good results, and when you see your first meteor trail on the film, you will get as much of a thrill as from making a hole in one; and all your former trials and tribulations will be forgotten. The study of meteors has become an important division of astronomy and it is a study to which you can contribute much, whether or not you own a camera.

There is a familiar old saw to the effect that "too many cooks spoil the broth," but the saying does not apply to meteor photography, for the greater the number engaged in this work and the more widespread the locations of the participants, the greater is its value. Paradoxical as it may seem, modest equipment is frequently more efficient for meteor photography than many expensive outfits.

Although hunting meteors can be done with any camera, some lenses give better results than others. Because there is reflection of light within a lens, and because the chance of photographing meteors also varies with the area of the field covered by the lens, the speediest lenses ($f/1.5$, $f/2.5$) available are not necessarily the most efficient.

Highly corrected lenses of small aperture-ratio (the f-number, equal to focal length divided by diameter of the aperture) are gen-

erally less efficient and have a smaller field of view in good focus than an $f/4.5$ lens. A good lens for meteor work should have a field of 30° to 40° in good focus. Such lenses as the Zeiss Tessar and the Voigtländer Skopar having an aperture-ratio of $f/4.5$ and a focal length of from 4 inches to 10 inches are ideal.

Plate cameras are to be preferred, but film pack and roll film can be used. However, if you do not have a Skopar or Tessar lens, that need not keep you from taking photographs of meteors. We have mentioned these instruments because they are known to give better than good results.

If you have a lens working at $f/4.5$, most plates and films can be exposed for an hour (with lens shade) without showing too much, if any, sky fog. But if you are near a large city and bright lights, or if the moon is up, the exposure should be reduced to 30 minutes; and if the sky as a whole is very bright, as it is at the time of full moon, you may have to cut the exposure down still farther, to about 10 or 15 minutes. A lens shade should always be used to keep out as much extraneous light as possible.

We assume that you will try direct meteor photography; that is, with a camera mounted on a tripod, so the star images will trail across the plate. Visual observations should supplement the exposures so the time of the appearance of a meteor will be known. It is also worth-while to estimate the length of time in seconds that a meteor is visible. You can count seconds by saying "one hundred and one," "one hundred and two," and so forth, at the same speed as you normally talk. The time of beginning and end of each exposure should be noted. That's easy, but to save yourself a lot of trouble trying to figure out which end of a star trail is the beginning of the exposure, try this trick. First note the time you open the shutter. One minute later cover the lens for from 5 to 15 seconds, then open it and expose as long as you want to or the conditions permit. About 15 minutes before you close the lens shutter for good, cover it for from 5 to 15 seconds, then note the time the exposure ends.

This closing of the shutter for 5 to 15 seconds will make a break in the star trails. These small breaks are more accurate reference points than the actual beginning and end of the trails. By covering the lens 1 minute after the beginning of the exposure and 15 minutes before the end of the exposure, the length of the trail from the begin-

ning to the first break will be shorter than that from the second break to the end of the trail. In this manner it is easy to determine by inspection which end of the trail marks the beginning of the exposure, thus doing away with any necessity for marking the films.

If you want your meteor photographs to be of value not only to yourself but to others as well, you should carefully and clearly record certain information, whether you supplement the camera with visual observation or read a book while the exposure is being made. In addition to the time of beginning and end of the exposure, you should note the geographic location (latitude and longitude) of the place where your camera is set up. Another piece of information you should write down is the part of the sky toward which your camera is pointed at the beginning of the exposure.

Sporadic meteors can occur anywhere at any time. Two or more observers stationed from 30 to 90 miles apart can produce valuable records by watching the same part of the sky at the same time. Suppose you and someone else many miles away should photograph the same meteor. With this information anyone studying the pictures can tell how high the meteor was and the direction of its flight with respect to the true north and south. Meteors photographed in both places can be matched and identified easily.

You can have real fun and get some interesting pictures if you rig up a rotating shutter in front of the lens of your camera (Figure 12). This arrangement is similar to that of an ordinary motion picture camera, but instead of having both film and shutter move, only the shutter should move for meteor work, and it should operate at the rate of from 20 to 40 revolutions per second. In this manner the meteor trail will be broken up into small segments (Figure 13). From such photographs the speed (angular velocity) of a meteor can be computed, and the ratio of luminosity (brightness) at any point to that of any other point, or to the whole trail, can be obtained.

———

Now you have three things to do with an ordinary camera mounted on a tripod and without special equipment—making star trails, photographing aurorae, and photographing meteors.

Perhaps the least important of these may seem to be the star trails, but even they become important if a meteor crosses the field of

view. So often does an otherwise seemingly unimportant action become important that it is always well to write down in a notebook specific data concerning each exposure. By so doing some of your pictures may have definite scientific value, whereas without the necessary information they may become more or less useless except as pictures to look at.

To illustrate this, suppose you are bent on taking a pictorial star trail photograph. After development you find a meteor has crossed the field of view, apparently spoiling an otherwise good picture. And well it may have, if you did not keep a record of what you did and how you did it. If you did note the position in the sky toward which your camera was pointed, the time the shutter was opened and closed, the day of the year, and the geographic location of your camera, it is possible to identify all the stars, the direction of the meteor's flight, and if you are one of several who photographed the same meteor from different places its height can be determined and possibly its speed. Thus will every exposure you make have value. Further information about what kind of records to keep, together with sample pages, will be found in Chapter 16.

Now, one more word before we introduce you to other fields.

Because meteors vary in color as well as in the amount (intensity) of light they give out, fast panchromatic plates or films will give the best results. Lenses of fairly short focal length with a large aperture are best, but portrait lenses and anastigmat lenses are also suitable.

So, join in the fun—get your camera out—point it skyward—and shoot the stars. Let's see what you can do.

On the morning of November 17, 1966, we saw what the amateur could do. He stayed out until the wee hours of the morning with everything he had from box cameras to highly specialized cameras, using black and white film and color film. What started out to be an ordinary meteor shower turned out to be one of the finest and certainly one of the most fantastic showers we have seen in many years, rivaling the great Leonid showers of 1799 and 1883. Yes, the Leonid shower of November, 1966 will go down in history. The greatest activity took place on November 17, between 11:30 and 12:30 Universal Time. At Kitt Peak, Tucson, Arizona it was estimated that meteors rained at the rate of 1000 to 2400 per minute from 4:30 to 5:30

A.M., Mountain Standard Time. The hourly estimates ranged from 90,000 to 150,000, which is a fantastic number.

This shower had everything—meteors, fireballs, bolides, and long-enduring windblown trains. Magnitudes of -8 were observed. It is obvious that no film was too slow to record them.

If you are interested, you might look up the January 1967 issue of *Sky and Telescope,* where pictures of the shower are shown in color on the cover, taken with High Speed Ektachrome; and there are many more photographs in black and white. Also the *Review of Popular Astronomy* for January–February 1967 has many pictures. Both these magazines show what the amateur can do with his camera.

SUMMARY

Meteors

Instrument	Any good camera.
Mounting	Tripod, rigid; or equatorial (see Chapter 5).
Setting	Infinity.
Aperture	Full. From $f/6.3$ to $f/3.5$.
Plates	10 to 30 minutes or more, depending on condition of
Exposure	the sky. Exposures of one hour can be made in a protective area on a dark moonless night.

Chapter 5

STARS

EVERYTHING we have asked you to do, up to this point, produces
star trails, not real pictures of the stars. Furthermore, you
have doubtless surmised there is a certain limitation to the amount
and variety of work that can be done with a fixed camera mounted
on a tripod. We have shown you only one way to make the stars
in your pictures look like those in the sky—by finding the exposure
necessary to produce no trail, such as a snapshot or an exposure of
only a second or two. If this is done, however, you are not getting
the most out of your film.

To the astronomer, the most valuable property of the photo-
graphic emulsion is its light-gathering power; that is, the longer
such film is exposed, the more light it gathers. Consequently, fainter
stars can be seen by the camera's eye than can be seen by the human
eye in direct visual observation.

Because no point of a star trail has a longer exposure than any
other point, it is obvious that a fixed camera is limited in the amount
of light and number of stars it can record. Therefore, in order for
you to make full use of the light-gathering properties of your film, it
will be necessary to keep the camera pointed to a star or group of
stars for a longer period of time than a snapshot. To do this your
camera should be mounted in such a manner that you can "follow"
the star or stars throughout the duration of the exposure. In this
way each star in your picture will have the same position on the
plate at the end of the exposure that it occupied when you first
opened the shutter, and single, round, pinpoint images will be
recorded.

A simple mounting can be made at very little expense; a few
pieces of wood or gas pipe will do the trick. Best of all, you need not
be a mechanical genius. But let's find out first exactly what you'll
get and what you can do with the pictures after you have made them.

When you look up into the sky on a dark, clear, moonless night

you see many stars of various colors and of different brightness. Your camera will see the same differences and record them. There are only about 6,000 stars in the whole sky (including both hemispheres) that can be seen by the unaided eye, and only about 2,000 stars can be seen at any one time. Some of the stars are very bright and others very faint. The astronomer grades each star according to its brightness, by what he calls a scale of magnitude. There are several different kinds of magnitude scales, but the most common are visual, photographic, and absolute.

Visual magnitudes are based on a scale of brightness that was set up in the following manner: the visible stars were graded into six magnitudes, the first being the brightest and the sixth the faintest. It was found that a star of the first magnitude was about 100 times brighter than one of the 6th magnitude, which made the stars of one magnitude about $2\frac{1}{2}$ times brighter than those of the next fainter magnitude. The scale of magnitudes begins at zero and it is expressed in numbers on either side of that point. For example: a star noted as magnitude 2 is about 6 times fainter than one of magnitude 0. On the other hand, a star designated as -2 (minus 2) is about 6 times ($2\frac{1}{2} \times 2\frac{1}{2}$) brighter than one of 0 magnitude. It may sound topsy-turvy or foolish to say a star of the 6th magnitude is fainter than one of the first magnitude, but it is not an unusual way of grading things. Ask any woman how spool cotton is numbered.

Photographic magnitudes differ from the visual because some stars are red, others blue, yellow, and so forth. Ordinary plates and films do not have the same sensitivity to color as does the eye. Therefore you can readily see that a red star and a blue star of the same visual magnitude will appear to be of different magnitudes on the plate, just as the same difference in color can be observed in ordinary pictures. Photographic magnitudes are based on visual magnitudes corrected for color (see Chapter 6).

Absolute magnitude refers to the brightness of a star at a standard distance from us. All stars are not the same distance from the earth, and this obviously would make a difference in the visual brightness. Therefore, the astronomer figures out how bright a given star would be at that standard distance, thus obtaining absolute magnitude.

Now, all this business about magnitudes has a great deal to do with your camera and shooting the stars. The astronomer has found that the number of stars of each magnitude increases greatly as the magnitude decreases—that is, the fainter stars are far greater in number than the brighter stars. You can verify that for yourself very easily by looking at the sky any clear night. There are nowhere near so many bright stars visible as there are faint ones.

Out of the 6,000 stars in the whole sky visible to the unaided eye, only about 20 are of the first magnitude, but there are more than 3,000 of the sixth magnitude. The fainter they are the greater their number, as shown in this table:

TABLE II

NUMBER OF STARS

Limiting Magnitude	Number of Stars
9.0	117,000
10.0	324,000
11.0	870,000
12.0	2,270,000
13.0	5,700,000
14.0	13,800,000
15.0	32,000,000

The number of stars shown in Table II is approximate only, and includes both the northern and southern skies. We have inserted these figures to indicate what your camera can do for you, because the size of the lens on your camera and the length of exposure have a lot to do with the magnitude or brightness of the faintest stars you can photograph. For example: a lens 1 inch or 1½ inches in diameter used with a fast plate will record stars as faint as the 13th magnitude, which is 7 magnitudes fainter than stars at the limit of visibility (6th magnitude). Or, to put it another way, a 6th magnitude star is about 600 times as bright as the faintest star on your plate. Look once more at the table above and you will find that with such a lens 5,700,000 stars are within your reach!

It doesn't require much imagination to see what your camera can do. No longer is it just a "picture taker" but a powerful instrument which reaches far out into space, bringing unseen objects to view.

One of the interesting things you can do to show the power within your lens is to make a photographic atlas of the sky, by systematically making exposures of overlapping fields. Most of you will have to confine your atlas to that portion of the sky visible from your locality. Because the work of mapping the sky has to be spread out over a whole year to include the sky in winter as well as in summer, little actual effort is required.

A photographic atlas of the sky is in many ways a good thing to have. By comparing your pictures with a good star chart such as Norton, Schurig, or Skalnate Pleso, you can rule the lines of declination and right ascension on the prints and in this way convert your atlas into a chart which can be used for reference or for determining the positions of stars invisible to the unaided eye.

The prints of your atlas can be used either individually or by cutting them up and pasting them together in a mosaic. The Milky Way is the richest star field in the sky and positive prints of overlapping exposures of this region can be cut up to form a mosaic of striking character and of great pictorial interest.

A photographic atlas may be used also to determine what objects you can photograph. It would then be a basic atlas that will define the magnitude of the faintest stars that can be recorded by a certain exposure, on a particular film, with your camera. Of course, if you make this basic atlas you should make each exposure under as nearly the same conditions as possible—each exposure of the same length of time, the same camera, same film, and if possible, the same sky conditions.

Right here we might as well tell you something about taking these pictures; namely, when to take them. There are various rules of thumb, but under normal circumstances do not begin shooting the stars earlier than an hour after sunset, and stop shooting an hour before sunrise.

It doesn't get dark for some time after sunset and the sky lights up appreciably some time before sunrise. A good stunt is to make a chart for your locality that will show you, at a glance, the best time to start and stop photographing, for each day in the year. Of course, you can always look up the time of sunrise and sunset in your favorite almanac and govern yourself accordingly, but you will soon tire

of doing that. The chart will save a lot of thumbing around the pages of a book.

By this time, you probably wonder just how faint the stars are that your own camera will record. Your star images will now be points instead of trails. The longer you expose the film the fainter the stars you can get and in some parts of the sky, such as the Milky Way region, so many stars will be seen on your film it will be hard to discern the familiar configurations.

The faintness of the objects photographed is governed by the diameter of the lens used and the length of the exposure. In order to give you some idea of the magnitude of the faintest stars you might expect to find on your plates, we have compiled the small table below. It will serve to indicate the approximate magnitudes of the faintest stars on pictures made with ordinary fast films, with hard focus lenses having a diameter of 1, 2, 3, and 4 inches, with exposures varying from 1 minute to a little more than an hour.

TABLE III

MAGNITUDE VS. EXPOSURE

Diameter of Lens (inches)	Exposure in Minutes				
	1	3	9	27	81
1	9	10	11	12	13
2	10.5	11.5	12.5	13.5	14.5
3	11.5	12.5	13.5	14.5	15.5
4	12	13	14	15	16

Example: A lens 2 inches in diameter will record stars of about the 12.5 magnitude by exposing the plate 9 minutes.

You can see from Table III that a half hour exposure with a lens 1 inch in diameter will enable you to take pictures of stars many times fainter than the eye can see, and if you turn back to Table II, you will find there are about 2,270,000 stars down to the 12th magnitude. Therefore, if you could photograph the whole sky visible at one time from one place you would find about 760,000 stars on your plate. Sort of staggering, isn't it? Well, let's get back to earth and see how you can find the magnitude or brightness of individual stars on your plates.

The magnitude of a star can be found in several ways, but because the determination of stellar magnitudes presents a problem even to the professional astronomer, we shall explain only a very general and rough method. We describe this method solely for the purpose of enabling you to get more fun out of your pictures of the stars.

The object is to compare star images on your plate with a scale of uniformly graduated images. First, you must make a scale. This can be done very easily by making a series of exposures on the same film, by varying each exposure in geometric ratio, thus: 1, 3, 9, 27, 81, 243 seconds, and so on. The plate should be shifted slightly after each exposure to separate the images. Placing a cap over the lens or closing the shutter for 1 minute will accomplish the same result as moving the camera, by allowing the stars to move instead. One minute will leave ample space between the star images. These images must not be trails—they must be points, and you will have to follow the stars during each exposure. (We'll show you how to follow, shortly.) The images on the scale plate will increase in size and density, and the interval between each image and the next will be about one magnitude. Figure 14 shows what such a scale looks like.

Now place the emulsion side of your scale against the glass side of the plate or film to be examined. Then by examination with a low-power magnifying glass find the image on your scale that corresponds in density with a star on the plate. This is called measuring. The star selected should be one that is known and whose magnitude you can obtain easily. Approximate visual magnitudes can be obtained from star charts like Norton's. For your convenience we have compiled Table XV (Appendix) giving more accurate visual and photographic magnitudes of 100 selected stars. Once you know the magnitude of the image on your scale that corresponds to the selected star, the approximate magnitude of other stars on your plate can be determined by comparing their images with those on the scale, because each image on the scale represents a difference of one magnitude. It is also possible to estimate fractions of a magnitude in this way.

Each plate examined will have to be treated in the same manner, because plates and films do vary. And remember, this is only an approximate method.

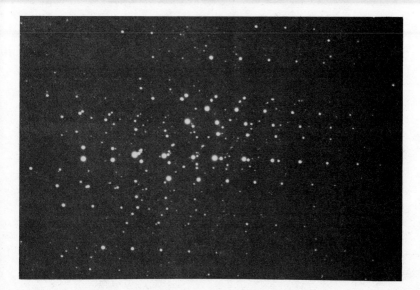

Figure 14. Typical Magnitude Scale

This scale was made with the camera "shooting" the Pleiades. Exposures: 1, 3, 9, 27, 81, 243, and 729 seconds (see Chapter 5). (William von Arx)

Once you have determined the magnitude of the faintest star on a plate, all other objects such as comets, variable stars, and so forth, must be of that magnitude or brighter in order to be photographed by comparable exposures with your equipment. Therefore, if you have made a basic atlas and have determined the magnitude of the faintest stars obtained, you can very quickly tell whether many other objects are within the range of your camera if photographed under the same conditions as your limiting magnitude plates.

This place is as good as any to stop talking about stars for a minute and tell you how to make a simple mounting so you can train your camera on a star and keep it there. When this is done by hand it is called "following" or "guiding," because there is another way of doing the same thing by means of motors or clockwork (see Chapter 14). If you have a telescope and know all about mountings you can skip what follows.

First, let's review a few facts about the motion of the stars—facts that explain why a special mounting is required and what you need for its construction. You know the stars appear to revolve about the earth in an east-west direction, as does the sun, and everyone is willing to accept the statement that this motion of the stars is really due to the rotation of the earth upon its axis in a west-east direction. We have also mentioned that the north and south poles in the sky are the points where the extension of the earth's polar axis cuts the celestial sphere, and that pictures taken with a fixed camera pointed toward the poles will show circular star trails. Therefore all you need is some kind of support to enable you to point your camera toward any point in the sky and be able to keep it there. As we have already said, this can be accomplished by hand (following), or by automatic mechanical clockwork or motor. However, we shall confine ourselves now to describing a simple mounting that can be guided by hand.

The diagram, Figure 15, will help you to understand the principle of this kind of mounting, which consists of a stand, a polar axis A-B parallel to the earth's axis, a board C-D mounted at the end of the polar axis to hold the camera G, and two sights E and F.

The celestial pole is always situated at an angle above the horizon equal to the latitude of your place—the farther north you go the higher the North Star is, and the farther south the lower it is. The

polar axis *A-B* must point to the celestial pole and be constructed so
that it can be rotated about its own center, as shown. At the north
end of the polar axis, affix the board *C-D* in such a manner that it
can be moved in a north-south direction as indicated by the arrows.
This board should be arranged so that it can be clamped in any posi-

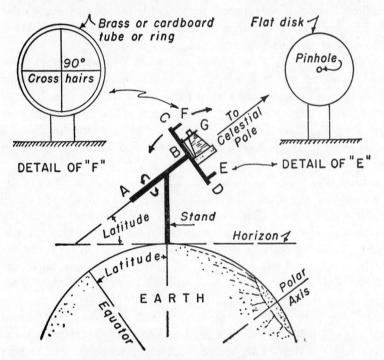

Figure 15. Principle of the Equatorial Mounting

The intersection of the cross hairs and the center of the pinhole must be the same distance
above the surface of the board C—D. The sights may be separated as on a gun, or a card-
board tube about 1 inch in diameter and about 1 foot long may be used. The beginner may
find the tube easier to use.

tion. The two sights are necessary and they are used just as you
would use sights on a gun. The sight at *F* will have two hairs cross-
ing each other at right angles; that at *E* will be a plain disk with a
pinhole in the center. It is a simple matter to keep the cross hairs
on an object as long as one cares to guide or follow, by turning the
axis very slowly but steadily toward the west. The polar axis should
be friction tight, but not so tight that it cannot be turned smoothly
and easily.

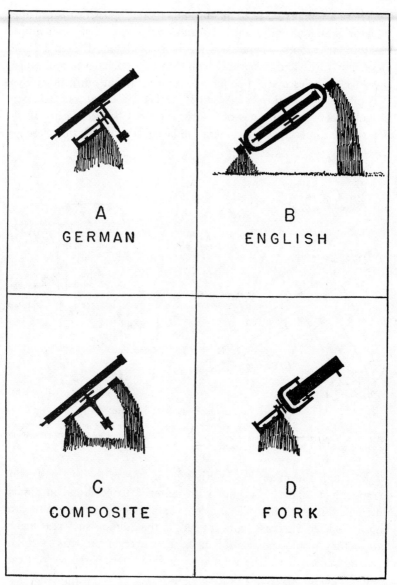

Figure 16. Four Common Types of Equatorial Mountings
A and D are the simplest. The fork type is the easiest to use and make.

There are many ways of making this mounting, which is called an equatorial mounting. Figure 16 shows the variations in common use with telescopes. Type A is the most common; B uses a closed yoke that turns and is parallel to the earth's polar axis, and within the yoke the telescope can be moved in a north-south direction; Type C combines the features of A and B; and Type D shows a telescope mounted between the tines of a fork, the tines being attached to the polar axis. In each case a camera can be substituted for the telescope.

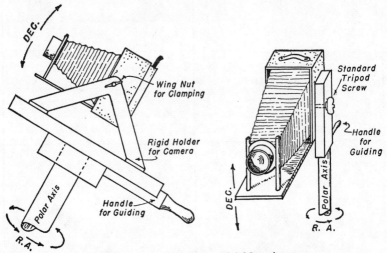

Figure 17. Simple Equatorial Mountings

Note, in the left-hand picture, that the board supporting the camera is rigidly fixed to the polar axis. The right-hand picture shows how you can attach your everyday camera to the mounting whenever you want to shoot the stars.

Although the mounting in Figure 15 appears to be a makeshift arrangement that can be built with material to be found in almost any cellar, it is serviceable. So long as a moderate amount of care is used to keep the cross hairs trained on the guiding star, reasonably satisfactory results can be obtained. However, if the axis *A-B* can be arranged so it can be rotated by a slow-motion screw, you can make longer exposures with greater ease.

In Figure 15 the board is movable, but in Figure 17 (left) a detail of the camera mount is shown where the board *C-D* is firmly attached to the polar axis and the camera is supported by two uprights which allow the camera to be moved in a north-south direction.

If you intend to use your regular camera, the simple arrangement shown in detail in Figure 17 (right) will serve the purpose. Here a tripod screw is used to hold the camera in position. It is a simple solution to the problem of mounting a camera which is used for other purposes during the day because the camera can be attached to this mounting as quickly and easily as to a tripod.

We are well aware of the ingenuity of the amateur photographer who rigs up all sorts of gadgets to make his work easier and to gain special effects. Are you going to be any less ingenious in mounting your own camera in the manner best suited to your needs? For that reason and because this book is intended to tell you how you can use your camera, and open up a new field of photography for you, complete working drawings correct in every detail are not given. We know from experience that you (and every other person with a hobby) like to work out your own problems in your own way, and carry to completion your own designs, because when you do this you take more pride in the completed product.

Then again, what might suit us may very well be impractical for you. Therefore we shall provide only the necessary facts, which you can apply in any way you see fit, together with a few hints from us as to what not to do.

Telescope makers throughout the country have built their own telescopes and constructed their own mountings—some simple, some complex. If you desire aid in designing a mounting we recommend the profusely illustrated books compiled by Albert G. Ingalls, *Amateur Telescope Making* (4th Edition), and *Amateur Telescope Making Advanced*. These are standard reference books for anyone who wants to make a telescope. In them you will find innumerable types of mountings made of all sorts of odds and ends, together with illustrations and complete descriptions of their design and construction.

Where you are most likely to get into trouble is in the application of the fundamental principle of the equatorial mounting, which we have just described (see Figure 15). Amateur telescope makers more often than not provide unsuitable mountings in that they are generally too lightweight for the instrument they are designed to carry. There is little danger that such would be the case in making a mounting for your camera, but we do want to impress upon you

the need to make it heavy enough—rather err on the side of heaviness, for it cannot be too strong or too heavy. An unsteady light mounting might just as well not have been made and the results obtained by your use of it cannot be satisfactory. Look first to your mounting and remember this: you can mount a light instrument on a heavy mounting, but never mount a heavy instrument on a light mounting.

Also, your mounting should be fixed firmly in place, whether it is stationary or on a tripod. All parts should be adjusted so the whole is as free from vibration as possible, is smooth working, and free from play resulting from imperfect bearings. Furthermore, there should always be quick and easy control of the guiding mechanism, whether turned by hand, slow-motion screw, motor, or clockwork; and wherever possible the stand and mounting should be set on a firm bed.

Setting up your camera—getting it ready for work—is always an interesting job because that is the last stage before placing the film and opening the shutter for the first exposure. We suggest you get everything ready and practice guiding. Set your cross hairs on any star; clamp your camera in position and then try to keep the cross hairs on the star for five minutes. After that trial spin at following, rest a few minutes, then try it again for ten minutes, rest again, then guide for fifteen minutes. This will be enough to get the hang of it and it will also help to get rid of whatever nervousness you may feel. That first exposure will be a bugaboo—it always is. Remember when you got a camera and snapped the shutter for the first time? That first roll of film was nothing to get excited about when compared with what you get now, was it? Shooting the stars is no different, so don't give up. It won't be long before you will be envied by your friends.

As you can see, high speed lenses are not so important, notwithstanding the fact that with them you can take snapshots of everyday objects in poorly lighted places, with some measure of success. When you take a picture of the stars, with your camera mounted as just described, you are no longer dealing with short exposures— long exposures are the rule; therefore a super-fast lens and its accompanying expensive equipment are not necessary. All you need is a good lens and a light-tight box. Any box camera such as a Brownie

or other simple instrument that may be purchased at little expense will give good service.

Many of you will want to have a special camera that will be used only for shooting the stars—one that will be ready to use at a minute's notice. If you do not have an extra camera you can use for this purpose, and you do not want to buy one, why not make one? You can make a very efficient camera by mounting a lens at one end

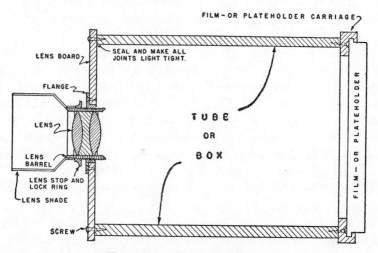

Figure 18. A Simple Box Camera

The shutter is not shown. A cardboard cap placed over the lens or the lens shade will serve as a shutter. If your lens has a built-in shutter, use it. Gun sights or a small pocket telescope can be mounted on the top or side of the box.

of a stiff cardboard tube and a plateholder at the other end. Such cameras are neat and light. Another way to make a camera for sky-shooting is to take four pieces of wood and put them together in the form of a box with open ends, to which you attach a lens and a plate-holder as shown in Figure 18.

If you do not have a lens, use a reading glass. Oh, yes you can! Figure 19 shows one in use. Generally speaking, a camera looks like a pretty complicated instrument, but a camera for skyshooting can be the simplest thing imaginable, and a lot of fun to make. Let's see how it's done.

First get your lens. Naturally you want to know what kind. We have mentioned the reading glass, which you probably have around

the house somewhere; but there are many lenses that can be pur-
chased inexpensively—among them are ordinary projection lenses
used to project lantern slides on a screen; rapid rectilinear lenses
that are standard equipment on many popular cameras; and the so-
called portrait lenses. All can be picked up in second-hand shops:
A good lens should have a hard (sharp) focus and a flat field. The
best results will be obtained with lenses working at an aperture ratio
of not more than $f/6.3$, although rapid rectilinears working at $f/8$
have been used to good advantage. Portrait lenses may be used at
$f/3.5$ and even $f/2.5$.

Lenses are designed for use with certain size plates and films.
For example, the lens in your Kodak will give a clear picture, in
focus, right out to the edges of the film. If, however, you should use
the same lens with a film of larger size the picture would not be clear
and in focus way out to the edges. In other words, when you hear
anyone say that a lens "covers" a 4 by 5 inch plate he means that
everything on that size plate will be in good focus. If you have a
lens that will cover an 8 by 10 inch plate, it will also cover a 5 by 7
inch or a 4 by 5 inch plate. Therefore, when selecting your lens ask
the dealer what size film it covers. We suggest the use of 4 by 5
inch plates or films, or film packs. This is a convenient and eco-
nomical size and will help keep down the size of your camera.

Generally the focal length of a lens is marked on its cylindrical
rim, or barrel. If you do not find a number something like F 10.5
cm. on your lens, you will have to find the focal length before cutting
the pieces for the box. To do this, mount a piece of white paper on
an upright board. Place your lens on a small block of wood and
move the block back and forth in front of the paper until a sharply
focused image is obtained. Then measure the distance from the
middle of the lens barrel to the paper and you will have its focal
length. (If you now divide the focal length by the diameter of the
lens you will have its speed—the f-number.) This is a simple method
of obtaining the approximate focal length.

Now get a tube or four pieces of wood of sufficient width to
accommodate your lens and a frame to hold the plates. Cut the tube
or pieces of wood to such a length that the distance from the lens
(when mounted) to the plateholder will be a little shorter than the
focal length. The length of the tube will vary for every type of lens.

Figure 19. Reading Glass Camera

This simple mounting supports a small telescope (left) and a homemade box camera (right) fitted with a reading glass for a lens. Focus 12 inches, working at $f/3$. Hand-driven mounting. (Equipment and photo by William von Arx)

Figure 21. A Brownie Shoots the Stars

A hand-driven mounting. (Mounting and photo by William von Arx)

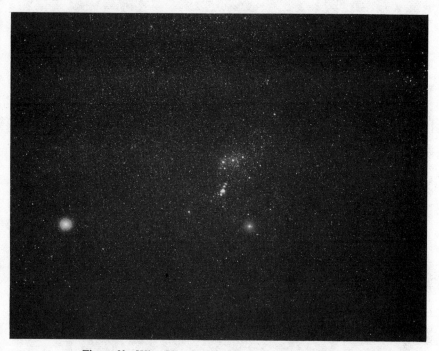

Figure 20. What You Can Do with a Homemade Camera

Again we show the constellation of Orion, which is familiar to all. The bright star to the left is Sirius; the group (V-shaped) of bright stars, in the upper right corner, is the famous Hyades Cluster. Note the nebulosity in the "Sword" of Orion. Test your endurance by counting the stars. This picture was made with an Eastman Kodak lens at $f/4.5$, of 8 inches focal length, using W & W panchromatic plate and giving an exposure of 30 minutes. (Edward A. Halbach)

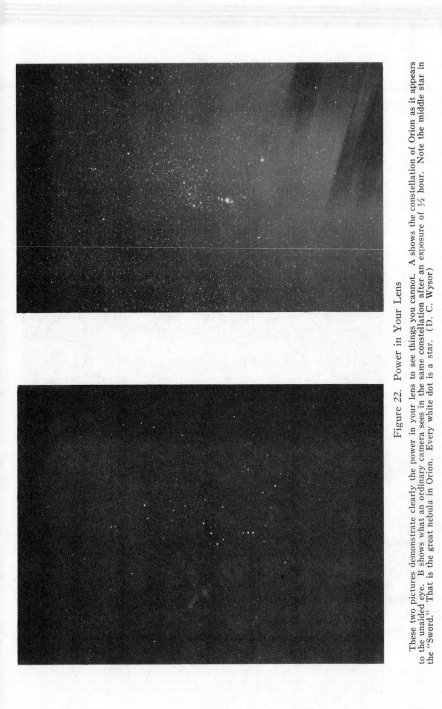

Figure 22. Power in Your Lens

These two pictures demonstrate clearly the power in your lens to see things you cannot. A shows the constellation of Orion as it appears to the unaided eye. B shows what an ordinary camera sees in the same constellation after an exposure of ½ hour. Note the middle star in the "Sword." That is the great nebula in Orion. Every white dot is a star. (D. C. Wysor)

When the box or tube is cut, paint the inside with a nonshiny black paint or ebony stain; varnish the outside, or paint it, too.

Keep everything as light as possible without sacrificing rigidity and strength, thus avoiding any unnecessary weight on the mounting, and be sure to have all joints light tight. It is better to use screws rather than nails in the construction of the camera.

Now you must provide some arrangement for adjusting the lens or the film, so the film can be placed in the proper focus. That is why the tube was cut shorter than the focal length of the lens. Getting the plate in focus is not a trying job. Care should be used in cutting off the ends of the tube or box so they are "square" with the line of the tube and parallel to each other. The easiest assembly is to fix the plateholder frame in place and provide a lock screw for the lens or some other gadget to hold the lens in position when properly adjusted to the right focus.

The lens board will have a flange attached, into which the lens can be screwed. (The flange and lens board should be a part of the lens when you buy it.) Screw the lens barrel part way into the flange, and place a ground glass in the plateholder. Then screw the lens until a good sharp image—one that appears to be in focus—can be seen on the ground glass. Then note the position of the lens by making a pencil mark on the top of the lens barrel and another mark directly opposite on the flange. This we will call the normal position of the lens. Then around the flange mark the quarter points and number or letter them, as 1, 2, 3, 4, or a, b, c, d. Now you are ready for the next step, which is to adjust the lens so that all images will be in sharp focus. To do this you must make a series of exposures on the same plate with the camera fixed in position. This is called making a "focus plate."

At the first opportunity point your camera toward a bright star, then screw the lens into the flange one full turn from the normal position, thus throwing it out of focus. Expose the film for 1 minute, then wait 5 minutes and expose again for 1 minute with the lens in the same position. This second exposure will be the first in the series, the 5-minute interval enabling you to locate the beginning of the series easily.

Now unscrew the lens $\frac{1}{4}$ turn and make a 1-minute exposure. Continue unscrewing and making 1-minute exposures at each quar-

ter turn right on through the normal position until one full turn beyond normal position has been reached. Wait 1 minute after each exposure. In this way the trails and the spaces between them will be of equal length—the 5-minute interval at the beginning will be the longest space. Thus you can tell easily just what position of the lens corresponds to any particular trail.

Examine your negative with a low-power magnifying glass and note the image that has the sharpest and narrowest trail—it will indicate the position of the lens at the best focus. If two trails appear to be identical, the correct focus will lie halfway between them. As a general rule, most hand cameras will be in good focus when the lens is set at infinity, in which case the experiment can be used as a test for checking the correct position of infinity. But if you use a camera whose lens can be racked out, do not unscrew the lens as suggested above.

When you have selected the image that denotes the best focus, all you have to do is to screw your lens to the position corresponding to the image selected. Then lock the lens in that position, and you are ready to shoot the stars. Once the correct focus is obtained the lens will remain in the same position for any star pictures you may want to take. However, it is a good idea to take a focus plate in the spring, summer, fall, and winter, to make sure the weather has not caused an excessive expansion or contraction in the camera—enough to throw the images out of focus. This checkup every three months is not hard to do. If the images are getting out of focus, just unlock your lens and make a few exposures as outlined above. If you develop your own film you will not even have to wait for it to dry before examining it to find the proper position of the lens. The whole thing can be done in half an hour; then go out and set the lens and continue taking pictures. Figure 20 shows what you can expect to get with a homemade camera.

Instead of trails you can use star images to determine the focus— the smallest, clearest, and sharpest image signifying the correct focus. In order to do this you will have to take snapshots of 1 second or follow for 1 minute. The fixed camera is easiest and serves just as well. Star images should be round sharp points—not triangles, crescents, or a variety of other forms.

If your lens does not give a uniform trail, but rather gives a black line on a gray background, it is not fully corrected and should not be used. Wide uniform trails signify the lens is out of focus. So you see we are back again making practical use of the stars.

There is just one more thing to add to your camera—the sights. You can make a pair of gun sights by attaching two threads at right angles to each other as shown in Figure 15, or any one of a number of small, pocket telescopes can be bought for a small sum and used as a sight. Two pieces of thread or thin wire can be attached, as above, to the eyepiece, by using beeswax to hold them in place. The cross hairs in the telescope should be inserted at the focus of one of the lenses of the eyepiece and within the tube, or they may be placed at the focus of the objective lens.

When using a guide telescope, the eyepiece should be pushed in or pulled out a little beyond the point where the guide star is in good focus. This throws the guide star slightly out of focus, thereby producing a small round disk of sufficient size to serve as a background screen upon which the cross hairs may be seen clearly.

Of course, if you feel too lazy to make a camera, mount a Brownie box camera on a piece of wood or between the tines of a fork mounting. Figure 21 shows how one amateur mounted his Brownie. You will be surprised with the results.

We know there is one question that you want to ask—"How long can I guide by hand?" It is obviously impossible to guide by hand over long periods of time; therefore exposures of from half an hour to an hour will be found best. Don't try to make long exposures at first. Try several at 5 minutes, a few more at 10 minutes, and still more at 15 minutes. When you have done this you will have a pretty good idea as to just how long you can keep it up. A slow-motion screw will about double the length of time you can guide without fatigue.

We have strayed from our subject, so one word more before going on to the real fun of using your mounting for purposes other than making an atlas of the sky. In making your atlas you will want to take in the whole sky right down to the horizon, but when you are taking pictures of stars at or near the horizon (at low altitude) a longer exposure will be required than for those stars at

high altitude. This is because there is a loss of as much as a whole magnitude or more between the brightness of stars in the zenith and those near the horizon, because of the greater thickness of the earth's atmospheric envelope as you look through it near the horizon, and to some extent because of manmade lights.

Once your camera is suitably mounted, you are well on your way to plumb the depths of the universe, and perhaps make discoveries of importance. At any rate you will have many new fields of endeavor open before you. Crude equipment need not turn you from earnest effort, therefore let's get on and use that mounting.

Power in Your Lens

There should be little doubt in your mind, if you have read this far, that your camera is a powerful instrument. It is fun to demonstrate the power in your lens. This you can do easily as is shown in Figure 22, where one picture was taken to show the region of Orion as it appears to the unaided eye; the other shows the same region taken with the same camera with a half hour exposure. The longer exposure shows a pronounced nebulosity in the middle of the "sword" of Orion; the three stars forming the belt are almost obliterated by the surrounding stars—stars that cannot be seen by the unaided eye. Yes, there is power in your lens.

We can give you some idea as to the power of your lens. The faintness of stars shown on the photographic plate varies with the size of the lens and the length of the exposure, as shown in Table III. But the faintness of stars that can be seen visually through a telescope varies in accordance with the diameter of the objective. The table below gives the size of the telescope objective required to see stars of a given magnitude, under average seeing conditions.

TABLE IV*
How Faint?

MAGNITUDE	7	8	9	10	11	12	13	14	15	16	17	18	19	20½
DIAM. TELESCOPE IN INCHES	0.4	0.6	1.0	1.6	2.5	4.0	6.3	10	16	25	40	63	100	200

From Table IV you will notice how valuable an ordinary field glass may be, for if you can see stars of the 6th magnitude with the

* See note on page 182.

unaided eye, a field glass will enable you to see stars of the 9th magnitude; and a 2½-inch telescope enables you to observe stars of the 11th magnitude! But a 2½-inch lens on your camera will show stars of 11th magnitude with a 1-minute exposure, and of the 13th magnitude with a 9-minute exposure (see Table III). Your eye, however, is limited to the 11th magnitude with a 2½-inch lens, no matter how long you look through it.

SUMMARY

Stars

Instrument	Ordinary cameras or homemade box cameras.
Mounting	Equatorial fitted with sights or guiding telescope.
Setting	Infinity, or by test.
Lens	Anastigmat, rapid rectilinear, projection, portrait. Preferably not less than 1 inch in diameter.
Aperture	Full, working at $f/6.3$ or better.
Plates	Fast and panchromatic. For general work, regular films will give good results. See Chapter 17.
Exposure	From 10 minutes to an hour or more, depending on the subject and the personal limit of guiding time without fatigue.
Objects	Any part of the Milky Way, particularly in the vicinity of the constellation Sagittarius. See also Tables X, XI, XII, XIII, XIV.

Chapter 6

VARIABLE STARS—NEW STARS—COMETS

WE HAVE SHOWN you how to determine the magnitudes of the stars in your pictures. Most of the stars remain of the same brightness but, as we have already mentioned, there are certain ones whose light varies in intensity. By that we mean that if they are observed night after night, a gradual change in brightness will be noticed when you compare them with nearby stars of about the same magnitude. Once a star of this type reaches a maximum brightness it slowly gets fainter until a minimum is reached when it again increases in brightness until it once more attains a maximum. This cycle of maximum to minimum and back again to maximum continues on and on. Such stars are called variable stars. This is where you come into the picture.

Variable stars are of great interest to the astronomer and much mystery surrounds them. These stars are also particular pets of amateur astronomers, who observe them with everything from an ordinary field glass to large telescopes, and also with cameras. Believe it or not, visual observation of variable stars is almost entirely done by amateurs—persons like you.

Back in 1911 the American Association of Variable Star Observers (popularly known as the AAVSO) was formed by about a dozen men who were intensely interested in the stars and particularly in variable stars. Since that time the AAVSO has shown a constant growth. Today it has about a thousand members scattered all over the world. These AAVSOers, as they are called, send monthly reports to the headquarters of the AAVSO in Cambridge, Massachusetts, where their material is correlated and analyzed by their own representative who in turn makes it available for use by the professional astronomer.

Perhaps the most important question in your mind is, "What is there in variable stars that would make a banker, lawyer, mechanic, or anyone else except an astronomer, sit up to worry about it?" The

answer is very simple—they are mysterious objects, and aren't you curious enough to want to know what makes them vary? Then too they do not all vary in the same manner; their history is also of interest. Some of them can be observed with the unaided eye. Much about variables is not known, and amateur astronomers take pride in the fact that their eyes and cameras are adding much to our knowledge. You skyshooters can get as much fun out of these tricky stars as the regular observers because in addition to taking the pictures you can determine the variation in brightness and the time interval from one maximum or minimum to another. You can make charts or graphs that will show you just how the star is varying, and perhaps in some cases you can predict the time when the next maximum or minimum will occur. There is a great fascination in watching these stars go through their paces—that is why they appeal to so many persons.

There are enough different types of variables to suit almost anyone. Some have a very short interval of time between maxima, as short as a few hours, and some have very long periods of a year or more. Still others are irregular, with no apparent well-defined cycle.

The times of maximum and minimum brightness can be predicted for a great many known regular variables. Algol, which we have already mentioned, is of this type. May we repeat that the interesting thing about Algol—which is also true about many other variables— is that it varies because there are really two stars there instead of one. These two stars move about each other in much the same manner as the earth and moon, and as we watch them one star eclipses the other in the same way the moon eclipses the sun. Because one of the stars is darker than the other the light seems to vary in brightness, yet neither one of the stars varies by itself. Stars of this type are called "eclipsing binaries," and they are not quite strictly variable stars. There are many stars, however, whose light actually does change, not by an eclipse, but by some cause as yet unknown.

The star known as Mira (the Wonderful) in the constellation of Cetus was the first variable star discovered. A German astronomer, D. Fabricius, first noticed Mira's variation in 1596. This well-known star of the fall and winter skies is numbered among the hundred brightest stars in the sky, yet it diminishes in brightness from a

magnitude of 2 to almost 10, over a period of about 330 days. Its minimum brightness is way beyond the vision of the unaided eye. Mira is a real variable, and you can watch this star disappear as did Fabricius.

Probably Mira and Algol are more or less unfamiliar stars to you. The most important star in the sky, one that has received your attention and held your interest since childhood, is a variable. This is the North Star (Polaris), which completes its cycle of variation in 4 days. To be sure, its variation is small when compared with the majority of variable stars and you probably will not be able to detect it, but it is a real variable.

By 1800, only 11 variable stars were known. About 1850, photography was first applied to the sky and by 1900 more than 500 variables had been found. In 1930 more than 6,000 were known and more than 4,000 of these had been found on plates at the Harvard College Observatory. In 1940, Dr. Annie J. Cannon discovered the 10,000th Harvard variable, on a photographic plate. Just think of it! Ten thousand variables found at the Harvard College Observatory alone—in the short space of about forty years, and the number is increasing. There are now more than 15,000 stars recognized as variable.

All this was made possible through the medium of photography and (here is what will interest you) many of these thousands of variable stars have been discovered on pictures taken with an ordinary camera lens 1½ inches in diameter, mounted in a box such as we described in the preceding chapter.

So you see it is possible for you to do a job as good as the astronomer's. You can work with your own plates and perhaps discover a new variable for yourself. We'll tell you how to go about it, but don't forget that from now on we assume that all your pictures are made with a camera that is mounted as described in the preceding chapter, and that all your stars are pinpoint images.

There are several methods by which you can discover variable stars. One is by spectroscopy, which is more or less confined to the astronomer, but some skyshooters have used it. Another, however, is an ideal method for you. Take two plates at different times, of the same region, and place one over the other so each star shows double. If a variable is in that region a comparison of the images

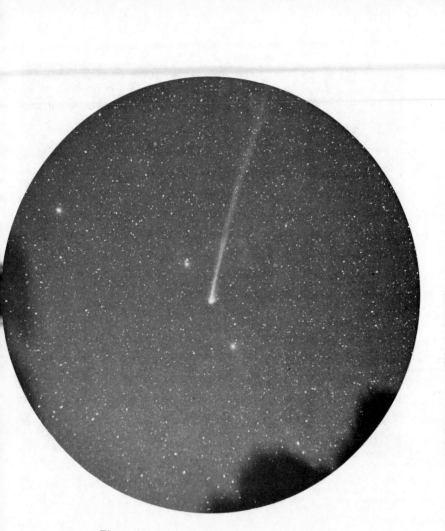

Figure 23. Finsler's Comet, August 10, 1937

This comet appeared in 1937 as a very faint hazy spot, barely visible to the unaided eye. The Lowers share it with you as they saw it with their camera, as it cut across the handle of the Big Dipper. The Lowers built all their own equipment and were pioneers in making and using the powerful Schmidt cameras. They had a lot of fun shooting the stars at every opportunity. Although amateurs, their work and photographs have received the admiration and acclaim of the professional astronomers. (Charles A. and Harold A. Lower)

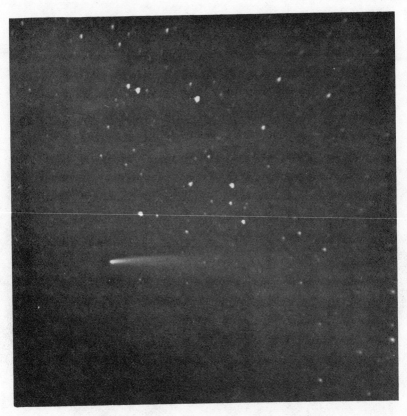

Figure 24. Comet 1948-1 (Temporary name)

This is the famous bright comet of the Southern Hemisphere in November, 1948. This picture was made atop Mt. Hamilton, California, with a hand camera using Eastman Plus X film and an exposure of 15 minutes at *f/2.9*, beginning at 0500 P.S.T. (Courtesy Peninsula Astronomical Society)

will show a difference in density which, as we have explained, is a measure of brightness. Even the astronomer relies almost entirely on this method of discovering new variables.

Now here's where the fun begins. Once you have found a star that appears to be a variable, get out all the plates you have taken of that region. A quick checkup on all these plates will soon confirm or refute your suspicions. If you have a sufficient number of plates available you can measure the brightness of the variable on each plate and make a chart that will show you just what the star is doing —whether it varies regularly or irregularly; how long a time elapses between maxima and minima; and about what time the next maximum or minimum will occur.

If you do not have sufficient material to do this, take more pictures of the region whenever an opportunity offers, and in this way build up a collection of plates by which you can keep track of the star's peculiarities.

We do not suggest photographing one region of the sky night after night, unless you have a definite purpose in doing so. Once you get the variable star fever you will probably pick out a few stars and watch them carefully with your camera. As they draw near a maximum or a minimum you may sit up all night to get a picture of those points in its variation. If cloudy weather should prevent you from getting in your shot, your disappointment will be great, but you'll get over it and be ready and waiting for the next time.

Just because you find one variable star on a plate, don't think that's all, for there may be a few more on that same plate. We do not expect you to find variables on every picture you take, but the chances that you will are good.

We said that if you see two images varying in density you could infer the star is a variable, but perhaps instead of seeing two images side by side there is only one image. Because you shifted the plates so they are not in register there should be two images for each star. The single image may be a variable also, either a new one or one already well known, whose brightness on one plate came within the range of your camera. But perhaps a greater thrill awaits you, for that single image may be a nova (new star), or a comet. A quick checkup on the available plates of the region will confirm the discovery. If it is a real object (not just a defect in the film or a speck

of dust) it may be a star whose peculiarities have not been noticed by anyone else.

When you are dealing with variable stars, you are really concerned about magnitudes and more particularly with the brightness of the stars as they appear on photographs. For this reason we just mentioned photographic magnitudes in Chapter 5, without saying too much about them. Now is the time to get acquainted with photographic magnitudes so you won't get fooled.

Red stars have less photographic effect on ordinary films than do blue stars of the same visual magnitude. The red stars will act like blue stars of less brightness. The astronomer has found that a very definite relationship exists between visual and photographic magnitudes. This relation can be determined and it is called the "color index" because it is dependent upon the color of the star. By means of the color index either the photographic or the visual magnitude can be deduced from the other, whichever is known, without actually measuring it.

The reason for this has to do with the spectrum—something we hesitate to mention. But if we don't tell you about it we know full well you will sooner or later come across some unintelligible looking figures and letters to be found in many star catalogues and atlases such as Norton's, and then you'll say we let you down. So here goes.

Do you remember what a lot of fun you used to have as a youngster, playing with a prism and shooting the prettily colored images all around the room? This band of colors formed by allowing the sun's rays to pass through the prism is called the spectrum. When you put this same prism in front of the lens of your camera and take a picture of the sun or stars a very different effect is obtained. Instead of a band of colors you will see a band with hundreds of lines running across it. The number of these lines will vary as the color of the light varies, and by just looking at the spectrum of a star the astronomer (that is, some of them) can tell you immediately whether the star is red, blue, white, yellow, and so forth.

There are a great many more facts the astronomer can tell you about a star by just looking at the kind of spectrum its light produces on a photograph. By means of these lines the astronomer classifies stars, since all stars having the same type of spectrum will also have about the same color. Therefore, the color index can be

correlated with spectral types, which are referred to by the letters, B, A, F, G, K, M, N, R, and S. Each of these types is further sub-divided into ten parts and they are listed thus: F0, F1,...F9, G0, G1, G2, and so on. These groups, then, represent a continuous change from the blue B stars through the A, F, G, and K types, to the very red M stars, just as the colors in the spectrum band start with blue at one end and blend one into the other to the red at the other end.

Here is a composite table (Table V) that shows in the top line the letters assigned to the various spectral types; the next line gives the numerical color index (to be added to or subtracted from the visual magnitude to obtain the photographic) beneath each spectral type; the third line lists well-known stars typical of each class. The last two lines give the visual magnitude and the photographic magnitude of the typical stars.

TABLE V

COLOR INDEX

Spectral Type	B	A	F	G	K	M
Color Index	−0.3	0.0	+0.3	+0.7	+1.2	+1.7
Typical Star	ε Orionis	α Can Maj (Sirius)	δ Gemi-norum	α Aurigæ (Capella)	α Boötes (Arcturus)	α Orionis (Betelgeuse)
Visual Magnitude	1.8	−1.6	3.5	0.1	0.0	0.6
Photo-graphic Mag.	1.5	−1.6	3.8	0.8	1.2	2.3

Now how can this be of use to you? Well, you are going to be looking at photographs, therefore you can get a more accurate deter-mination of the magnitude of the various stars by using the color index. In the list of 100 Selected Stars (Table XV) we have included the visual and photographic magnitudes and the spectral type, so you will have something to play with.

An example will explain how the color index works. In Table V we used only the very brightest stars so you could go out some night and notice the different colors by eye. Sirius is a bluish-white star,

whereas Arcturus is a red star. Now you find out what color Capella (in Auriga) and Betelgeuse (in Orion) are.

Suppose you have selected a star which appears in the list of 100 Selected Stars, then you can get its visual magnitude and its spectral type. Let's say it is of the 5th magnitude and spectrum type A. Then by looking at Table V you will find the color index for an A star is 0.0. If the color index is added to five the photographic magnitude will be five. In other words, a star like Sirius has no color correction—it appears on the photograph as it does to the eye; therefore it will have the same brightness visually and photographically.

Take another star of the 5th magnitude, whose spectrum is type M, then look in the table and you will find a color index of +1.7, which means you must add 1.7 to 5.0 which will give a photographic magnitude of 6.7; and if the spectrum is type B the photographic magnitude will be equal to 5 minus 0.3, or 4.7. Thus the color index is used to obtain photographic magnitudes. By reversing the process the visual magnitude can be derived from the photographic.

No, we haven't forgotten the planets. Here they are: the color index for the moon is +1.8; for Venus +0.8; for Mars +1.8; for Jupiter +0.5; and for Saturn it is +1.1.

Enough of that. Most variable stars are more or less regular in their actions and they are always with us, but there is a type of variable star whose activities are wholly unpredictable and no one knows the cause—this is the "new star" or nova, as it is called.

When you see a nova you are witnessing one of nature's great spectacles. An insignificant or even invisible object may suddenly burst forth in a blaze of glory more resplendent than Sirius, Vega, or Venus, which are the brightest objects in the sky. The most understandable reason for this phenomenon is that a dormant body suddenly explodes.

It is hard for mortal man to grasp the magnitude of the cataclysm that makes possible this sudden flare into brilliance. The camera is being used constantly to help solve this riddle of the universe and by careful examination of photographs novae are found at the rate of at least one a year. If you are a detective story fan, novae present a mystery for you to pit your wits against. Our observatories are full of evidence and the professional and amateur alike are picking up

more evidence, which must be studied carefully. You and your camera can be of great service.

Although novae are variable stars, they flare up for a short period and then recede into oblivion. Do you remember the new star in the constellation of Hercules that appeared in 1934? Nova Herculis, almost overnight, became one of the brightest stars in the sky where none could be seen before. You may have been one of those who spent many nights watching this star fade away into nothingness. A careful study of all available photographs of the region, taken over a period of 50 years, revealed a very faint star in the position of Nova Herculis. That is, the star was there but was too faint to attract attention until the great catastrophe occurred which made it suddenly become visible to the eye.

Today Nova Herculis seems to have settled down as a star of about the 11th magnitude—not bright enough to be seen by the unaided eye, but you can see it through a small telescope and find it easily with a camera. Needless to say, this star has been watched closely by amateurs, in hopes that it will either get fainter—so faint they can no longer reach it with their cameras—or, more interestingly, suddenly blow up again. If something does happen to Nova Herculis you can just bet there is going to be a wild scramble to be the first to announce the change. If you are interested, here is its position: right ascension, 18^h05^m; declination, $+45°51'$. Look it up on your star chart.

Many novae never reach naked eye brilliance; in fact, most of them are discovered on photographs. They stay with us such a short time that in the relatively brief period of a week or so you could photograph their birth, watch their rise to maximum brightness, and then observe their death.

When you are looking for variable stars you might just as well examine your plates for novae. This suggestion brings us to another interesting object in the sky, a comet, because novae and comets are discovered in the same way.

When you are examining two plates of the same region that are just off register, you may notice a single image instead of two. This single image may be a variable star just come within the limiting magnitude of your camera, but it may be a nova or a comet. Then

you'll have a real thrill and you can have a lot of fun determining which it is.

A nova or a variable star image would be a clean-cut image like other stars on your plate, but the image of a comet would tend to be somewhat hazy and ill defined. If you take a few more pictures of the region on succeeding nights, the nova will probably show a very rapid rise in brilliance, whereas if your new object is a variable it may show very little change over just a few days. If you get hold of a new star, hang on to it.

Although novae come upon us unexpectedly, many comets return to us periodically. Like novae, there are many more comets discovered than we have been able to see with the naked eye, for some are so faint they never reach such brightness. Therefore, if you discover a comet on your plate it may be a new one or it may be the return of an old one. Watching for the return of old comets is an added incentive for you to photograph certain regions more or less systematically, because the orbits and positions of those comets that have visited us are pretty well known, as is the time of their return. If you consult a list of known comets the approximate dates of their returns can be obtained.

Here is where you, by the aid of your camera, can steal a march on your less fortunate friends. If you know the time a comet is supposed to return, start taking pictures in or near the region where it is expected, about two or three months before the date of its return engagement. Your camera will record the comet long before it can be seen by eye, and long after it passes out of sight.

It is not an unusual thing to photograph an entirely new comet when you are really trying to find an old one. Perhaps the new one may never reach visibility except on your film.

If you discover a new comet, you will be more than satisfied with your efforts and your name will go down to posterity, for comets are named after the persons who discover them. Leslie Peltier, in addition to his observation of variable stars, also "sweeps" the sky with his telescope, night after night, looking for comets. As a result, his name has gone down in the annals of astronomy for the number of comets he has discovered.

You may think a comet is nothing to get upset about, but your eyes will never see all the delicate detail to be found in the tail which

the camera will record. That is not only true of comets but also of all pictures of stars. The real glory of the heavens lies not in what you see with your eyes, but what your camera sees. You can produce some startling effects by taking successive photographs of a comet over a period of a day; sometimes spectacular changes take place within an hour's time.

Most comets are found on photographs. Did you know that about six comets appear every year? Probably not, because most of them can be seen only by your camera or with a large telescope, and only those that become visible to the unaided eye are brought to your attention by the newspapers. Yet the astronomer has a lot of fun, and so can you, if you watch for them with your camera.

If you think you have discovered a comet, photograph the region on successive nights, because comets rapidly change their positions among the stars. If your successive pictures show movement in the hazy object, report it to your nearest observatory and give as complete information about its location as you can. Then continue to photograph it at every opportunity. Because, as we have said, a change in position can be noticed in a time as short as one hour, it is possible in some instances to confirm a discovery in one evening by developing your films immediately upon conclusion of the exposure. The quicker you confirm your discovery the greater is the chance of getting your name attached to one of these wanderers of the sky. But don't forget, you're going to run into a lot of stiff competition. We know of more than a dozen ardent comet seekers scattered throughout this country; then too, you have the observatories to reckon with. Astronomers get as much thrill out of discovering a comet as you will.

Whenever you see a published notice of the discovery of a comet, jot down its position. Try to get it with your camera. Give an exposure too short rather than too long.

Comets showing a distinct tail structure have been photographed with a $3\frac{1}{4}$-inch (diameter) portrait lens of 8 inches focal length working at $f/2.5$, with an exposure of 5 minutes, which compared favorably with a simultaneous exposure made with a 6-inch reflecting telescope of 24 inches focal length working at $f/4$.

For cometary work, some lenses will be found more suitable than others. A comet can be photographed with ordinary lenses, but you

will find that portrait lenses, for instance, will show greater detail in the tail structure, particularly if the comet is bright.

A 10- or 15-inch focal length lens is sufficient to obtain excellent results, although a 6-inch focal length lens will show more of the spread of the tail, if the tail is large. That is because the 6-inch lens will cover a larger portion of the sky than the 15-inch.

If you want to try some tricky photography, you can make a very interesting group of comet pictures by taking two pictures of the same comet, about an hour apart. Then if you paste them together on a card, in the proper relation to each other, a stereoscopic view of the comet may be seen through an ordinary stereoscope. In this manner you will have a three-dimension picture and the comet will present a striking appearance. Try it. You will find more about stereoscopic photography in Chapter 11.

Stereoscopic pictures are usually made with two lenses mounted side by side and separated by a distance equal to the distance between your eyes (about 63 mm.), called the pupillary distance. This type of camera is commonly called a stereo-camera. The distance of the stars is so great that two simultaneous exposures made with an ordinary stereo-camera will not give the proper stereoscopic effect. The late Professor E. E. Barnard found that in some cases a difference of one hour between exposures was perfectly satisfactory, but in a few instances the prints had to be adjusted in order to produce the proper effect. Such pictures, when viewed through a stereoscope, make the comet appear to be hanging in thin air, as it really does. If you have never used a stereoscope or taken stereo pictures you've missed a lot of fun—but that is another field of photography that does not concern us here.

When you start taking photographs of the stars for an atlas you will accumulate a series of pictures that will serve as a foundation. You will constantly refer to them if you are looking for novae, comets, or variable stars. In each case you will be comparing two pictures, which is called "examining." You can examine your plates in your own way if you want to, but if you really want to find new stars, hunt for comets and variable stars, a lot of time will be saved by following some systematic procedure.

The real fun in shooting the stars comes in examining the plates. This is best done by placing your plates on a conveniently located

open frame fitted with a glass window, similar to that shown in Figure 25, or you can use an illuminated box just as well.

You should use the open frame in a north window or with a diffused light set to one side so the direct rays from the lamp will not be reflected into your eyes by the mirror or white paper laid on the base of the frame. Some people examine plates with artificial light. Either a frosted white bulb or a fluorescent tube may be used in back of the glass window.

Figure 25. A Frame for Examining Star Pictures

A piece of white paper (for artificial light) or a mirror (for daylight) should be laid on the base.

You will need a low-power magnifying glass with a broad and flat field. If you own a telescope, a low-power eyepiece may be used as a magnifier.

Always examine your plates from the glass side. The emulsion side should rest on the glass window of the frame, so the magnifying glass or a careless gesture will not scratch it. Also, in that position the stars will be in the same relation as you see them in the sky.

When you have your frame, or illuminated box, and a magnifying glass you will be ready to do a good job of examining. The first thing to do is to place your plate on the window of the frame and look for a streak or meteor trail (this can be done by inspection without the aid of a magnifier). Then pick up your low-power magnifying glass and look at every square inch of the plate. See if you can find any faint hazy spots—these may be comets. Unless you

have other plates of the same region, or overlapping plates, there is little else you can do except look at the beauty of the plate as a whole, or at the clusters (close groups of stars) that may appear there.

If you do find a hazy spot (within a day or two after the exposure was made) take a few more plates of the same region and examine them to see if the hazy patch is brighter or fainter than on the first plate, and to see if it has moved. If it has moved, it is undoubtedly a comet, and you should report it immediately to your nearest observatory, and continue to take pictures frequently so its movement can be traced.

If you have two or more plates of the same region, examine each one first, as above, then take them two at a time, and place one over the other, first by "registering" the stars so only one image of each star can be seen when you look through both plates at once. Then, either by inspection or with your magnifying glass, look for double images. A double image may signify a planet, but on the other hand it may be a comet. If you do find double images make a note of them, or better still draw a small circle around the image in ink on the glass side of the plate.

Now slide the top plate to the right or left a very slight amount, just enough to make each star appear double, then look for single images. If you can see any single images they may be variable stars, novae, planets, or comets. Make a note of them in the same manner as above. The next step is to distinguish what you have found.

In the first case above, the object will be on both plates, because all the usual stars were in register and presented a single image to your eyes. In the second case, the image will appear on only one plate, because each regular star image was out of register and appeared double. If you continue to compare all the plates of the same region in this manner, you can detect motion, variation in light, or no motion at all can be determined, thus signifying planet or comet, variable or nova, respectively.

You won't have to worry about planets unless the picture you are examining happens to have been taken near the ecliptic (the ecliptic is the path the sun appears to trace in the sky). Only within this region will motion refer to planets as well as to comets. Anywhere outside the region of the ecliptic an object that shows motion would undoubtedly be a comet, an asteroid, or an artificial satellite. The

ecliptic is marked on all star atlases, where it appears as a curved line which crosses the equator twice.

In any case, comets are characterized by fuzzy images which on successive plates will show great movement in relation to nearby stars, whereas a planet will be clean and sharp with perhaps a slightly elongated appearance because it does not travel at the same rate of speed as the stars. Clean and sharp images that show no movement may be novae or variables.

If you are taking a picture of either a comet or a planet you would use it as a guide star, in which case do not be surprised if the stars appear as short trails, because the comet or planet travels either faster or slower than the stars, therefore only that object which is followed will appear sharp. A comet cannot be used as guide star with pinhole sights, unless it is bright enough to be seen with the unaided eye. If it isn't bright enough, a star must be used to follow with and an exposure as short as possible must be used to record the comet in order to show no motion in the comet itself on that plate.

We mentioned the use of charts or graphs to watch a star vary. This is done by estimating the magnitude of a variable on several different plates, the more the merrier. Make a note of the apparent brightness on each plate, together with the date the picture was taken. Then get some paper with blue lines marked on it, regular section paper, or lay out squares $\frac{1}{16}$, $\frac{1}{8}$, or $\frac{1}{4}$ inches on a side. In the horizontal dimension, let each square represent a day; and in the vertical dimension, one magnitude. Sometimes it is best to let 2, 5, or even 10 of the squares in the vertical dimension equal one magnitude.

Now all you have to do is to plot the brightness of the star on any particular day, in accordance with your estimates. The more plates you have showing the same variable, the greater number of points you will have and the better the curve. Once all your points are plotted, connect them with a light pencil line. This will be an irregular line which you can smooth up by averaging the deviation from a straight line or smooth curve. This smooth line is called a curve and it is used to determine the period from maximum to maximum or minimum to minimum brightness. Figure 26 shows what such a curve looks like when there are many observations to play with.

As you take more pictures of the same star, estimate the brightnesses and plot them on your chart. In this way you can keep track of the star, see how it is varying, find its maximum and minimum brightnesses, and its period. If you plot your own curves for variables you have many fascinating hours before you.

Novae are in the same category as variables and their curves are plotted in the same manner.

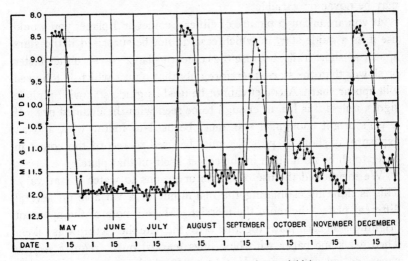

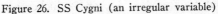

Figure 26. SS Cygni (an irregular variable)

R.A. = 21h41m Dec. = +43° 21' (1950). Observations by AAVSO May 1, 1936 to January 1, 1937.

This light curve of SS Cygni shows the method of plotting your observations. Furthermore it is an excellent example of why so many amateurs like to observe variable stars. Just look at these observations—there is mystery in them. What is your star going to do next? This curve shows what happened in 1936, but SS Cygni has not changed its way since then. It is still the same fickle, unpredictable object you see above.

The last thing to do when examining your plates—but perhaps you will do it first anyway—is to look at the pictorial value. No more beautiful objects can be found anywhere than in the sky. Our only fear is that once you look at what is relatively a bare spot to the eyes, and find that your camera sees myriad stars arranged in globular clusters, clouds, and many other forms, you will be apt to forget that your pictures have other values of a scientific and technical character. Then it will be hard for you to turn back and look for new stars, variable stars, comets, and a host of other objects. So let's examine the plates for their pictorial value, last.

If you ever get a chance to see astronomers at work, you will notice that they have a good sense of humor and a sense of value for practical things. For example: that magnitude scale we showed you how to make is called a "fly spanker" at the Harvard College Observatory. If you want to know where they got this term, just look at your own scale plate, or the one illustrated in Figure 14. As an example of practicality, you will find the astronomer uses ordinary clothespins to hold his plates together on the frame when he is examining them. There's a hint for you, too.

Now just a word about lenses. One of the best ways to keep track of the vagaries of known variables and of the discovery of new ones is to plan a definite program. Select certain regions and shoot them periodically, so many each month or week. How frequently you will do this depends of course upon the importance of the object you are interested in. This periodic photographing of specific areas is called patrolling. For patrol work your lens need not cover a large field. A lens of 12 to 15 inches focal length can be used with a film $2\frac{1}{4}$ inches by $3\frac{1}{4}$ inches, and a lens of 20 to 30 inches focal length can be used with a 4- by 5-inch film or plate. The longer the focal length of your lens the greater the separation of the star images.

Now just one last word of caution. When examining your plates for new stars or comets, it is well to look for two possibilities. First, make sure the image is not a defect in the plate, or a speck of dust. Second, check the position of the planets, in some almanac. Pictures taken in regions near the ecliptic will show the progress of the planets among the stars. Therefore, if you should examine two plates of an ecliptic region a single image might be a planet. A planet (that is, excluding Uranus, Neptune, and Pluto), should be identified easily, from its brightness, and planet tables or almanac position. Planets may show a slight trailing effect on a plate of long exposure because the planets do not travel at the same rate of speed as the stars. But, anyway, it is well to check for their position, and for plate defects, before jumping to the conclusion that any single or new image is a new star or comet.

All these things—star atlases, variable stars, novae, comets—can be photographed with meager and inexpensive equipment, and with relatively short exposures.

If you contemplate doing any of this type of work, such as observing variable stars, or hunting comets and novae, you will find it to your advantage to join a local amateur astronomical group. There are many such groups throughout the country, located in practically every large city. Many of them are carrying out definite programs in cooperation with some observatory. In this way you can get a great deal of help in making or setting up equipment, and in using it.

Why don't you get in touch with your nearest amateur group, and enjoy the friendship and associations to be found there? If it is not convenient for you to do this and you really want to do something with your photographs that will be of value to others, write to your nearest observatory, or to the headquarters of the national organization concerned with the things of particular interest to you. Many of these national organizations have world-wide memberships. Help, guidance, and instruction can be received from the secretaries of the various societies. If you are interested in variable stars and novae, address the American Association of Variable Star Observers, Cambridge, Massachusetts (see Appendix).

SUMMARY

Variable Stars—New Stars—Comets

Instrument	Ordinary cameras or homemade box cameras.
Mounting	Equatorial fitted with sights or guiding telescope.
Setting	Infinity, or by test.
Lens	Anastigmat, rapid rectilinear, projection, portrait. Preferably not less than 1 inch in diameter.
Aperture	Full, working at *f/6.3* or better.
Plates	Fast and panchromatic. For general work, regular films will give good results. See Chapter 17.
Exposure	From 10 minutes to an hour or more, depending on the subject and the personal limit of guiding time without fatigue.
Objects	Variable stars—Algol in Perseus. Novae—Nova Herculis. Comets—return of known comets. See also Table X.

Chapter 7

CLUSTERS AND NEBULAE

PINWHEELS! Fluorescent lights! Clouds of smoke! Vast filmy lacework! Balls of fire! No, we're not describing some Fourth of July fireworks but the so-called clusters and nebulae, some of the most majestic and beautiful objects in nature. Most of them are invisible to the eye and only your camera can see them in all their resplendent beauty. If you want pictorial subjects for your camera, clusters and nebulae will satisfy your fondest desire.

Fluorescent lights have the property of glowing without giving off heat. The soft glow is easy on the eyes and seems to bathe a room with light. A similar effect may be seen in the sky if you look at the nebula in the constellation of Orion (the most famous winter constellation) with its three-starred belt and sword (Figure 27). The middle star of the sword does not look like a star when it is seen through a telescope or photographed with a long exposure. It resembles a great fluorescent cloud.

These illuminated clouds are the result of expansive areas of dust and other matter that lie between us and a star, which is brilliant enough to produce an ethereal glow in a great sea of floating matter far out in space. The light comes from behind the cloud, or the star may be within the cloud, just as in our modern fluorescent light, which is opaque when the electricity is turned off.

Clouds of smoke? Yes, these are great rifts or lanes of dark material in the sky that cut off our view of the stars beyond. In this case the clouds of dust are so far away from the nearest star, or so dense, that the stars beyond cannot illuminate the particles sufficiently for them to be seen. There are many such areas in the Milky Way. One of the most prominent is the so-called "Coal Sack" near the famous Southern Cross. Similar dark patches are frequently referred to as "dark nebulae."

The fluorescent cloud in Orion and the Coal Sack seem to stand apart from their surroundings. But when similar objects are com-

bined with stars as a foreground or a background, other startling
effects can be photographed. We do not mean that you will have to
take "fake" pictures—far from it. Such combinations exist in the
sky and they are within the reach of your camera. An example is
the beautiful Lacework Nebula in the constellation of Cygnus.
When turned upside down, a photograph of this nebula presents an
excellent picture of a dancing lady dressed in a filmy gown, and hold-
ing a crystal ball high above her head.

Not so far from the Lacework Nebula and in the same constella-
tion is another interesting nebula similar in character to the Lace-
work, but very different in appearance, in that it presents a very
easily recognized outline of the continent of North America, hence
its name, the North American Nebula. Here Cape Cod, Canada,
Hudson Bay, Florida, the Gulf of Mexico, Central America—all can
be located as easily as on an ordinary globe or atlas. This type of
nebula is also called "diffuse" because of its filmy or cloud-like
appearance. The North American Nebula can be seen in top center
of Figure 28.

If you have looked at your pictures with any degree of interest
you could not but notice a very close gathering of stars in certain
areas. These closely grouped stars are referred to as clusters. They
appear to be a thing apart from the rest of the stars and give you the
idea they do not belong to our universe, but they really do. Such
clusters are of two general types—open and closed. Of these, the
clusters of closed or globular type are by far the more spectacular;
they are the fireballs in the heavens.

Clusters are not new to you because you are already well ac-
quainted with one of the open type. This is a cluster that rises just
ahead of the familiar constellation of Orion and with its appearance
you are sure that winter is not far behind. Yes, we mean the
Pleiades. Some night go out and take a picture of the Pleiades, then
you'll wonder why in the world it was ever called the Seven Sisters—
more like seven hundred sisters would be nearer the truth. But
when this open cluster was given its name there was no such thing as
a camera or a telescope. The ancient observers of the heavens cer-
tainly had good eyesight. Can you count seven stars in the Pleiades
group with your naked eye? If you can't, don't be alarmed, because
few persons can. If you honestly do see seven stars consider yourself

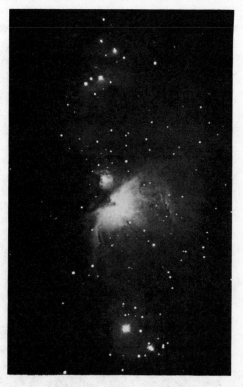

Figure 27. Nebula in Orion

This beautiful object was photographed with a 12-inch reflecting telescope. Exposure 20 minutes at $f/4.5$ with Ilford Hypersensitive Pan plate. (Charles A. and Harold A. Lower)

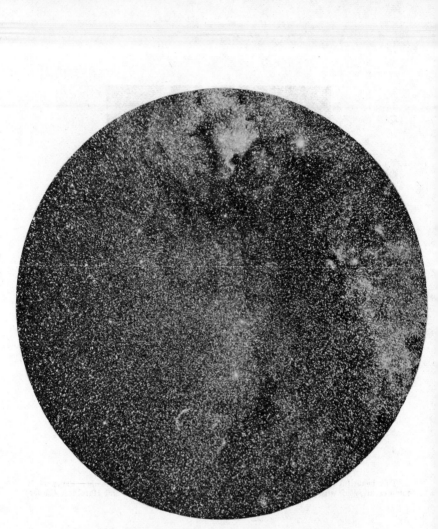

Figure 28. Section of Milky Way in Constellation of Cygnus

Note the North American Nebula (top) and the Filamentary Nebula (lower left). Another example of the work of the $f/1$ Schmidt camera. Exposure 2 minutes. (Charles A. and Harold A. Lower)

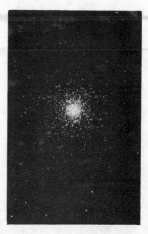

Figure 29. Globular Cluster
in Hercules (M 13)

An excellent object for your camera.
Eastman I-0 spectroscope plates. Ex-
posure 4 hours at f/25. (William von
Arx)

Figure 30. "Great Nebula" in Andromeda

Made with $f/1$ Schmidt camera. Exposure: 2 minutes, with Super
Pan Press film (Ansco). This picture is evidence of the fast speed
of the Schmidt camera. Note the casual meteor that cut across the
field of view. (Charles A. and Harold A. Lower)

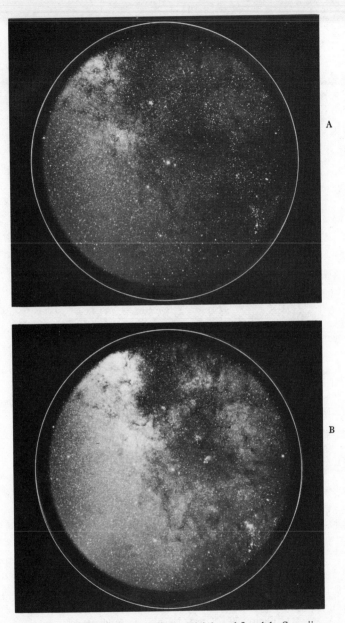

Figure 31. "Red" Nebulae in the Vicinity of Lambda Scorpii

These two pictures, which made the professional astronomer sit up and take notice, show what the amateur can do when he sets his mind to it. Picture A was taken in the ordinary manner using Eastman Ortho-X film. Exposure 2 minutes at $f/1$. Picture B shows the same area taken through a dense red filter, with Ansco Super Pan Press film. Exposure 15 minutes at $f/1$. Compare the two pictures. In B you can see the "red" nebulae (a little to the right above center) that are invisible in A. The Lowers are credited with the discovery of these nebulae. (Charles A. and Harold A. Lower)

as having exceptionally good eyesight. Furthermore, your photographs will show you that each of the naked-eye stars in this group is cloaked by a luminous cloud (nebulosity).

Another good test of your eyesight is the globular (close) cluster in the constellation of Hercules (Figure 29). It appears as a small hazy patch of light near the limit of visibility. It is known as M 13, which means Messier 13, or the 13th object listed in the catalog of clusters and nebulae compiled by Charles Messier, a French astronomer of the 18th century. And we might as well tell you here how stars and other objects are given names or numbers.

Before man had telescopes to aid his vision, all he had to work with were his own two eyes. With his eyes and crude instruments such as a quadrant or a graduated circle, the stars were plotted on charts similar to those we have today. The stars in the sky were divided into large communities called constellations, just as the United States is divided into states, each state is divided into counties, and so forth.

Each constellation was given a name, and each star in each constellation was given a letter or number for identification and reference. This was accomplished by using the Greek alphabet and by assigning the first letter of the alphabet (alpha, α) to the brightest star, the second letter (beta, β) to the next brightest; and so on down through all the letters.

Of course, some of the constellations had more stars than there were letters in the Greek alphabet. In such a case the sequence was continued by using the letters of the Roman alphabet in the same manner as for the Greek. Then when telescopes made possible the observation of stars fainter than could be seen with the unaided eye, the sequence was continued by using numbers in the same manner.

Some of the brighter stars were given names, as well as numbers or letters. These names have been handed down to us from ancient peoples. The shepherds of old lived out under the stars and the name of each star and its constellation was as familiar to them as your telephone number is to you. When you refer to the List of Objects, Tables X, XI, XII, XIII, XIV, remember that the Greek letter, Roman letter, number, or the combination of letter and number preceding the name of the constellation is the identifying number of the star. These numbers and letters agree with those found on star

charts. (Note, however, that many telescopic objects are identifiable only by reference to their right ascension and declination.)

Therefore, if you want to photograph a star cluster, you would turn to Table XI, and in the right-hand column you would find a short description, then in the first column you find the name or number of the cluster, together with the name of the constellation. The second and third columns give you the position of the object, which enables you to look up the star cluster on a star chart and determine its position among the naked eye stars. Point your camera to that field and shoot! For instance, the Hercules cluster, M 13, is an easy one to find and a very pronounced grouping of stars can be seen with a short exposure.

When we mentioned pinwheels in the sky we referred to those objects that are commonly called nebulae. That word *nebula* has been terribly overworked and you might just as well get it straight in your mind as to what is meant when the astronomer speaks of a nebula. Just as the name implies, a nebula is a hazy or ill-defined mass of luminous or nonluminous material. The Orion nebula, Lacework Nebula, Coal Sack, and similar objects are real nebulae. These all belong to our own galaxy and move about in the same system as all the stars we can see.

But way out beyond the limits of our galaxy are other galaxies. So far distant are those groups of stars that they too appear as small, hazy, ill-defined patches of light and they too were called nebulae. Now here is where the trouble comes in—they are not nebulae at all! Modern equipment, fast and large cameras, have proved beyond a doubt that these are but vast galaxies made up of stars much like our own galaxy. Hence they have been called "extragalactic" nebulae but the best term of all and the most descriptive is "island universes." That's just what they are—universes floating around in space. Each is composed of an almost incalculable and incomprehensible number of stars, all moving together in accordance with certain physical laws. These are the pinwheels in the sky.

The Great Nebula in Andromeda (Figure 30) is of the pinwheel type. This is the most familiar because it is the model the astronomer uses when explaining the appearance of our own universe. Most of these island universes can be photographed only with special cameras or large telescopes 24 inches in diameter or more, and with

very long exposures. But there are many island universes near enough and bright enough to be recorded by a small camera. A list of such objects will be found in Table XIII.

The astronomer calls the stellar pinwheels "spiral nebulae" because of their structure—great spiral arms, like a pinwheel. These, together with the clusters, are the pictorial objects of the skies. Even if you could see some of them by looking through a large telescope, it would be impossible for you to observe all the intricate detail of their structure and beauty, as it is revealed by the camera. Some of them can be photographed by hand guiding, as are novae, variables, and so forth. There is a limit to human endurance, however. An hour's exposure can be used to good advantage to photograph clusters, nebulae, and island universes, but to give such long exposures you must provide some mechanical means for following the stars. Such a mechanism is called a mechanical drive, which can be operated either by an electric motor or by clockwork. Many of these objects are so faint that a guide telescope will not aid in finding them, therefore it is customary to add two circles to your mounting, marked in degrees and hours and corresponding to declination and right ascension. With them you can point your camera to an invisible object without actually checking its position by eye. This is called "blind setting."

For your convenience, we have included a chapter (14) that deals with the fundamental principles of the mechanical drive and another chapter (15) will tell you how to use the circles so you can set your camera "blind."

Careful guiding on a visible star by hand or by a slow-motion screw affixed to the polar axis of your mounting will accomplish much, but a mechanical drive is necessary to take what might be termed better than good photographs, regardless of the lens used. In most cases an hour exposure as a minimum will be required with fast plates.

Shooting the stars is a good deal like regular photography, where you can take just as good pictures with a pinhole or a Brownie camera as your friends can with Contaxes, Leicas, Graflexes and other supercameras. Even so, there is no doubt that some lenses will do a better job than others, under certain conditions. Many sky-shooters have obtained excellent photographs of clusters and nebulae by using portrait lenses. The portrait lens is larger in diameter

than the ordinary lens and its focal length is such that it may be used at speeds of $f/2.5$ and $f/3.5$. The larger the lens the greater its light gathering power; the smaller the number of the aperture-ratio the faster the lens—that is why portrait lenses are so well suited to this type of work.

You can always profit by knowing what the other fellow has been able to do with his equipment. A few examples of what has been done will give some idea as to what you can do with a portrait lens.

Two portrait lenses, one of 3¼ inches diameter, 8 inches focal length, working at $f/2.5$, and another of 4⅛ inches diameter, 13½ inches focal length, working at $f/3.5$, with an exposure of 30 minutes, were sufficient to show the double cluster in the constellation of Perseus, and 50 minutes' exposure was enough to show the luminous cloudlike nebula in Orion. The Great Nebula in Andromeda, the nebula in Orion, and similar bright objects can be photographed by exposures of as little as 20 minutes with a portrait lens working at $f/4$.

The Lacework Nebula in Cygnus and other large diffuse nebulae also can be photographed with such lenses, yet they cannot be seen through the average telescope. Excellent definition in outline can be seen in the photographs of a nebula such as the North American Nebula by using an exposure of an hour and a half with a lens working at $f/3$ or $f/4.5$. Taking pictures of clusters and nebulae is a little more fussy than for other objects already mentioned.

Many lenses will have beautiful definition (the images will be sharp and clear) near the center of the picture but the images will be distorted near the edges. Therefore we must introduce you to another term used in connection with lenses, namely, the "usable angle" of the lens. This differs from the "angle of the lens" or the "angle of the field of view."

For example: your lens may cover a 4- by 5-inch plate for general photography and everything will be in good focus right out to the edges. But when you use that lens to shoot the stars the area within which the images are nice pinpoints of light may be only two inches or so in diameter. This small area is called the usable portion of the plate, and the angle of coverage for that area is called the "usable angle" of your lens. The usable angle can be determined by comparing your plate with a star chart, or you can find the scale of the plate

by the method we described in Chapter 2, which will enable you to measure the usable angle.

Once you know the extent of the usable area, or the usable angle of your lens, there is no need to use a plate or film that covers more than the usable area. In this way you can save money by using a 2¼- by 3¼-inch plate instead of 4- by 5-inch. It is much better to cover a small area well than to cover a large area with the edges poor. Many lenses, however, will cover a 4- by 5-inch and even larger plates.

As you have no doubt surmised, there is a definite advantage in using a lens of fairly large diameter working at fairly high speed, when photographing clusters and nebulae. The search for a means of shooting the stars with a compact instrument that will have the advantages of large telescopes and at the same time work at high speeds has led to the development of the so-called Schmidt-type camera. Many amateur telescope makers have made Schmidt-type cameras. These are very fast instruments with an aperture-ratio of $f/1$ or better. Some are $f/1.5$. Because of this small f-ratio the results obtained with an exposure of only 10 minutes are truly amazing. If you happen to be the lucky owner of one of these cameras we cannot urge you too strongly to shoot the stars with it, or at least make it available to someone who will. With such an instrument you hold the most beautiful objects in nature and the universe within the palm of your hand.

Now we wish to draw your attention to the photographs accompanying this chapter, for they were made by the late Charles and Harold Lower, amateurs, who constructed every bit of the equipment used. Many of their pictures were taken with a Schmidt-type camera of their own make. We are particularly fortunate in being able to reproduce a picture of the red nebulae (Figure 31) in the region of the tail of the Scorpion (constellation Scorpius). The American Astronomical Society has publicly given the Lowers credit for the discovery of these nebulae, and for bringing them to the attention of astronomers. These two amateurs built their own observatory, telescopes, and accessories, which enabled them to carry out any program they desired. By their use of the "red" plates they were able to observe nebulae previously unknown to the astronomer! Such accomplishment is worthy of the highest praise. If medals

were given for such work, the Lowers would have received them.
They were skyshooters, in the broadest sense.

<h2 style="text-align:center">SUMMARY</h2>

Clusters and Nebulae

Instrument	Regular cameras or homemade box cameras fitted with ordinary or special lenses. Also telescopes and Schmidt-type cameras.
Mounting	Equatorial with mechanical drive and circles. Hand slow-motion drive can be used, with limitations.
Setting	Infinity or by test.
Lens	1-inch diameter or larger, including anastigmat, rapid rectilinear, and portrait lenses.
Aperture	Full. Working at $f/6.3$ or better.
Plates	Fast and panchromatic. For general purposes, regular films will give good results. For serious work, plates are generally used. See Chapter 17.
Exposure	1 hour or more. With certain types of lenses, ½ hour may be sufficient. With Schmidt-type cameras, 10 minutes or more.
Objects	Pleiades, Orion, Cygnus, etc. See Tables X, XI, XII, XIII, XIV.

Chapter 8

THE SUN

IF YOU HAVE any doubts as to why we inject the sun into a book so obviously given over to the subject of stars, we just want to remind you that the sun is really the nearest star, only a mere 93,000,000 miles away from us. All other stars, clusters, nebulae, and island universes are so far distant that the astronomer has always astounded his audience when he recited incomprehensible numbers that refer to the distances of these bodies. But the world has changed a lot in the past few years and the astronomer can no longer astound us with distances given in billions of miles; just look at our national debt!

But even though astronomical figures may no longer hold you spellbound, the astronomer can still make you gape in awe when he shows you what can be done with a camera. Because the sun is so near to us, we should know more about it than we do about any other star in the sky—and we do.

Ever since man began to roam this earth of ours, the sun has played an important part in his activities. Take the sun away, how long would you live? Probably that is why some persons try to make you believe the sun affects your life, the stock market, and your chances of getting a job. Be that as it may, without the sun we would have no seasons; without it, where would we obtain the life-giving warmth it imparts? And its apparent motion has a lot to do with the principle of timekeeping. Small wonder there have been people who worship the sun. Even to us, who try to convert the sun-worshiper, the sun is the most important of all the heavenly bodies.

Just project your mind a few centuries into the past, to a period when there were no clocks and watches as we know them today. A sundial was the official timepiece and man's eyes served as his telescope. Then you can easily imagine the surprise and amazement Galileo felt when he looked at the sun through his telescope and

85

found its surface full of blemishes, blemishes that you know as sun-
spots. You know more about these objects than Galileo ever knew
and they offer an interesting study for you and your camera.

Sometimes no sunspots are visible but at other times as many as
a hundred can be seen. Most sunspots are quite small when com-
pared with the huge size of the sun, which is a million times as big
as the earth. Every now and then, however, a spot will appear that
is large enough to be seen by the unaided eye. All you need is a
piece of smoked glass or some other kind of dark filter to protect
your eyes. These naked eye sunspots may be as much as 100,000
miles across.

A sunspot looks like a black spot in the center of a surrounding
lighter area. The black area is commonly called the umbra and the
lighter area the penumbra. Although the spots look black, the
astronomer tells us that if you were able to place a brilliant light
(such as an arc light) so that it could be seen against the spot alone,
with no part of the rest of the sun visible, the arc, notwithstanding
its great brilliance, would look black. This is because the arc light
is not as bright as the "black" sunspot! And a study of light and
color has resulted in this interesting fact—that if all the sun could
be totally obliterated except for one of the large spots, we would not
find ourselves in total darkness, because the light emitted from one of
the large spots would be sufficient to produce an illumination equal to
a hundred times that of the full moon!

Spots are not the only blemishes on the sun's surface. There are
many whitish or bright streaks and patches, called faculae. With
your camera you can watch the development of these blemishes, even
the smaller ones.

We have already mentioned how Schwabe, an amateur astron-
omer, discovered that sunspots increase and decrease in number in a
definite cycle just as some variable stars show a regularity in increase
and decrease in brightness. The spots vary in number over a period
of about eleven and one-third years, a minimum number occurring
about six and one-half years after a maximum. No one knows why
the number of spots varies with this regularity. Perhaps you will be
the one to solve the puzzle.

A sunspot will make a complete traverse across the sun in about
13 days, because of the sun's rotation. If you take pictures of the

sun every day, say for two or three weeks, you can have a lot of fun by making tracings of the spots as you photographed them on successive days. In this way you can clearly show the path of a particular spot or spots. Furthermore, by making these tracings you will observe that the spots are confined to a fairly narrow band across the sun.

Perhaps you have wondered if there really is any truth in the statement that sunspots have any effect on terrestrial affairs. According to recent theories, based on observations made over a great many years, their appearance and disappearance, together with the number of spots, do seem to have some effect on radio reception. Also, there appears to be a relation between the spots and aurorae. These relationships, of course, are still just theory, but there is sufficient evidence to suggest them and they seem to be valid. In so far as radio is concerned, it is a fact that radio reception is greatly affected when auroral displays occur.

The visual observation of variable stars has been practically taken over by amateurs, and the day-by-day, routine photographing of the sun is being incorporated in their programs. Photographing sunspots, strange as it may seem, can be done more satisfactorily by amateurs like you than by the professional astronomers. Here again, just as with variable stars, it is often necessary to keep a close watch on the activities of sunspots. Amateurs are distributed over a wide area, and it is possible for some amateur, somewhere, to take sun pictures every day in the year, whereas observatories are few in comparison. For the same reason, you can forge ahead in other fields such as aurora and meteor photography, both of which require constant observation.

So much is known about the sun that it is futile for us to attempt a summary, but we have tried to pick out a few things that you will find of interest, a few things that will make you want to shoot the sun with your camera. But before going any farther we want to point out one fact that is common to the sun, moon, and planets: these celestial objects have a certain amount of surface detail that you can see through a telescope. The planet Mars has certain curious markings; and the moon, well, you can see some of its markings by just looking some night at a full moon—you know, the "man in the moon" and that sort of thing.

At any rate, when you want to see detail at a distance such as horses racing at the far end of the track, or when your pocketbook is not fat enough to buy orchestra seats for the opera, you carry along a pair of field glasses or opera glasses to bring the distant objects nearer. A telescope, of course, is used for the same purpose but the stars are so very far away that no amount of power nor size in a telescope makes any difference in the stars' size and apparently does not bring them any nearer; hence it is impossible to photograph any detail in them. However, the sun, moon, and planets are near enough to us so that the property of the telescope of bringing things nearer to you so you can observe them to better advantage can be used. Therefore, because the most interesting things to your camera are the various details on the surface or around these bodies, and because you can see these details better by magnifying them, a telescope should be used instead of direct photography as with the stars, clusters, and nebulae. Then too, the sun, moon, and planets (except Uranus, Neptune and Pluto) are all bright enough to be photographed with very short exposures.

To be sure, the sun, moon, and the four brightest planets can be photographed with an ordinary camera, and are even bright enough to be caught with a snapshot exposure with the camera held in your hand. However, as we said before, each of these objects has certain characteristics that can be brought out best by magnification; hence the use of a telescope.

If you are the proud possessor of a telescope, whether you made it or bought it, you can readily see that all the things mentioned in the foregoing chapters can be accomplished also by substituting a plate holder or film-pack adapter in place of the eyepiece. In this way you can make a camera because the telescope objective, or the mirror, acts as the lens of your camera. The Schmidt-type camera mentioned in the preceding chapter is nothing but a special type of telescope with a plate or film inserted where normally there would be an eyepiece.

The use of a telescope will enhance and increase the value of your photographs because the larger lens of the objective has a greater light-gathering power than the relatively small ordinary camera lens. Therefore, you can photograph objects and stars much fainter than those obtained with your regular camera. More detail will be

obtained in clusters, nebulae, and comets. The degree of faintness and the depth of detail as well as the pictorial value of your photographs will be commensurate with the size of your telescope, aperture-ratio, and the exposure given. The larger your telescope, the greater is the light-gathering power, and the smaller the f-ratio the faster faint objects can be photographed. This in turn also affects the ability of your camera to resolve double stars and clusters—that is, stars which are so close together that they appear as one star or as a hazy mass.

What you want to know is, "How can one adapt a telescope for photography? What is required?" Well, there are two ways of taking pictures with a telescope. The first is by inserting a plate or film at the focus of the objective lens. This is called photographing at the primary focus. The second method is by placing the film in back of the eyepiece, thus producing an enlarged image.

In the first case, you must devise some means of attaching a plate-holder at the primary focus. This can be done easily by affixing a carriage to hold the plate holder to a brass tube which can be placed in the tube of the telescope from which the eyepiece was removed. The correct focus can be obtained by following the same procedure described in Chapter 5.

In the second case, the idea is to magnify the primary image, and the eyepiece is not removed—it is used as a projection lens. The plateholder must be arranged so it can be attached to the eyepiece, or the telescope, and at the same time be perpendicular to the optical axis of the telescope. By optical axis we mean that a line drawn through both the center of the objective and the eyepiece would intersect the center of the film, and the film itself would be perpendicular to that line. In this manner the plate or film becomes a projection screen which will record an enlarged image of the size desired.

The size of the enlarged image is dependent upon the distance you place the plate from the eyepiece. A low-power eyepiece of about 1 inch focal length will be sufficient to give excellent results.

Now the most important question is, "How large is the image of the sun on a photograph?" If your photographs are made at the primary focus, you can expect to get a picture of the sun whose image will be of a size roughly equal to one one hundredth the focal length of the lens (or objective or mirror). That is, divide the focal length

of your lens by 100 and you will have the approximate size of the image on your plate. This term "primary focus" may not be perfectly clear and if you haven't already guessed it, your ordinary camera uses a film that is placed at the primary focus of your lens. Get it now?

For example: if the focal length of the objective lens is 100 inches the image of the sun will be about one inch in diameter; if the focal length is 50 inches, the sun's image will be about half an inch, and so forth. The shorter the focal length the smaller the image. Also notice that the size of the recorded image has nothing to do with the diameter of the mirror or objective of your telescope. Therefore you can readily see that, if your lens has a short focal length, you will find it desirable to enlarge the "primary image" (size obtained at primary focus) to about half an inch or a little larger. This you can do as described above, by using the eyepiece of your telescope as a projection lens and the film as a screen.

The next thing you want to know is how far away from the eyepiece the plate should be in order to obtain the image size you desire. First of all you should find the amount of magnification necessary to produce the image you want. This can be found by obtaining the size of the primary image as above; you then divide the size of the enlarged image by the size of the primary image and you will have the number of times the primary image is magnified.

Knowing the number of times the primary image is to be magnified, the distance you will have to fix the plate in back of the eyepiece can be determined approximately by the following simple formula:

Plate distance = (magnification + 1) × the focal length of the eyepiece

Suppose you have just a small telescope whose objective is 25 inches focal length and your eyepiece has a focal length of ½ inch. Then the size of the primary image would be equal to 25 inches divided by 100, which gives you ¼ inch. Now suppose you want an enlarged image of the sun, which will be 1 inch in diameter. The number of times you will have to magnify the primary image will be 1 inch divided by ¼ inch which is equal to 4 times. Then the distance of your plate from the eyepiece will be approximately 2½ inches. (4 plus 1 equals 5; 5 times ½ equals 2½.) So you see this whole

business is pretty simple after all. This figuring does not come under the heading of mathematics, it's just plain arithmetic.

There is one very important thing for you to remember when you are using an enlarged image, namely, that when the primary image is magnified there is a certain loss of light. If you enlarge the image 2 times, you will have to give an exposure 4 times that given for the primary image; if magnified 3 times, the exposure increases to 9 times that for the primary image. In other words, the relative increase in exposure for the enlarged image over that for the primary image is equal to the square of the number of times the primary image is magnified.

And similarly, if the focal length of your objective lens is doubled or tripled, the exposures must be increased by an amount equal to the square of the number of times the focal length is increased. Why? Because if the focal length is doubled the area of the image is increased four times; therefore, four times the exposure will be required (this assumes you do not change the size of the aperture of your lens). These are important generalities to remember. They are sorts of rule-of-thumb methods to use in determining various exposures when you change your equipment, thus saving a lot of time and trouble.

When taking pictures of the sun with a telescope, sights of some sort should be used, and you should make a set of disks that you can place over the objective or the mirror to "stop down the lens," which means to cut down the aperture-ratio. Cut it down to as much as $f/64$. The sun is a pretty bright object, so you do not need a fast lens, nor do you need to use a lens wide open. This will be apparent when you read the next few paragraphs, where we are not going to tell you how to do it, but let a man who engaged in photographing sunspots tell you in his own words how he did it.

For some twenty years the late Reverend William M. Kearons took photographs of the sun every day it was possible to do so. Mr. Kearons was thoroughly in love with his hobby, and we are sure his work stands out above others in this field. The excellence of his photographs is known throughout the world. Therefore we are greatly indebted to him for so kindly describing his method of photographing the sun, illustrated by some of his photographs. Mr. Kearons wrote as follows:

"It is a fascinating experience to watch from day to day the development and disintegration of the large sunspot groups and the masses of faculae [bright streaks and patches] that are especially noticeable on the east and west edges of the sun. One obtains much satisfaction from making daily photographs of solar events as they happen.

"I find that here in New England, spring and autumn are the best seasons for photographing the sun. In the summer the atmosphere is likely to be heavy or moisture-laden. In winter all the chimneys in the neighborhood are belching gases and smoke, thus contaminating the atmosphere, for I live in a large city. All my observations, except when I am on vacation, are made in a large, spacious attic, where the telescope is pointed either through a skylight facing south or a large western window. During vacation, I work in the open on a platform that is to be the floor of a future observatory. Early morning is generally the best time for observation. Heavy rain or snow tends to clear the atmosphere, and I usually get the best results after a storm.

"When a routine technique has been developed, the photography takes only a few minutes. Systematic work is desirable if one is to have a permanent record of the changes that take place in the sunspot groups, whenever present, as rotation carries them across the sun's disk. Thus do we see and record many occasions of unusual outbursts and rapid development. Mrs. Kearons is also an enthusiastic observer.

"I do not count myself an expert. I have used various kinds of films, plates, and filters. For the last few years I have been employing Eastman Process plates and films in conjunction with Red A or Orange filters, which give better results than any method previously used. The filter is placed between the eyepiece and shutter of the camera. It may be held in the hand or snapped on the shutter at the moment exposure is to be made.

"My photographs are taken through a 4-inch refracting telescope, with a low-power eyepiece to project an enlarged solar image on the film. A good size square of cardboard or other material with a hole in the center is slipped over the eyepiece end of the telescope to serve as a shade to cut off the direct light. The camera is a $6\frac{1}{2}$ by $8\frac{1}{2}$, but I find 5 by 7 film or plate in an adapter most convenient. No

lens is used in the camera, the eyepiece of the telescope acting as the lens. A Compur shutter with steel blades is used. Experience has taught me that ordinary shutters are too easily damaged by the intense heat of the sun. The camera is not attached to the telescope but is set up behind it on a separate tripod and carefully aligned with the tube of the telescope. Generally the timing is $\frac{1}{5}$ of a second, but in summer I use $\frac{1}{10}$ or sometimes $\frac{1}{25}$ second. Focusing is done on the ground glass. The filter should be of glass, as I have found after burning a hole in more than one of gelatine.

"There are, of course, many possible modifications of the experimental procedure. I hope that other amateurs may feel encouraged to take up this simple and interesting work."

Photographing sunspots is one of the things you can do with your telescope, but there are such things as eclipses of the sun that you can photograph either with a telescope or with your camera mounted on a tripod as for aurorae. A total solar eclipse is one of nature's most glorious spectacles, but many persons who have seen one have nevertheless entirely missed some of an eclipse's most interesting features, such as the shadow bands and crescent shadows. They appear for just an instant, therefore you should know what they are and where they occur if you and your camera are to be alert, ready, and waiting.

As the moon cuts across a direct line between us and the sun, it appears to be a gargantuan mouth cutting out crescent chunks until the sun is entirely consumed. The progress of the moon across the sun's disk makes an interesting series of pictures, which will show the various stages of the eclipse from the beginning right through totality, to the end when the moon restores the original state of the sun to our eyes.

Just before the total phase, and as totality nears, there are certain bands that can be seen on the ground. You should keep a sharp lookout for these shimmering grayish bands, called "shadow bands," because they announce the approach of the shadow cast by the moon as it gets in front of the sun. You can photograph these bands with an ordinary hand camera but, owing to the great speed at which they travel, fast lenses and short exposures are necessary to catch them. If you spread a sheet on the ground you will have a much better background upon which to see or photograph them.

About three or four minutes before the sun disappears, watch the sheet carefully. Soon, wavy shadows will appear. In order to photograph them successfully you should be equipped with a camera having a lens working at $f/1.5$, $f/2$, or $f/3.5$, and an exposure of about one one hundredth second should be given. Supersensitive panchromatic films will show the bands clearly, but good results can be obtained with other fast films.

Some like to photograph the landscape, near and during totality. Ordinary films like Verichrome Pan and Plus-X Pan are excellent for this work. If you want to do this, give an exposure of ½ second at $f/11$. Also, just before or just after totality you can take some interesting pictures of the shadows under the trees. The shadows produced at this time are crescents.

Now for the eclipse itself, surely one of the loveliest sights of nature. Just a brief moment before the sun is completely hidden from view and just before it again comes into view, you can observe and photograph two interesting phenomena. The first is known as "Baily's Beads," which are small, round, brilliant spots of light that encircle the moon and resemble a pearl necklace. Following close upon the heels of Baily's Beads you can see a thin circle of light, then the beautiful coronal streamers appear, and just as the sun reappears there is a great flash that can be seen somewhere on the ring of light. This phenomenon is called the "Diamond Ring." It lasts only a very small fraction of a second, like the sparkle of a diamond. Baily's Beads and the Diamond Ring are caused by the peaks of great mountains that stick out beyond the edge of the moon, thus allowing the sun to be seen between the peaks just before the general circular outline of the moon cuts off all the light, or just before the sun emerges.

The corona is the luminous atmosphere surrounding the sun, and it is visible for only a few minutes, eight at the most. It is for this short period that the astronomer travels thousands of miles to make observations (both visual and photographic) that are hard to make when the sun is not eclipsed. This great halo is composed of two parts, called the "inner corona" and the "outer corona," and to photograph them different exposures are required. No two pictures of the corona will be the same; its form and size vary from one eclipse to the next.

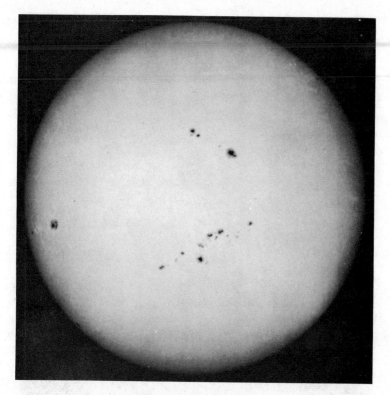

Figure 32. Sunspots

The sun is not so perfect as one might think. More than thirty spots are visible in this picture. At other times there may be more or less, or none at all. (William Kearons)

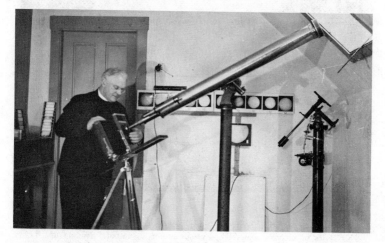

Figure 33. Attic Observatory

This is the way Mr. Kearons makes his sun pictures in his attic observatory. See his description in Chapter 8. (William Kearons)

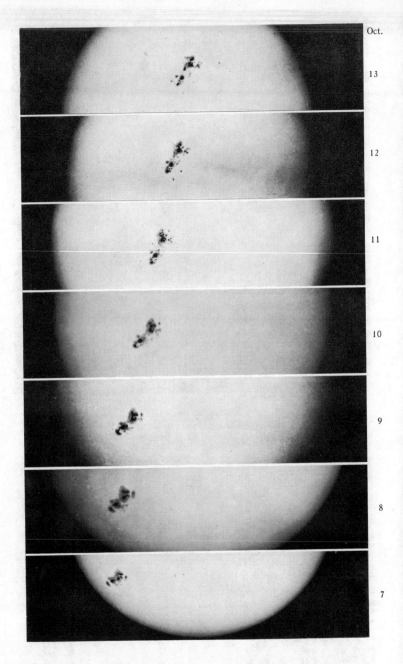

Oct.

13

12

11

10

9

8

7

Figure 34. Development of Sunspot

This series of pictures shows the development of a sunspot. Reading up, they
show the appearance of the spot on October 7, 8, 9, 10, 11, 12, and 13, 1938. (Wil-
liam Kearons)

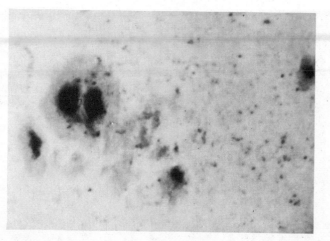

Figure 35. Individuality in Sunspots

A no less interesting pastime is the minute examination of individual sunspots, for radical changes in their structure can be seen from day to day. This picture shows a bright bridge spanning the large black spot. (Charles A. and Harold A. Lower)

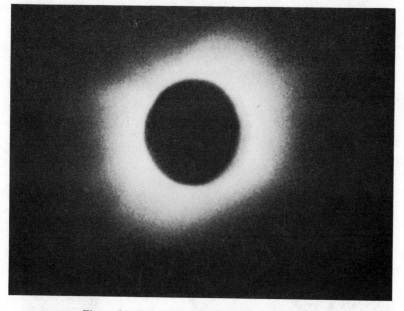

Figure 36. Total Eclipse of Sun, October 1, 1940

This turned out to be the best of the very few pictures taken of this eclipse, and it is a triumph for the amateur. Engine Cadet Officer McStay took the picture at sea, aboard the *Mormacgull*. His camera was an ordinary Kodak, and he gave an exposure of 1/25 second at *f/6.3*. The film was Macy's Multichrome. Ironically, McStay was on the ship that transported many astronomers to Brazil, where they witnessed a complete blackout because of bad weather. On the return trip the *Mormacgull* crossed the path of the eclipse at the time of totality. (Photo by William McStay, courtesy *Sky and Telescope*)

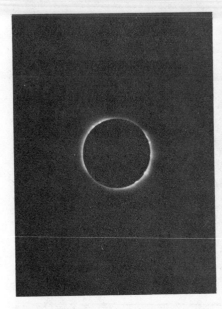

A

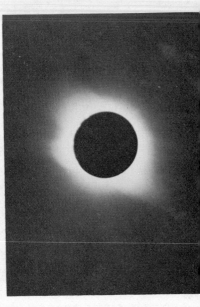

B

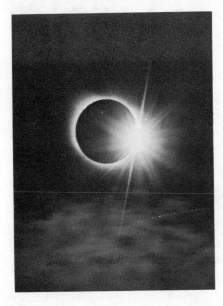

C

A—The phenomenon known as "Baily's Beads."

B—The Corona.

C—The "Diamond Ring"—a beautiful phase of the eclipse.

Here is the way they were taken. Equipment: 4- by 5-inch Graflex, fitted with rear element of 16½-inch Goerz Dagor lens, giving a focal length of 29 inches. Photos A and B were made with this camera. Photo C was made with an 8- by 10-inch Century Camera fitted with the rear element of a 12-inch Goerz Dagor lens giving a 23-inch focal length. Film: Gaevert 500 plates were used. Exposure: A—1/10 second at f/16; B—4 seconds at f/16; C—1 second at f/22. (Ralph W. Chadbourne and C. B. Crowell)

Figure 37. Total Eclipse of Sun,
August 31, 1932

Also during totality you can see great columns, arcs, and clouds of swiftly moving hot gases shoot out from the edge of the sun. These are called "prominences," and they change in size, shape, and color. Some of them extend hundreds of thousands of miles out from the rim of the sun. Of course if you are busy photographing them you will be unable to see them unless you set up a second telescope through which you can squint now and then, if you have time; but your photographs of the sun's activities will remain with you.

For star pictures you want to use the fastest plates you can get, but when you are photographing the sun, particularly when it is not eclipsed, slow plates can be used. To show the progress of the moon across the sun's disk before and after totality, you should use a very small aperture-ratio (about $f/64$) and a very short exposure (about one one thousandth second) if ordinary films are used, without a filter. If you use a gray filter with such films the exposure can be increased to $1/50$ second with your lens working at $f/32$.

During totality it is not necessary to use a filter. The following exposure table is a guide for taking pictures of the prominences, the inner corona, and the outer corona:

For the prominences	1/25s at $f/8$	1/100s at $f/4.5$
For the inner corona	1/2s at $f/8$	1/10s at $f/4.5$
For the outer corona	3s at $f/8$	1s at $f/4.5$

Any exposures you may make that exceed 1 second should be made with your telescope or camera mounted equatorially, and you will have to guide the camera, because in 4 minutes the sun will move a distance equal to its own diameter.

If you do not own a telescope, some coronal effect can be obtained with an ordinary hand camera. You can take snapshots, as indicated in the table of exposures given above. However, most of you have a pair of binoculars around the house somewhere. You can use them as a telescope by mounting them on a board in front of your camera. Just be sure the camera and binoculars are in line, and rigidly fixed in that position. You can do all your focusing before the eclipse, by using distant objects.

If you cannot buy or make a telescope, you can pick up some of the old army periscopes or monoculars very reasonably. You can mount these with a plateholder in back of the eyepiece and get excellent

results that will serve you well until such time as you can provide better equipment. In fact, no one need be without a lens, for excellent photographs have been made with an ordinary reading glass working at about $f/3.5$. With such an arrangement you can make very nice pictures of the Milky Way with an exposure of only 20 minutes.

There are two interesting experiments you can make with your telescope. We'll show you how to do them, then proceed to see what there is on the moon.

Sometimes, when you look up into the sky on a cold, clear winter evening, the stars seem to crackle and you immediately think what a clear night it is. Yet if you are a good skyshooter, you will know better—it may be an excellent night for your eyes, but not for your camera. If you are going to shoot the stars, you certainly ought to know what is and what is not a good night. Now, here is the way to find out, and don't forget you should make a few notes from visual observations as regards the weather, appearance of the stars, and so forth at the same time you take the photographs so you can compare the two later. In this way you can become familiar with what is "good seeing" and what is not "good seeing."

Point your telescope toward two stars that are very close together, such as the famous double star Mizar in the handle of the Big Dipper, or some other close double star. Then make a trail plate—don't move the telescope, just let the stars trail across the field of view. The uniformity of the trails of the two close stars can be used to indicate the steadiness of the rays of light passing through the camera.

When the skies are clear and the "seeing" is said to be good, you will find the two close trails will appear as smooth, clean-cut parallel lines. On a bad night (although you may think it is a good one) the trails will show an unevenness that is caused by unequal refraction; and when the stars seem to crackle as they twinkle, a very irregular trail will be recorded.

Another interesting experiment to make with your telescope is to photograph the sun when it is farthest away from the earth (called aphelion) about July 2, and then again when it is nearest the earth (called perihelion) about January 3. You can obtain the time of perihelion and aphelion from any almanac. You should make each

picture with the same equipment, and the primary image should be magnified the same amount each time. Now make positive prints on paper of each picture, and cut each print in half; then match two different halves. You can easily guess what you will see—yes, there is an appreciable difference in diameter between the two halves.

Not much is gained by doing this, but you do learn something, you do have an interesting picture to show your friends, and you do have a lot of fun.

Summary

The Sun

Instrument	Regular camera or telescope.
Mounting	Fixed or equatorial, with or without drive.
Setting	Infinity or by test.
Lens	1-inch diameter and up.
Aperture	Out of eclipse $f/64$ to $f/32$ with neutral density (ND) filter 4.0 to 6.0. In totality $f/8$ to $f/4.5$ without filter.
Plates	Slow and panchromatic. Also lantern slide plates. 35-mm. film may be used.

SOLAR ECLIPSE PHOTOGRAPHY FOR THE AMATEUR

Approximate Exposures

For Still and Movie Cameras
(Courtesy Eastman Kodak Company)

ASA SPEED		Partial Phases		Totality (Prominences)		Totality (Inner Corona)		Totality (Outer Corona)	
		STILL	MOVIE	STILL	MOVIE	STILL	MOVIE	STILL	MOVIE
25-32	Lens Opening	f/5.6	f/11	f/4.5	f/8	f/4.5	f/2.8	f/4.5	f/1.4
	ND Filter	5.00	5.00	none		none		none	
	Time (seconds)	1/100	16FPS	1/100	16FPS	1/10	16FPS	1/2	16FPS
40-50	Lens Opening	f/6.3	f/13	f/5.6	f/11	f/5.6	f/3.5	f/5.6	f/1.9
	ND Filter	5.00	5.00	none		none		none	
	Time (seconds)	1/100	16FPS	1/100	16FPS	1/10	16FPS	1/2	16FPS
64	Lens Opening	f/8	f/16	f/6.3	f/13	f/6.3	f/4	f/6.3	f/2
	ND Filter	5.00	5.00	none		none		none	
	Time (seconds)	1/100	16FPS	1/100	16FPS	1/10	16FPS	1/2	16FPS
125-160	Lens Opening	f/11	f/22	f/8	f/16	f/8	f/4.5	f/8	f/2
	ND Filter	5.00	5.00	none		none		none	
	Time (seconds)	1/100	16FPS	1/100	16FPS	1/10	16FPS	1/2	16FPS
200-250	Lens Opening	f/16	f/9.5	f/11	f/22	f/11	f/6.3	f/11	f/2.8
	ND Filter	5.00	6.00	none		none		none	
	Time (seconds)	1/100	16FPS	1/100	16FPS	1/10	16FPS	1/2	16FPS
400-650	Lens Opening	f/22	f/11	f/16	f/11	f/16	f/9.5	f/16	f/4
	ND Filter	5.00	6.00	none	1.00	none		none	
	Time (seconds)	1/100	16FPS	1/100	16FPS	1/10	16FPS	1/2	16FPS
1250	Lens Opening	f/32	f/16	f/22	f/16	f/22	f/13	f/22	f/5.6
	ND Filter	5.00	6.00	none	1.00	none		none	
	Time (seconds)	1/100	16FPS	1/100	16FPS	1/10	16FPS	1/2	16FPS

FPS = Frames Per Second

Chapter 9

THE MOON

THE POOR OLD MOON has been blamed for everything from making marriages to making men mad; yet it is one of the loveliest objects in the sky. The moon's pockmarked surface, rugged mountain ranges, and jagged rimmed craters are superb subjects for your camera. There is something fascinating about this arid, waterless, atmosphereless satellite of ours—something that makes you want to look at it again and again.

The best times for you to look at or to photograph the moon are near either the first or last quarter, or when it is in a gibbous phase (about halfway between the quarters and the full moon). At these times less light is reflected from its surface and the shadows cast by the mountain ranges and crater rims are longer and more pronounced than at other times nearer the full of the moon.

The moon is much brighter than you think. For example: at first quarter you can see distinct shadows cast by earthly objects such as telephone poles; at full moon the sky is so well lighted that you can barely see stars of the 4th magnitude in the north, whereas with no moon in the sky you can see stars of the 6th magnitude! Perhaps you can appreciate better the brightness of the moon when you recall that the number of stars visible at any one time at a particular place on a moonless night is about two thousand. Well, at the time of full moon this number is cut to about four hundred!

A standard 6-inch telescope will produce a primary image of the moon about one-half inch in diameter. Notwithstanding the loss of light in enlargement, this primary image can be magnified 2 times and still be bright enough to photograph with an exposure of less than a second. Yes, the moon is bright, very bright.

Let's forget all those things the moon is supposed to do to us (according to some persons) and think of it as the celestial body nearest us, only a mere 250,000 miles away; only $\frac{1}{400}$ the distance of the sun! Because of its nearness you can see an amazing amount

of detail which, even through an ordinary field glass, is an awe-inspiring sight. What then can you expect to see with a small telescope? But before looking through your telescope, use your eyes.

As you know, the moon travels around the earth and presents an ever-changing appearance, or phase. For a day or two each month you cannot see the moon at all. That is because it is somewhere between us and the sun; not directly in line, but nearly so. This invisible phase is called the new moon, or rather it is that point where the moon is either above or below or directly on the line between us and the sun. You're right; an eclipse of the sun can take place only at the time of new moon.

Shortly after new moon a thin crescent gets larger and larger until the whole surface of the moon is illuminated by the same sun that warms us during the daylight hours. At this time the moon is said to be full and rises in the east just as the sun is setting in the west. In other words, the full moon is either on or nearly on a direct line with the sun and the earth—the earth is then between the moon and the sun, whereas at new moon the moon is between the sun and the earth.

Then right after the full phase the size of the illuminated portion of the moon gradually diminishes until it can no longer be seen, and we have new moon again. The period from full moon to full moon or from new moon to new moon is approximately 29½ days. You can readily see how our calendar month is linked up with it. A series of pictures showing the different phases will make an interesting panel for your room, or observatory if you have one. Under each picture you can write the age of the moon and in this way learn to recognize those phases between the quarters. The age of the moon refers to the number of days that have elapsed since the preceding new moon. Almost any calendar or almanac will give you the exact time of the new moon, full moon, and each of the quarters.

Every once in a while your attention is attracted to the moon because of its peculiar appearance. You probably squint and look again, for where you were accustomed to seeing only a thin crescent low in the west, you see not only the familiar crescent but the rest of the moon as well, dimly to be sure. This particular appearance of the moon is commonly termed "the old moon in the new moon's arms." This effect is caused by the direct illumination of the moon

on one side (the thin bright crescent) by the sun, while the rest of the moon's surface is very dimly lighted by sunlight reflected from the earth.

Even to the naked eye the moon presents a pleasing appearance. How welcome it is after a few moonless nights! At a very early age you were shown the "man in the moon," the "lady," and the "boy and girl." Looking for pictures in the moon is much the same as looking for them in cloud formations and among other things in nature such as in the mountains. A face on a mountain can be seen only from one position and the clouds roll by quickly, but the "man in the moon" is with you no matter where you are. Now pick up a pair of field glasses and try to find the man's face, or the boy and girl—they are gone. In their place you will find vast flat areas, and rugged mountains whose shadows created the picture for you. No, the human forms you see outlined on the moon are not just illusions. Whatever forms you may see there and their number depend a great deal upon whether you are looking at the moon with your eyes, through a field glass, or through a telescope.

You can have a lot of fun by using a field glass to determine just what surface markings make up the human outlines or other forms you may see with your eyes. At the same time you cannot but notice that the moon's surface is just as interesting and varied in topography, if not more so, than that of the earth. Our present-day telescopes have enabled the astronomer to chart every crevice, mountain, and crater on the moon, in great detail. Do you know that, through them, it is possible to see an object on the moon as small as the Empire State Building in New York City?

When you look at the moon through a telescope there are two very noticeable characteristics: very flat smooth areas and thousands of craters. The extensive flat areas or plains are called "seas," a term handed down from the time of Galileo when it was thought there really was water on the moon. The lunar seas, however, are not what attract you. The extensive mountain ranges and innumerable depressions are what cause you to gasp in awe when you first look at the moon through a telescope.

The lunar landscape bears little resemblance to that on the earth. Lunar craters vary in size from small holes hardly a quarter of a mile across to craters forty or fifty miles in diameter. The sidewalls of

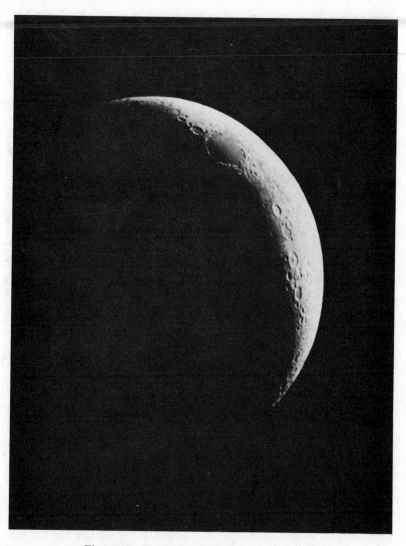

Figure 38. The Moon—4 Days Old. New Moon

Can you doubt that the moon is an interesting object? This picture and Figures 39, 40, and 41, were made at the primary focus of a 12-inch reflecting telescope. All the equipment was made by Mr. Stephens. Exposure: 1/25 second at *f/8*, using Ansco Superplenachrome film. (R. G. Stephens)

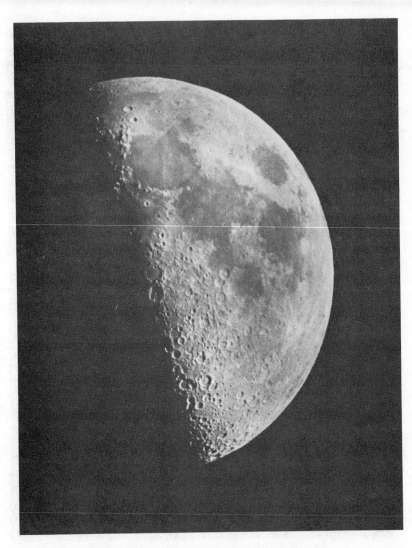

Figure 39. The Moon—7 Days Old. First Quarter
Exposure: 1/25 second at *f/8*. Ansco Superplenachrome film. (R. G. Stephens)

these craters extend three or four miles above the general surface—a few are even higher. One of the most interesting things about the craters is that some of them have craters within craters, and others have mountains that extend thousands of feet up from the floor of the crater. When you think of the moon as being only one third the diameter of the earth it is hard to believe so much could be there and you will wonder what caused it all. The answer is easy—no one actually knows.

Most star atlases have excellent maps of the moon. You should use such a map, for with it you can study and name the various objects shown in your photographs. You will find many familiar names on a map of the moon. Lunar mountain ranges have been given names of a terrestrial origin, such as the Alps, Apennines, and so forth. The more important craters and mountain peaks bear the names of ancient astronomers, such as Tycho, Plato, Copernicus, and Kepler, which when united with the names of modern astronomers applied to other craters constitute an astronomical Hall of Fame. In fact, there is a small book called *Who's Who in the Moon.*

Surely there is one question in your mind, and that is, "How do the mountains on the moon compare with those on the earth?" Mount McKinley, 20,300 feet above sea level, is the highest mountain in North America; and Mount Whitney, 14,495 feet, is the highest in the United States. But on the moon you can see a great many jagged mountain peaks extending to a height of 20,000 feet; and earthly craters are just pigmies beside those on the moon. Let's find out how you can photograph these things and then go on to other interesting pictures of the moon.

You can cut down the intensity of the light by photographing an enlarged image of the moon in the same manner as described for the sun. This will enable you to use faster plates on the full moon, when you would ordinarily use slow ones. The size of the primary image will also be about one one hundredth the focal length of your lens, and if you want to make an exposure of the moon of more than 1 second you will have to guide the telescope, because the moon has an apparent motion of twice its diameter, in 4 minutes.

In general, you should photograph a primary image about ½ inch in diameter, or an enlarged image of about the same size. Remember, the longer the focal length of your lens, the larger the primary

image. However, we have seen some excellent photographs of the moon taken on 35-mm. (candid camera size) film, of a primary image only ¼ inch to ⅜ inch in diameter. What is more to the point, these small images were enlarged, on paper, to 6 inches in diameter, with striking clarity of detail.

Any of the regular films or plates can be used such as Eastman Verichrome Pan and Plus-X Pan, comparable Ansco and Agfa films, lantern slide plates, and many other easily obtained fast or slow films and plates.

However, regardless of the film or the instrument you use, be sure to have your pictures in good focus, so you can obtain a hard, sharp negative that will allow great enlargement. For instance, it is possible for you to take a picture of the moon with a 6-inch telescope having a focal length of 6 feet, working at $f/12$, that will give you a primary image about ⅝ inch in diameter, which you can enlarge to 10 inches in diameter without showing any appreciable loss in definition.

Just as with the sun, you can photograph the moon with your telescope fixed. But if the primary or the enlarged image is an inch or more in diameter, you should not make an exposure of more than 1 second, because a 2-inch image will move about one sixtieth of an inch in 1 second. The real reason you will take pictures of the moon is so you can show your friends all the craters and jagged mountain peaks, therefore any motion visible in the photograph would spoil the picture. You want sharp detail. And when you are guiding, any stars that may appear on your picture will show a slight trail in a long exposure, because the moon does not travel at the same rate as the stars, as you well know.

If you have a telescope that is equipped with a mechanical drive that is set to follow the stars, you can photograph a magnified image of the moon, up to 2 inches, with some degree of sharpness provided you give an exposure of not more than 10 seconds. But even so, it is safer to watch the moon carefully in the guiding telescope or sights throughout the exposure.

If your telescope is not equipped with a mechanical drive, you will have to guide carefully by hand for a time exposure. You can do this best by setting the cross hairs on some conspicuous crater or mountain peak. If sights are used you may have to use the edge of

the moon, depending upon how much surface detail you can see at the time you take the picture.

We have already mentioned that for the best results you should photograph the stars at as high an altitude as possible. This also applies to the moon. There are certain times of the year when the moon is in a better position, photographically, than at other times. At these times the moon will reach its highest "southing," which means that its altitude is greater when it is on the meridian than it is at other times. Look in your favorite almanac for times of highest southing. The moon rides high in winter and low in summer.

Now, when should you use fast plates and when slow plates? Generally speaking, use slow plates or films from first quarter through full moon to the last quarter, and the faster films after last quarter and before first quarter. In any case, you should use fairly slow plates and films—how slow can best be determined by experimenting with your equipment. Don't use a plate that is so slow you cannot make a short enough exposure to prevent fuzziness resulting from motion. That is particularly true for a fixed camera.

In order to help you get started right, we must once more warn you about the brightness of the moon, so here are a few hints that will aid you in making your exposures:

The full moon is about nine times brighter than either the first quarter or the last quarter. You must take this fact into account if you want to obtain good pictures of the various phases of the moon, pictures that are comparable in general appearance. By that we mean each picture, when the series is hung up side by side, should have the same general appearance. One should not look light and washed out and another look dark.

Before you make a series of pictures showing the phases, try for a good picture of the full moon. Then you can obtain comparable pictures of the various phases without much trouble. The exposure at the quarters would have to be about five times as long as at full moon, and the thin crescent would require an exposure of two or three times as long as the quarters or about fifteen times as long as for the full moon.

This great difference in brightness is caused by the greater number of shadows cast by the mountain ranges and the crater rims, shadows that are not present at full moon. Also, there is a great

decrease in the area of the surface that is illuminated. When the moon is full and there are no shadows and the whole surface is reflecting light, don't be afraid to cut down the aperture ratio of your lens to about $f/32$, even when using slow plates such as Process plates.

As you no doubt have guessed, the moon is less interesting when it is full than at any other time. The reason, of course, is the full moon's lack of shadows, which means that many interesting lunar details cannot be brought out. Shadows make a lot of difference, no matter what kind of picture you are taking. Nevertheless, there is something on the moon that is visible at the full phase, and it is well worth photographing. We refer to the great system of rays that appear to radiate from the crater called "Tycho." Another crater, called "Copernicus," also has a system of similar rays. These ray systems are among the most interesting features of the surface markings. Look at them some night through a field glass, and then photograph them.

Another reason for the difference in the intensity of the light we receive from the moon is its varying distance from us. We know you want to ask why not the sun too? But remember, the sun is much farther away from us and is the source of light for the moon as well as for the earth. However, it is a fact that you can observe an appreciable difference in the intensity of the light reflected when the moon is nearest the earth (in perigee) and when the moon is farthest from us (in apogee). The ratio of the light intensity is 3 to 4, which means that any exposures you make when the moon is in apogee should be about one third longer than those made when it is in perigee, if you want to have comparable pictures.

You have a camera, and there are a lot of things you still don't know about it. Yet your camera, your telescope, and the stars, sun, moon, and planets afford an excellent laboratory ready for use at any time you want it. Some of the facts we have written here about the sun and moon can be applied to explain some of the things you have been trying to have explained about everyday picture taking. And of course, what would you do with your camera if there was no sun? So you see, shooting the stars can be linked up with your everyday use of the camera.

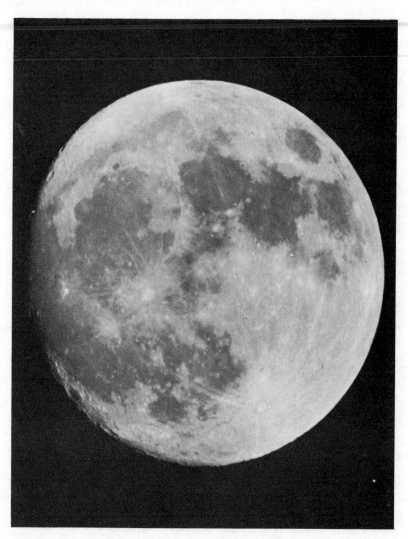

Figure 40. The Moon—14 Days Old. Full Moon
Exposure: 1/25 second at *f/12*. Ansco Superplenachrome film. (R. G. Stephens)

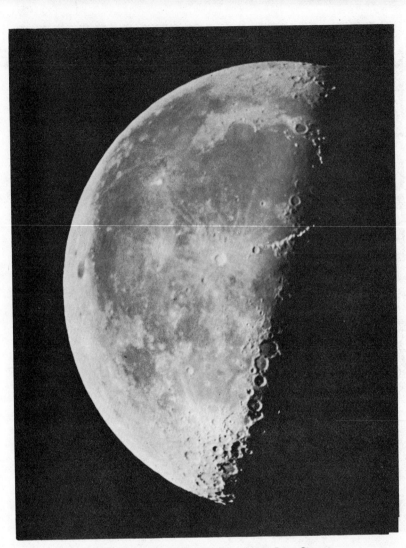

Figure 41. The Moon—23 Days Old. Last Quarter
Exposure: 1/25 second at *f/8*. Ansco Superplenachrome film. (R. G. Stephens)

One of the hardest things to photograph is that "old moon in the new moon's arms" phase. There are two good reasons for this: first, because it is so low in the sky; second, because the thin illuminated crescent is about three thousand times as bright as the remaining portion of the surface which is illuminated by light reflected from the earth, called "earth shine." The best times for you to photograph this phase are in the winter and spring. Here you have a condition similar to what you encounter in photographing a room by means of light entering through one window—and you know what happens then!

Lunar photographs, in general, have little value other than pictorial. Astronomically speaking, the moon is right in our own back yard, and astronomers are well versed in its structure, vagaries, and so forth. But there still are some photographs you can take that will be useful and valuable in a scientific way. These are lunar eclipse photographs.

Every now and then the earth gets in line between the moon and the sun, thus causing an eclipse of the moon. Lunar eclipses are more frequent than those of the sun, and more people have seen them. The changing color, from the familiar brilliant disk to the dull reddish glow at totality, is a fascinating phenomenon to watch. A lunar eclipse is a much longer affair than a solar eclipse, because the earth is more than twice the diameter of the moon. Consequently, the earth's shadow is larger than that of the moon and the moon takes longer to pass through the earth's shadow than the earth does to pass through the moon's shadow at the time of an eclipse of the sun. However, all of you have seen a lunar eclipse, know what it is and how it is caused, so all that is left for us to do is to tell you how to photograph it.

At each eclipse the intensity of the light varies; how much it varies is something the astronomer is eager to know about. He wants good records of light intensity during a lunar eclipse and you can get such pictures easily because a fixed camera is used. Because of color gradations, you should use panchromatic film or plates. You take these intensity trails, as they are called, in the same way you made those for star trails, by letting the moon trail across the plate. Begin the exposure about two or three minutes before the

beginning of the eclipse, and end about two or three minutes after the eclipse. The result will be a long trail, very bright at the beginning and gradually diminishing in brightness, being faintest at mid-eclipse, then gradually increasing in brightness. Try this in color.

Now, if you want a complete trail on your film, you will have to use a short-focus wide-angle lens, because the time from beginning to end of the eclipse is about four and one half hours. Therefore you must use a lens that is capable of showing a trail that will cover from 70° to 90°. However, if you want to photograph only the total phase, that portion of the eclipse will last about two hours, and a lens covering 30° will be sufficient. Therefore you can determine quite easily whether your lens will give you a complete trail, and if not, how much of the eclipse you can expect to photograph. Of course, you will have to know what angle your lens covers.

This brings to our minds a simple little method of finding out what focal length a lens with a given angle of coverage must have in order to cover a plate of given size. For an example : suppose you are using 4- by 5-inch plates or films, and you want to use a 30°-lens. What should the focal length be? In accordance with the accompanying diagram (Figure 42) draw the line *AB* equal to ½ the distance across the plate, say 2 inches. Then at *B* draw a line to *C* of indefinite length,

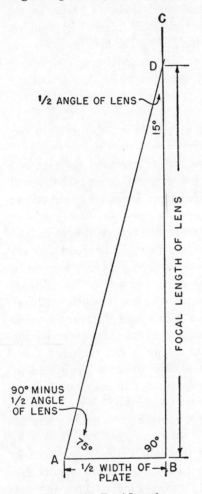

Figure 42. Focal Length

Here is an easy way to find the focal length of your lens.

perpendicular to *AB*. Now lay a protractor on *A* and mark off an angle equal to 90° minus ½ the angle of your lens, which in this case is 90° − 15° = 75°. Draw the line *AD* until it intersects *CB*. Then you can find the approximate focal length by measuring the distance from *D* to *B*, which will be about seven and one half inches. If you feel too lazy to do all that drawing, then try this: the focal length of the lens is approximately equal to ½ the distance across the film multiplied by the cotangent of ½ the angle of your lens.

You will also find that the focal length of many camera lenses is approximately equal to the diagonals of the plates they are supposed to cover. These are just tools for you to play with if you want to.

We have said quite a bit about the moon's being eclipsed by the earth and the sun eclipsed by the moon, but there is still another eclipse you can photograph. This is an eclipse caused by the moon's getting in line between the earth and a star. In the case of an eclipse of the moon or sun a shadow plays an important part, but the shadow plays no part in a stellar eclipse, which the astronomer refers to as an occultation.

The occultation of a star does not consume much time—the whole business is over within the short space of about an hour or less. All that happens is this: the moon gets between us and a star or a planet, thus cutting off the star's or planet's light. This act may seem nothing for you to get enthusiastic about, but astronomers are interested in occultations and seek the help of others with similar interests because they make use of them to detect irregularities in the moon's position.

Many amateur astronomers have a lot of fun computing when an occultation will occur, but photographs of actual occultations are greatly desired. Both stars and planets are occulted by the moon.

The stars are relatively stationary. Only a very few have an appreciable motion that can be observed in a lifetime. Therefore, you can expect only those stars that lie within the path of the moon to be occulted or eclipsed.

Photographing occultations really is an interesting occupation. You can take all the pictures of occultations you want, but accurate timing and accurate determination of latitude and longitude are required for scientific observations. If you are serious about wanting to try your hand at anything to do with occultations we are sure you

will be welcomed by the American Association of Variable Star Observers, Cambridge, Massachusetts (see Appendix), who will get you started in the right way. We remind you again always to give your correspondents enough information about your background, equipment, and so forth. Otherwise you will be apt to waste their time and yours.

As you can see, there is little difference between making a camera out of your telescope and using an ordinary camera lens, except when the eyepiece is used to enlarge the primary image. Another method of taking pictures of the moon is to remove the eyepiece from your telescope and replace it with a double concave lens, one that is hollowed out or curved in on both sides. With such an arrangement excellent pictures can be made between the quarter and full moon with an exposure of ½ second, using a K2 filter with a 2½-inch objective lens of 30-inch focal length. This type of telescope can be bought at a very reasonable price. A 12-inch reflecting telescope (and a great many people have them) fitted with a double concave lens between the mirror and the plate or film will enable you to take good photographs of an enlarged image of the moon 3 inches in diameter, with an exposure of ⅕ second at $f/9$.

And now just a reminder. The same experiment you made with the sun can be carried out with the moon, by taking pictures of the full moon when it is at or near perigee, and again when it is at or near apogee (see your almanac). If you cut the prints in half and match the different halves you will find a greater variation in the diameter of the moon than you did in the case of the sun.

SUMMARY

The Moon	
Instrument	Regular camera or telescope.
Mounting	Fixed or equatorial, with or without drive.
Setting	Infinity or by test.
Lens	1 inch diameter and up.
Aperture	About $f/12$.
Plates	Slow and panchromatic. Also lantern slide plates. 35-mm. film also may be used.
	Kodachrome, Ansochrome, and Agfachrome. See Chapter 17.
Exposure	From 1/100 second to 10 seconds depending on phase, equipment, and enlargement.

Chapter 10

THE PLANETS

THE PLANETS are always "on the go." Remember how you were taught to recognize them, because "stars twinkle and planets don't"? That is true, except when the planets are near the horizon; then you learned to recognize them by watching the sky a few nights. Planets change their positions with respect to nearby stars and you can always find them on or near the ecliptic (path of the sun). Like the moon, planets shine by reflecting light obtained from our own sun.

There are a lot of interesting things about the planets, all nine of them. Oh, yes, there are nine, not eight. Forgot the earth, didn't you? Some of these wanderers in space are smaller than Mother Earth, and others are ten or twelve times the diameter of the earth. Some of them have moons just like that of the earth, others have none. And, what is of greater interest to you, many of the planets have certain characteristics that you can photograph. But, anyway, let's enumerate the planets and then find out what there is about each one that should attract your camera.

We said there are nine planets and here they are in the order of their distance from the sun, the nearest listed first—Mercury, Venus, Earth, Mars, Jupiter, Saturn, Uranus, Neptune, and the most recently discovered, Pluto (1930). The planets are usually listed in this way because they all travel in well-defined paths (orbits) around the sun. An easy way to remember them in this order is to recite the following mnemonic sentence: "Men Very Early Made Jars Serve Useful Needs, Period." We are solely to blame for the last word because when we learned the unpunctuated sentence, Pluto had not been discovered. Don't ask us what we'll do if another planet is discovered. However, it's an easy line to remember and the first letter in each word corresponds to the first letter of each planet. In addition to the nine major planets there are also the asteroids, which we will tell you about later on in this chapter.

Mercury is a small object and so close to the sun it cannot always be seen. Haven't you ever gotten up early to see it just before sunrise, or turned your head westward just after sunset? A picture of Mercury will be much like a star, and your chances of photographing it are slim, because it cannot be seen long after dark.

Venus, however, is another story. If you ever had the idea that our moon is the only object that has phases, just take a look at Venus. It goes through the same phases as our moon. An interesting paradox can be attributed to the phases of Venus because it appears brightest when it is reflecting the least light. At that time it is one of the brightest objects in the sky and may be seen even in full daylight.

The reason for this paradox is the fact that when Venus is nearest the earth only a thin crescent can be seen, whereas when it is farthest from the earth the full phase can be observed; but the relative value of the brightness and size, because of distance, is much greater in the crescent phase than in the full phase. There is something for your camera to do—make pictures showing Venus in various phases, just as you have done for the moon.

Mercury also goes through the same phases as our moon and Venus. Probably you have already guessed why only these two, among all the planets, have phases. Yes, it is because their paths lie between the earth and the sun; therefore when they get between us and the sun only a portion of their illuminated surface can be seen, which gives the crescent. The paths of all the other planets lie outside the earth's path. That is the reason why we see them always in full phase.

We must skip over the earth. You've taken a lot of pictures of it, and what we're trying to get you to do is to shoot the stars.

Now we come to Mars, a garnet in the sky. Such a beautiful gem, bearing the name of the God of War! Perhaps it was rightly named after all, because more controversies have arisen over the character of its surface markings than about any other object in the sky. The Lowell Observatory at Flagstaff, Arizona was erected for the purpose of making a special study of this planet. You cannot expect·to photograph minute detail or very faint markings on Mars with a small telescope. Nevertheless, several of the larger markings and the so-called "polar caps" (white) can be recorded with fairly

small instruments. Through a fairly large telescope your eye can see only the polar caps and a few large spots.

Are there canals on Mars? Again we must say, no one knows. By this time you probably think astronomers do not know very much. On the contrary, they do, but you must give them credit for admitting it when they don't know. Certain surface markings on Mars have been referred to as "canals" for want of a better word.

In addition to the permanent markings on the surface of Mars there are temporary features that appear to be the result of what might be termed "seasonal changes." These are large enough for you to observe with a telescope of moderate size and your camera. The most noticeable temporary features are the polar caps. You can take pictures that will show the progression (enlarging) and recession (diminishing) of these white patches that occur at the top and bottom of the planet.

Many persons have been led to believe there is life on Mars; whether there is or not is not known. There are many good reasons why Mars could sustain life, but the point has not yet been proved. You skyshooters won't be worried about such things anyway, so get out your cameras and see what you can do with one of the most interesting objects in the sky. The best time to photograph Mars is when it is nearest the earth. When this occurs you'll read about it in your favorite newspaper.

Next on the list is Jupiter, the largest of all the planets, being some 88,000 miles across. If you look at Table VI you will find that Mercury has no moon and neither has Venus. The earth has one, as you know, and Mars has two. But Jupiter has twelve! Four of Jupiter's moons are an easy mark for your camera. A small telescope will be sufficient; in fact, these four can be seen with a good field glass.

In addition to its moons Jupiter offers another interesting object for your camera. This is a series of dark bands that encircle his middle like a great belt. There is still much speculation about these bands, but most astronomers believe they are cloud drifts because their details continually vary in relative positions. If you take photographs of Jupiter on successive nights, not only will the bands show clearly, but you can also watch the changing configurations of his four brightest moons.

TABLE VI

Planetary Facts

Name	Symbol	Mean Diameter (Miles)	Mean Distance from Sun (Miles)	No. of Moons	Length of Day	Length of Year	Date of Discovery	Discoverer
Mercury	☿	3,100	35,950,000	0	59 days	88d	Prehistoric	
Venus	♀	7,700	67,170,000	0	244 days	225d	Prehistoric	
Earth	⊕	7,927	92,870,000	1	24 hours	365¼d	Prehistoric	
Mars	♂	4,200	141,500,000	2	24½ hours	687d	Prehistoric	
Jupiter	♃	88,700	483,400,000	12	9¾ hours	11.86y	Prehistoric	
Saturn	♄	75,100	885,900,000	10*	10¼ hours	29.46y	Prehistoric	
Uranus	♅	29,200	1,782,300,000	5	10¾ hours	84.01y	1781	Sir Wm. Herschel
Neptune	♆	27,700	2,792,700,000	2	14? hours	164.8y	1846	U. J. J. Leverrier
Pluto	♇	8,700?	3,700,000,000	?	6.39? days	247.7y	1930	C. W. Tombaugh

(Observer's Handbook 1967)

* The tenth moon of Saturn was discovered in December 1966 and was named Janus. The discovery was made photographically by Audoin Dollfus, of Meudon Observatory, near Paris. The satellite is of magnitude 14. The rings were edge on to the earth, a favorable time for detecting the satellite.

Once in a while one or more of Jupiter's moons will pass between the earth and the planet. When this happens the moon casts a shadow on the surface of the planet, and succeeding pictures will enable you to watch the progress of the shadow. There's something worth trying for.

If you want to photograph a real stellar beauty, pick out Saturn. Some liken this beautiful object to an orange in a ring of spun sugar, or to a derby hat. Personally, we think of Saturn as a crystal ball surrounded by a thin crêpe de Chine ring, floating through space. Whatever you think it looks like, there will be no doubt in your mind as to its pictorial value, and you will not need a large telescope to photograph it.

You cannot find a counterpart to Saturn anywhere in the sky. The ring is the most interesting thing about it. What you will get in a photograph of Saturn depends, of course, upon the size of your telescope. If your instrument is large enough you will probably be able to see the ring not as a single solid affair but divided into three distinct concentric rings. For a great many years Saturn was thought to have only two concentric rings, but in 1850, William Cranch Bond, of the Harvard College Observatory, discovered a third ring which is called the "crêpe ring" because of its appearance. You can see these three divisions with the aid of an ordinary 6-inch telescope.

Over a period of time the rings change their apparent position, because of the tipping of Saturn's axis. The first time you take a picture of Saturn the rings may be in such a position that you will see only the thinnest knife-edge line cutting across the planet; if you are using a small telescope you may not see them at all at this time. However, a little later one side will be lowered and the other side raised. Then you will have the chance to photograph one of the most beautiful things in the heavens. You can obtain the best pictures when the rings are tipped down so you can see the broad flat side, and when Saturn is fairly high in the south.

Uranus, Neptune, and Pluto are left. They are so far away they will look like stars on your plate. The only way you will recognize them is by comparing photographs to see if they move. There is nothing of particular interest that you can photograph. However, the story of Pluto is worth telling. Uranus was discovered acciden-

tally by Sir William Herschel in 1781 but, believe it or not, both Neptune and Pluto were discovered mathematically—truly a great achievement of modern astronomy. Let us tell you about the discovery of Pluto.

Neptune had been discovered and its path in the sky had been traced for many years. By keeping a careful watch on its motions and studying them, an astronomer decided by means of mathematics that there should be another planet located in a certain position way out beyond Neptune. No one had ever seen this new planet and it could not be found on any existing photographs of the region where it was supposed to be. Over a period of many years, thousands of photographs were taken in an endeavor to find the new planet, but none was found.

More calculations were made and the search was carried on at the Lowell Observatory and at other observatories. Then one day in 1930, Clyde W. Tombaugh, a young assistant at the Lowell Observatory, discovered a new object on a photographic plate. After a lot of checking he concluded that it was the new planet. You know the rest, for no story that ever came out of an observatory had as much publicity as this one. The amazing part of the story is not the discovery of the planet on a photograph, but that it appeared in almost the exact position predicted by the computations! Which only serves to prove the astronomer really does know a thing or two.

The most unfamiliar of all the planets will be of the greatest interest to many of you. These are the asteroids, a large group of small bodies roaming around in space between Mars and Jupiter. That is, "between" as measured in distance from the sun. These small bodies vary greatly in size from only a few miles (four or five) across to about five hundred miles (the largest) in diameter. More than 1,500 of them have been discovered—mostly on photographs.

Every now and then a new asteroid is discovered. That is the reason why they should be of interest to you. Here is another chance for you to discover something in the sky. If you discover a comet, it is given your name, but if you discover a new asteroid the privilege of selecting a name is yours. However there is a string attached to the privilege; the name you select must be feminine or have the Latin feminine ending "ia." Thus the asteroids have such

names as Mildredia, Harvardia, and so forth. You will find a few exceptions among the earlier discoveries, such as that of Eros.

Asteroids are pretty faint objects, as you can well imagine from their size. Nevertheless, you can photograph them either with or without a telescope. You should look for them on your ordinary star pictures. An asteroid would show a definite trail on an exposure of about an hour. Then all you have to do is to eliminate all the other planets, by checking their positions. The discovery of new asteroids is your reason for photographing them. The rediscovery of those already known is also of importance to the astronomer, because the more information he can collect on individual asteroids, the happier he'll be.

Venus, Mars, Jupiter, and Saturn are the most interesting of the planets. All the rest will appear as ordinary star images on your photographs, and with the exception of Mercury they are so far away from the sun and the earth that nothing will be gained by trying to enlarge their primary images. Even by the eye aided by a large telescope no distinguishing surface markings can be seen. But when you watch Venus you can see the various phases from crescent to full; Mars shows you his white and dark patches; Jupiter will flaunt his belt of dark strands and a parade of moons; and Saturn's rings will impress you with the wonders of nature.

These four planets—Venus, Mars, Jupiter, and Saturn—stand out above the rest. When you photograph them, use the fastest plates or films you can get. The planets are very bright, but not nearly as bright as the moon. Furthermore, they do not appear as large as the moon, so their primary images will have to be highly magnified in order to obtain an enlarged image of only $\frac{1}{4}$ inch in diameter. Therefore you should use a telescope with a long focal length, in order to obtain a primary image as large as possible. The primary image will probably not be more than $\frac{1}{20}$ inch at the best.

Because of the long focal length, the great enlargement of the primary image, and the different rate of speed of each planet, you will have to "guide" throughout the exposure period. You will find it necessary to have a mechanical drive for long exposures but that will not do away with guiding.

It is almost impossible for us to give you explicit instructions for photographing the planets, because each telescope or camera is differ-

ent. And it is barely possible that you might get better results with smaller equipment than we would with somewhat larger equipment. You will have to do quite a little experimenting to get the best results. However we can give you a few examples of what others have done, and you will have to govern your activities accordingly.

Always remember that what you really want to photograph is the characteristic detail of each planet. In order to do this you must have your telescope firmly fixed and mounted equatorially. You should also have a smoothly working guiding mechanism, and preferably a guide telescope rather than gun sights. A mechanical drive is almost essential, and with it you can guide with greater ease over longer periods of time.

Venus will not give you any trouble. An exposure of 5 seconds should be sufficient to record the phases. As with all the planets, you should use an eyepiece that is capable of projecting an enlarged image of from $\frac{1}{8}$ to $\frac{1}{4}$ inch in diameter. As you can see, the primary image will be highly magnified. However we have seen excellent paper enlargements made from a negative showing an image only $\frac{1}{20}$ inch in diameter. This was obtained with an 11-inch reflecting telescope working at $f/9$ with a double concave lens placed between the mirror and the film.

Except for color, Jupiter, Mars, and Saturn are more or less in the same boat. An 11-inch telescope working at $f/9$ will produce good pictures with an exposure of $\frac{1}{10}$ to $\frac{1}{5}$ second, using fast plates, or their equivalent in film.

A reflecting telescope of 6 or 8 inches in diameter will produce good pictures of Jupiter, Saturn, and Mars, if the seeing is good. When we say both the large and small instruments will give you good pictures, they will, but don't get confused. You can see quite a lot of detail with the larger telescope, whereas in the case of Mars a smaller instrument will record only the polar caps and a few large dark spots. Nevertheless, regardless of the size of the telescope, it is still exciting business.

You will find there is a great deal of come and go with exposures. For example, we have just mentioned a fraction of a second with an 11-inch telescope. Yet we have seen other pictures of the same planets that were made with a 12-inch telescope and an exposure of 5 seconds, and still another set was made with an 8-inch telescope and

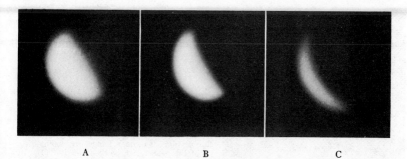

| A | B | C |

Figure 43. Venus

Here are three phases of Venus. Taken at the primary focus of a 12½-inch reflecting telescope. A—April 6, 1940. Exposure: 4 seconds at *f/10*. B—May 5, 1940. Exposure: 2 seconds at *f/10*. C—June 3, 1940. Exposure: 3 seconds at *f/10*. All were made on Verichrome film. (D. C. Wysor)

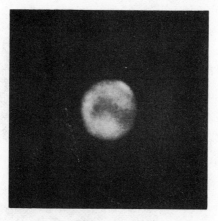

Figure 44. Mars

An excellent photograph showing the polar cap (white) and the dark markings. (Charles A. and Harold A. Lower)

Figure 45. Jupiter

Enlarged from the primary image made with a 12½-inch reflecting telescope. An exposure of 5 seconds at *f/10* was given with Verichrome film. The dark bands, so characteristic of this planet, can be seen clearly. (D. C. Wysor)

Figure 46. Saturn

Surely one of the loveliest objects in the sky. Made with 12½-inch reflecting telescope. Exposure: 1 minute at *f/10* with Verichrome film. (D. C. Wysor)

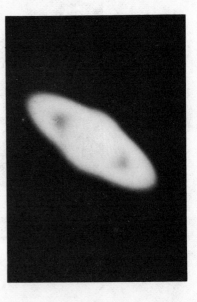

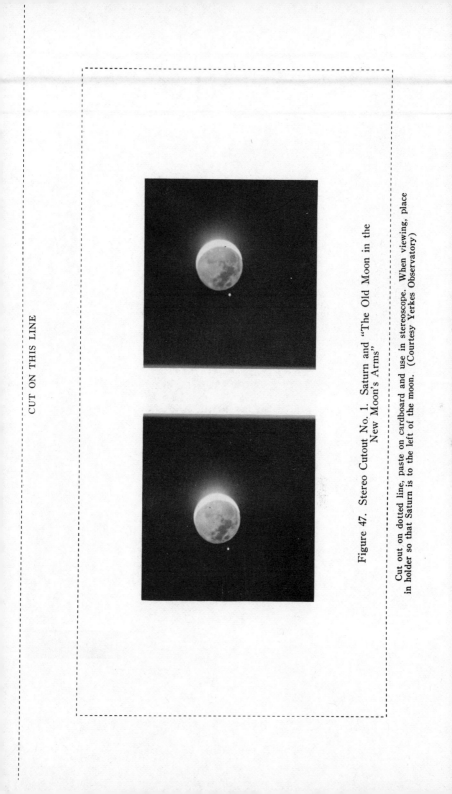

Figure 47. Stereo Cutout No. 1. Saturn and "The Old Moon in the New Moon's Arms"

Cut out on dotted line, paste on cardboard and use in stereoscope. When viewing, place in holder so that Saturn is to the left of the moon. (Courtesy Yerkes Observatory)

an exposure of ½ minute. All these pictures were good and almost equally so.

If you want to photograph Jupiter's moons you will have to give about ten times the exposure you would give for the planet itself.

Now, before we turn you loose, we urge you to try taking pictures of the planets through color filters. We do not mean for the purpose of compensating the density of your negatives for the difference in the color of the planets. The use of red, blue, yellow, and other color filters will show you a vast difference in the amount of detail you can see in a photograph obtained with, say, a red filter, when compared with one obtained by using a blue filter. You should try this stunt, especially on Mars and Jupiter. And lastly, take all your pictures of the planets when they are high in the south, for the best results.

And if you have good equipment, you might try color film (Kodachrome, etc.) on Mars, Jupiter, and Saturn.

———

Only on the photographic plate and film can the beauty and wonders of the universe be brought to human ken. We have outlined what there is in the sky—the rest is up to you. Good luck!

SUMMARY

The Planets

Instrument	Telescope.
Mounting	Equatorial, preferably with drive.
Setting	By test or infinity.
Lens	1 inch diameter and up. For detail, 6 inches and up.
Aperture	$f/6.3$ or better.
Plates	Fast and panchromatic. 35-mm. film may be used. See Chapter 17.
Exposure	5 seconds or more, depending upon equipment.

Chapter 11

FUN FOR THE FAMILY

As children, we used to get a great thrill out of looking at photographs through grandma's stereoscope. Perhaps you, too, have spent many happy hours doing the same thing. Even though looking at stereographs was a popular pastime in the gay 'nineties, it is a no less pleasant way to entertain your friends today. We know, because our interest in this kind of photography is greater than ever. We carry a stereocamera with us wherever we go. The lifelike (three-dimensional) relation of objects in pictures, when viewed through a stereoscope, makes your photographs take on a new meaning.

Probably all the stereo pictures you have seen deal with earthly subjects. Have you ever seen a stereograph of the moon, or of a comet? Well, if you haven't, you have a rare treat in store. We thought you and your family would get as much fun out of looking at stereographs of celestial bodies as we have, therefore we are including a few on the following pages. These stereographs are ready to use—all you have to do is to cut them out on the lines indicated, mount them on cardboard, and place them in your stereoscope. If you don't get a surprise, we lose our bet. If you think you do not have a stereoscope, look in your attic—attics seem to have a monopoly on these instruments. If you don't find it there, take the pictures down to your public library. You will find a stereoscope there—or buy one.

Some of you will want to try this stunt with your cameras. We'll tell you how it's done as we describe each picture.

The Moon and Saturn (Figure 47). This is a picture of that interesting phase called "the old moon in the new moon's arms." Saturn is the small white spot just to the left of the moon. When you put the picture in your stereoscope, notice how the moon appears like a ball hanging in thin air. Also notice how clearly you can see that the moon is nearer to us than Saturn.

Now examine each photograph carefully. In the left-hand picture, Saturn is a little farther away from the moon's edge than it is in the right-hand photograph. That is the secret of taking stereographs of celestial objects.

Ordinary stereographs are made with a camera fitted with two lenses that operate together simultaneously. The lenses are separated by an amount equal to the distance between your eyes. This is called the pupillary distance and it is equal to about 63 mm. (about 2½ inches). That's all right for objects not too far away, but the stars and planets are so far distant that no three-dimensional effect can be obtained by photographing them with an ordinary stereocamera. However, this effect can be obtained easily with the moon, planets, meteors, and comets. You can make stereographs of any celestial body that moves appreciably. This is done by photographing the object twice, so that its position, relative to other more distant objects, appears shifted.

Now look again at the pictures of the moon and Saturn. Saturn does not show a great change in position—only what might be expected of either the moon or a planet in an hour's time. Therefore, you could make such a picture as this by taking two pictures an hour or two apart. Then mount them as shown here, always remembering that in the left-hand picture the nearer object must be farther to the right with respect to the more distant objects. This is apparent in the photographs reproduced here.

THE MOON, 17 DAYS OLD (Figure 48). This picture was taken 2 days after full moon. As we have said, something must move in relation to something else, in order to obtain the life-like effect given by stereographs. When you look at this picture you'll immediately doubt our veracity, because nothing but the moon shows in each picture. Therefore, how can such a feeling of looking around the moon be obtained? There is no doubt that you do get that feeling when looking at this picture through a stereoscope.

Again, examine each picture closely. If you look at the two small dark spots that appear very close to the right edge of the moon and just a little above the center, you will notice that in the left-hand picture the distance between the edge of the moon and the spots is less than in the right-hand photograph. This difference in distance is slight, to be sure, but it is enough to do the trick.

As you know, we always see the same side of the moon, but the axis of the moon is not exactly parallel to the axis of the earth. For that reason you can see more than half of the moon. Furthermore, the moon does not travel at a uniform rate in its path around the earth. That is why you can see certain mountains and craters near the edge of the disk at one time, and at another time they will be invisible. That is why these pictures seem lifelike. There is an apparent motion of objects such as craters, with respect to the edge of the disk.

You can make stereographs like this by making two photographs of the same phase of the moon, spaced about one month apart.

METEOR (Figure 49). Here you see a meteor cutting across the constellation of Orion. Note how the meteor stands out in bold relief against the background of stars. This stereograph was an accident. One night two members of the staff of the Yerkes Observatory were working with two cameras some distance apart. Each observer happened to point his camera toward the same region of the sky. Each caught the meteor, and it was not until after the plates had been developed that either knew what the other had done. The distance between the two cameras was great enough to show a sufficient displacement of the meteor against the background of stars to enable the three-dimensional effect to be obtained. This meteor was 90 miles distant.

This is a rare picture and your chances of duplicating it are slim indeed, but if you have a friend who is interested in photographing meteors, ask him to point his camera toward a region of the sky at the same time you do. Then mount the pictures of any meteors you may catch in the manner shown here and see what happens.

———

The stars are so far away, and so few of them move far enough in a lifetime to be observed, that you would have a hard time making stereographs of them. Point your camera to the planets, the moon, meteors, and comets, rather than to the stars, for this type of photograph.

If you do try making stereographs you may have to experiment a little, but in the end you'll have more fun than you have ever had before with your camera.

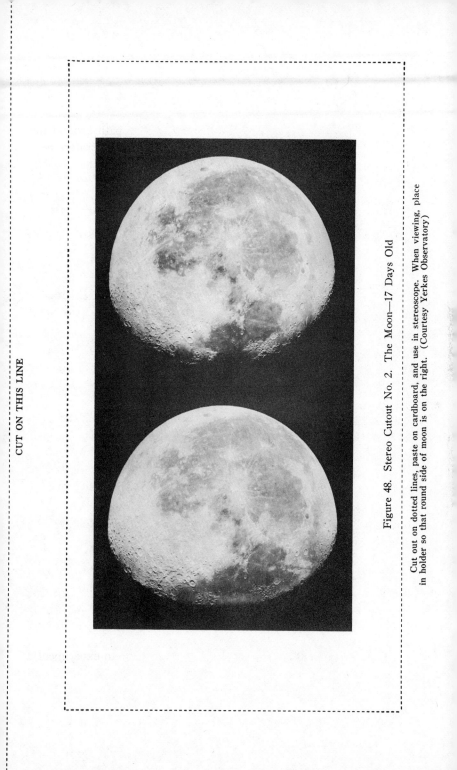

Figure 48. Stereo Cutout No. 2. The Moon—17 Days Old

Cut out on dotted lines, paste on cardboard, and use in stereoscope. When viewing, place in holder so that round side of moon is on the right. (Courtesy Yerkes Observatory)

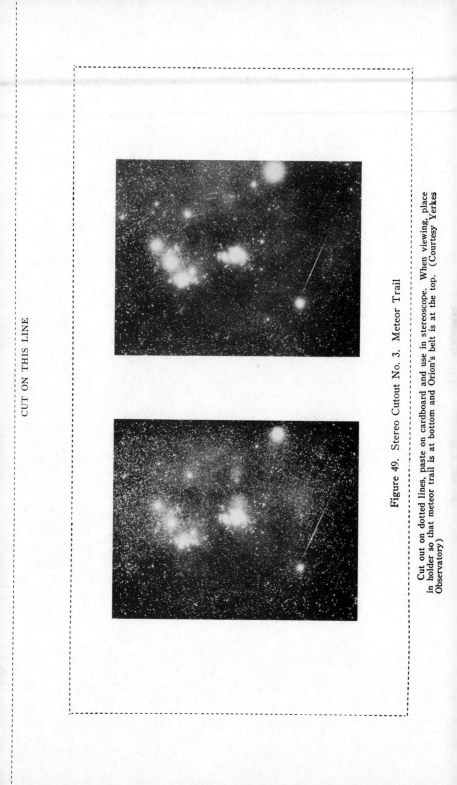

CUT ON THIS LINE

Figure 49. Stereo Cutout No. 3. Meteor Trail

Cut out on dotted lines, paste on cardboard and use in stereoscope. When viewing, place in holder so that meteor trail is at bottom and Orion's belt is at the top. (Courtesy Yerkes Observatory)

Chapter 12

PLATES AND FILMS
DEVELOPING, PRINTING, ENLARGING

OFTTIMES it is the first try that makes or breaks one's enthusiasm for a hobby—particularly a new one like shooting the stars. We do not think it right that this should be so, but nevertheless it is. Many of you will be unable to get in touch with other skyshooters and profit from their advice as easily as a beginning stamp collector can find a fellow stamp enthusiast. So, in order to help you avoid many of the pitfalls that will beset you as a beginner, we'll outline a few methods of procedure that have been tried and tested. Try them first and experiment afterwards.

Unless your interest in photography has been more intense than that of the majority of camera fans, you will want to know what kind of plates or films to use when shooting the stars. Also, you will want to know how you can develop your own films. You should do your own developing, because for some unknown reason many commercial developing houses seem to delight in always doing just the opposite to what you ask them to do.

In other words what you really want to know is what you can do to be assured of good results. There is nothing more discouraging than to go through all the motions, only to find the results unsatisfactory. We can't guarantee results, but we can steer you right, so let's start with plates and films.

PLATES AND FILMS

You can use any of the popular brands of films and plates. If you have a favorite brand, use it. However, if you are not partial to any particular type of film, the only rule we know is to use the fastest film you can get. Always use panchromatic film because, as you know by now, all the stars are not white, and best results are obtained by using a type of film that covers the widest range of color.

Such films are made by all manufacturers and you can get them in sizes to fit practically any camera.

You will not find it necessary to use a very fine grain film. Moderately fine grain will serve your purpose equally well, if not better, for in most cases the finer the grain the slower the plate or film. Whether you use glass plates, cut film, roll film, or filmpack is wholly up to you. All come in a goodly assortment of sizes that can be bought almost anywhere.

We said that fast panchromatic films and plates are preferable, but you will find some of the films most widely used in everyday photography perfectly satisfactory for general purposes. Among these are Ansco All-Weather Pan and Eastman Verichrome Pan, Plus-X, Tri-X, and Panatomic. Each has a fairly wide color range; however, a film that is more sensitive to the blue than to the red will show the most stars, if that is what you are after.

DEVELOPING

If you have never developed your own films and made your own prints, you have missed most of the fun in taking pictures. In some parts of the world, even today, the transformation of a perfectly blank piece of paper into a beautiful picture by means of a light and a few deft motions in a liquid would be considered a miracle. A good skyshooter would never trust the development of his films to commercial houses. We are not trying to discredit commercial finishing, but you must remember that most of their work is done on a production basis and your pictures of the stars should not be developed in that manner. However, in every city you will find some photographer who is not hampered by high speed production methods. He will give you individual attention, but it is going to cost you more money. Therefore, aside from the nature of your star pictures, you will find it more economical to learn to develop your own films. We shall assume you know how to do this.

In general you can do all your developing of star photographs by rule. Here are a few do's and don't's.

Never force or restrain development in any way in any portion of the plate or film.

Never reduce or intensify any portion of the picture.

Always develop to bring out the faintest stars and the bright stars will take care of themselves.

Also bear in mind that you are now making photographs that have scientific value, and *no tricks are allowed.* *"Doctored" plates or films have no scientific value.*

You will find the most suitable developer one that is slow, contrasty, and fairly fine grain. Use one of this type as recommended by the company that manufactures the plates and films you are using. If you use Ansco emulsions, follow Ansco instructions; if you use Eastman products, follow Eastman instructions. It is always well to assume the manufacturer knows a lot more about his own product than you do, and for that matter, more than the salesman.

The astronomer always tests his plates for speed and sensitivity. He also tests developers for the particular type of work he is doing. Many observatory darkrooms used to use Rodinal as a general allround developer for plates and films.

We know of no easier developer to use than Rodinal. There are plenty of others equally good, but Rodinal can be bought in a concentrated solution in a bottle of convenient size. The concentrated solution keeps well. It can be handled easily, and it can be made ready for use by just diluting the bottled concentrate with water. Here is the proportion to use:

1 ounce Rodinal 32 ounces water

Develop 10 minutes at 68° F.

In this proportion Rodinal is a slow developer, but slow development is to be desired. When you are using this solution it is not even necessary to examine the film during development.

We have given you the basic proportion. Obviously, it will not be necessary for you to mix that much each time. Two drams (¼ ounce) of Rodinal added to 8 ounces of water will be sufficient to develop three 8- by 10-inch plates in an 8- by 10-inch tray. In any case, use enough developer to cover the plate. Pour the developer over the film evenly and smoothly so the emulsion is covered as evenly and quickly as possible; or slide the plate or film quickly into the developer.

Do not keep used developer—throw it away. Mix only enough to do the work at hand.

Rock the tray back and forth gently during development. After developing for 10 minutes (in Rodinal), rinse the plate or film well, under a gentle stream of water. Then place it in the usual acid hypo fixing bath, where it should remain for at least 15 minutes. Any time after 15 minutes, remove the plate from the fixing bath, and wash it in running water for not less than 30 minutes, then swab off all excess water from the plate with a wad of soft cotton, and dry. As you can see, it is just as easy if not easier to develop star pictures than it is to develop everyday pictures, and probably all you will have to buy is an inexpensive bottle of Rodinal.

One last word of caution! Always be sure that all your trays are washed thoroughly after use and be sure they are clean before you use them. This is just one step in insuring clean pictures. Cleanliness throughout the process is necessary if you expect to obtain the best results.

PRINTING

One glance at a star plate will be enough to indicate the type of contact printing paper to use. Unlike ordinary photographs, you are now dealing with a negative that has small round black images showing on a clear background. Therefore you have to use a very hard, glossy, contrasty paper. Your finished positive print should show clean-cut, sharp, white images on a uniformly black background.

There are a great many good printing papers on the market. Again we recommend you use that brand with which you are most familiar. Doubleweight stock is best unless you intend to mount your prints, in which case singleweight may be used.

Although we have urged you to use the developers and developing formulas recommended by the manufacturers of the products you use, we insert the following formula for use with contact printing papers. It will give satisfactory results and may come in handy some time.

Water	8 ounces
Metol	4 grains
Sodium Sulphite (anhydrous)	105 grains
Hydroquinone	15 grains
Sodium Carbonate (monohydrated)	75 grains
Potassium Bromide	3 grains

Mix in the order given. Use full strength at 70° F.

ENLARGING

Any pictures you may take of the planets, nebulae, clusters, comets, and other objects will often be more striking in appearance if they are enlarged from the original negative. You can accomplish this with any standard enlarging machine. As you know, bromide papers are used in direct enlargement. Making enlargements is similar to making contact prints, therefore there is little we need to say about this process. But there are a few helpful hints that we gladly pass on to you in the hope they will make your life easier.

There are two ways of enlarging your negatives. The first is by direct enlargement onto a glass plate or paper. The second is by the so-called "step method," which is accomplished by first making an enlarged positive on a glass plate, from which a glass negative can be made by contact printing; then enlarged paper or glass positives may be made by printing from the enlarged negative.

Sometimes enlargements show "grain." You can get rid of most of the grain by a process similar to the step method just described. First enlarge your original negative two or three times normal size, by using special Process Plates or good lantern slide plates, both of which have a very fine grain and a slow speed. This positive enlargement can then be further enlarged and most of the grain will have disappeared.

You can also use this step method to obtain more visible detail from negatives of comets, nebulae, and so forth. This is done by using a very slow plate for making a contact positive from the original negative; then make a new negative from the positive by contact printing. Continue the process if necessary.

Although direct enlargements can be made, enlarged paper prints of the sun, moon, and planets will gain much if you use the step method, by making a contact print from an enlarged negative.

GENERAL HINTS

There are two schools of thought about removing dust from the emulsion side of a plate or film before loading the plates into the plateholders, and before immersing the plates in the developer solution: the "brushers" and the "tappers." The brushers use a soft

camel's hair brush. The disadvantage of or argument against this practice lies in the fact that sufficient static electricity can be manufactured to charge the emulsion, which will cause the film to attract dust and any particles present will stick all the harder.

The tappers hold the plate or film by the edge, tilt it slightly at an angle (with the emulsion side down), then they tap the edge of the plate or film lightly against the edge of a shelf or other conveniently located solid object. Take your choice—we rather like the tapping method.

When drying plates, leave plenty of room between them to allow a free circulation of air.

Rock the tray frequently in all directions during development.

Be sure you are using a safe darkroom lamp. If in doubt, test a plate. It is just as well to keep the plate covered during development.

Keep the developer and fixing bath at the same temperature.

Never use old hypo. We've said this before but it is worth repeating.

Do not forget that the main object is to produce negatives of extreme sharpness and accuracy in detail.

While loading, unloading, developing, fixing, washing, and setting up to dry, protect your plates and films by handling them only by the edges. This is a good practice to follow after the plates are dry.

Keep the darkroom and all utensils clean.

Wherever we have mentioned the name of a manufacturer, you must not infer or take it for granted that no other manufacturer's products will do. Such is far from the case. The products we mention by name are only a guide to help you get started. Your own experience with other plates, films, papers, developers and so forth will show them to be equally satisfactory.

Any moderately fine grain film can be used, and any good contrasty developer will do. Once you find plates, films, and developers that are satisfactory, stick to them.

Chapter 13

SIDEREAL (STAR) TIME

"SIDEREAL TIME" is the technical expression for what you call "star time." Your telescope or camera is primarily set up for use with the stars, so if you want to take life easy while shooting the stars you should know something about sidereal time and how you can use it.

There are two applications of sidereal time that will be of practical value to you. The first is a mechanical drive (see Chapter 14) ; the second, the use of two circles attached to the axes of your mounting. But before you can make the former or use the latter you must know what makes them work and why. There is no need to go into technical details so we'll just outline briefly what time is and how we get it, then show you a simple method of obtaining sidereal time, which is quite different from Standard Time.

A true north-south line on the earth is called a meridian. Now, if you place two upright sticks or poles in the ground, some distance apart, and both in a true north-south line, you can sight across the poles and observe the time the sun crosses your particular meridian. The period of time we call the day (solar day) is determined in that manner : by noting the interval between two successive crossings of the sun over the same meridian.

In other words, our everyday method of timekeeping is based upon the period in which the earth makes one complete revolution upon its axis. However, the sun's motion is only apparent and it is irregular. Therefore if you should observe the sun's crossing of your meridian each day in the year you would find the interval between two successive crossings varies throughout the year—it is not always the same length of time. Obviously, a clock which ticked off exactly 24 hours every solar day would be an irregular mechanism difficult to construct.

You wouldn't think much of a clock that did not run uniformly day after day. In order for a clock to do that, the day must be uni-

form in length also, throughout the year. In order to obtain a day of uniform length, all the values for the length of the solar days throughout the year were averaged and a mean (average) solar day was obtained. A clock adjusted to tick off 24 equal hours in the interval of a mean solar day is keeping what we call mean solar time, which is usually shortened to just "mean time."

The irregular solar time is called apparent (real) solar time, which is more frequently referred to as "sun time" as shown by the ordinary sundial. It is easy to see that if we had two clocks (one showing mean time and the other apparent time) reading 0 hours, and if we started them off simultaneously, they would disagree in a very short time. The difference between their readings is called the "equation of time." This discrepancy between the two clocks can be tabulated for each day in the year. Therefore it would be possible for you to obtain the reading of one clock from the reading of the other, for any day in the year, by using the equation of time.

In this way, man devised a means of keeping time with a mechanical device that was capable of regular and uniform operation. But the mean time as shown by the clocks in one city would differ from that shown by the clocks in another city by an amount equal to the difference in longitude between the two cities. This difference amounts to 4 minutes for each degree of longitude. Local mean time worked well for centuries, but the automobile, railroads, and the general speeding up of man's activities made it impossible to continue under a system of timekeeping where each city had a different time. So, in 1883, the United States adopted what you know as the Standard Time System. This was the invention of Dr. Charles F. Dowd, a schoolmaster in Saratoga Springs, New York.

The Standard Time System is a method of timekeeping whereby all clocks in a specific time zone show the same standard time, differing from the clocks in adjacent zones by exactly one hour. The zero zone is that which has the 0° of longitude (Greenwich or Prime Meridian) running approximately through its center. Beginning with the zero zone the earth was divided into 24 zones, which were numbered in accordance with the number of hours the time in each zone varied from that of the zero zone. Those zones west of the zero zone were called plus (+) zones because the number of hours they are west must be *added* to the Standard Time of each zone to

equal Greenwich Civil Time (the Standard Time of the zero zone) at any particular moment. Those zones east of the zero zone were called minus (−) because their difference from Greenwich time must be *subtracted* from the time of each zone to equal Greenwich Civil Time.

Therefore the Standard Time system is really an hourly zone system, and in the United States we make use of four "plus" zones (west of Greenwich)—namely, the 5th, 6th, 7th, and 8th. You know these zones as the Eastern, Central, Mountain, and Pacific Standard Time zones, respectively. Boston and New York City, for instance, are in the 5th zone, where if you add 5 hours you will have Greenwich Civil Time. Likewise, Chicago and Dallas are in the 6th zone, Denver and El Paso are in the 7th zone, and Seattle and San Francisco are in the 8th zone.

Now, here is one thing more which you should remember. The Standard Time in each zone is referred to a specific meridian which is a multiple of 15° of longitude, counting from the 0° or Greenwich meridian. These meridians are called the Standard Time Meridians. In the United States they are 75°, 90°, 105°, and 120° west of Greenwich. Therefore the Standard Time of each zone is really equal to the local mean time of the Standard Time Meridian of that zone. Hence Standard Time and Local Mean Time are one and the same thing if you are situated on a Standard Time Meridian. If you are not on a Standard Time Meridian, mean time and Standard Time are not the same. We want to make this point clear because you will have to learn to obtain the local mean time of your place if you want to make the best possible use of your equatorial mounting. This is not hard to do as you will presently see.

The difference between the Standard Time of a particular place and the local mean time of the same place is a constant quantity which is equal to the difference in longitude between the place and its Standard Time meridian. To convert your Standard Time to local mean time, you must know how many degrees of longitude you are either east or west of your Standard Time Meridian. Naturally you must convert the degrees of longitude into time measure—1° equals 4 minutes and 15° equal 1 hour. We have included a conversion table (Table XVII) so you won't actually have to figure it out.

Here is the formula for finding local mean time when the Standard Time is known.

Local Mean Time = Standard Time + or − the difference in longitude
(expressed in time) between your locality and
your Standard Time Meridian.

If you are east of your Standard Time Meridian, *add* the difference in longitude (time measure) to the Standard Time in order to obtain your local mean time. If you are west of the standard meridian, *subtract* the difference in longitude (time measure). Just remember where you are and you will have no trouble. Perhaps one example will make things even clearer. Suppose you live in a town whose longitude is 74°. Since one degree equals 4 minutes of time, your clock face would show 6 o'clock but the exact local mean time would be 6 :04.

So much for time as based on the sun. You may be familiar with all this, because the radio has made everyone more conscious of our methods of timekeeping and the differences in time between various places throughout the world. So when those of you in the Eastern Standard Time zone listen to a news broadcast from London at 10 P.M. E.S.T., have a little sympathy for the poor reporter who is speaking to you at 3 A.M. the following day in London.

As you can see, longitude is a vital factor in timekeeping, therefore you should know where your instruments are located with respect to the 0 meridian of Greenwich. You can determine the longitude of your place most easily from the topographic maps of the U. S. Geological Survey. These maps are drawn on sheets about sixteen and a half by twenty inches, at various scales. Your latitude and longitude can be obtained from them accurately to within 1 to 5 seconds of arc. Index maps for each state, showing the areas for which topographic maps are available, may be procured without charge. The larger stationery stores throughout the country generally carry these maps in stock at nominal prices, or they may be procured by writing to the Director, U. S. Geological Survey, Washington, D. C.

We have mentioned that, by adding to your mounting circles which correspond to right ascension and declination, you can set your camera or telescope on an object invisible to the eye. Hence they are

Figure 50. Patrol Camera

This camera is used by the professional astronomer; note its simplicity. A Cooke lens, 1½ inches in diameter, is mounted on a metal box and a plateholder is fixed to the back. (R. Newton Mayall)

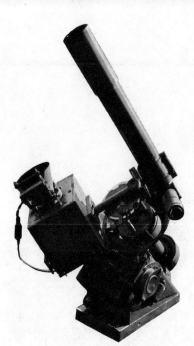

Specifications for patrol camera:
Camera: Homemade box.
Lens: Schneider Xenar, $f/4.5$, 10.5 cm. focal length.
Guide telescope: 1.6-inch objective.
Drive: Telechron clock.
Mounting: Equatorial, designed to be bolted to bracket on roof of apartment house.
Accessories: Objective prism; 25° flint.
(Equipment and photo by William von Arx)

Figure 51. Patrol Camera

Specifications for aerial camera:
Camera: Eastman Aerial.
Lens: $f/6$, 508 mm. focal length.
Guide telescope: 3-inch objective, 22-inch focal length.
Drive: Victrola motor.
Mounting: Equatorial, English type. Used on apartment house roof.
Accessories: Grating (coarse), 30° crown prism.
(Equipment and photo by William von Arx)

Figure 52. Aerial Camera

called "setting circles." In order to do this you must make use of sidereal time. If you want to be professional about setting your camera on a cluster or nebula you should know what sidereal time is and how to obtain it.

The beginning of spring is called the Vernal Equinox, but to you skyshooters the Vernal Equinox means a lot more than that. First of all it is a specific point in the sky. The location of this point is determined by the sun the instant the sun crosses the celestial equator in its journey from the south to the north. Sidereal time is measured by the daily motion of that point. Furthermore, the Vernal Equinox is the zero point from which the right ascension of the sun, moon, and all other celestial bodies is measured.

This all ties in with Standard Time in this way: a sidereal day is the interval of time between two successive crossings of the Vernal Equinox across the meridian of any given place. The length of this sidereal day interval is determined by the time used in everyday life—Standard Time. A sidereal day is only 23^h56^m long, or 4 minutes short of a mean solar day. Also, sidereal time is always reckoned consecutively from 0^h to 24^h. Life would be a lot simpler for us in this country if Standard Time were reckoned in the same way, as it is in many countries of Europe and in many other parts of the world.

All that is left for you to do is to learn how to find the sidereal time for a given place and date. Here again you need to use only ordinary arithmetic. Because many of you will not have access to any of the more technical books that treat this subject we will first give you a simple formula for computing sidereal time, together with the two tables which are necessary (Tables VII and VIII). After that, we'll explain each part of the formula.

First, let L.M.T. = Local Mean Time; Sid.T. = Sidereal Time; and G.C.T. = Greenwich Civil Time. (In some books you will find Greenwich Civil Time referred to as Universal Time, and the abbreviation "U.T." is used.) Then the formula is

Sid.T. = L.M.T. + Sid.T. for 0^h G.C.T. + Correction *for* G.C.T.

This may seem complicated, but it isn't. After two or three attempts you will find it extremely easy to solve, and quicker than other methods because two of the values are derived by means of

constants, and the others are obtained directly from the accompanying tables.

The *local mean time* at a given place is found by adding or subtracting, from the Standard Time of the locality, 4 minutes of time for each degree of longitude the place is located east or west of its Standard Time Meridian. If the place is east, the difference is added to the Standard Time; if west, it is subtracted.

The Standard Time Meridians (S.T.M.) in the United States are:

75th = Eastern Standard Time (E.S.T.) = 5^h W. of Greenwich
90th = Central Standard Time (C.S.T.) = 6^h W. of Greenwich
105th = Mountain Standard Time (M.S.T.) = 7^h W. of Greenwich
120th = Pacific Standard Time (P.S.T.) = 8^h W. of Greenwich

EXAMPLE: Find the local mean time at Cambridge, Mass., at 9:30 P.M. E.S.T. The longitude of Cambridge is 71°07′30″ W. of Greenwich, which if expressed in time would be $4^h44^m30^s$ W. (See Table XVII). In other words, Cambridge is 15^m30^s east of its Standard Time Meridian (the 75th). From the following formula we find that at Cambridge 9:30 P.M. E.S.T. the corresponding local mean time is equal to 9:45:30 P.M.

Standard Time + or − Diff. in Long. from S.T.M. = Local Mean time
9:30 P.M. E.S.T. + 15^m30^s = 9:45:30 P.M.

Greenwich Civil Time may be found by adding to or subtracting from the Standard Time of a place the number of hours its Standard Time Meridian is west or east of Greenwich. If the place is west of Greenwich the quantity is added; if east, it is subtracted.

EXAMPLE 1: To find the Greenwich Civil Time corresponding to 4:30 P.M. E.S.T., at Cambridge, Mass., on May 15, you would add 5 hours (the S.T.M. for Cambridge is the 75th or 5 hours west of Greenwich), which would give you 9:30 P.M. G.C.T. on May 15.

EXAMPLE 2: Suppose it is 9:30 P.M. E.S.T., at Cambridge, Mass., on May 15. In this case you add 5 hours and get 14^h30^m G.C.T.; but this would be after midnight, so 12 must be subtracted. Thus the G.C.T. would be 2:30 A.M. on May 16 (the following day).

The *sidereal time for 0^h Greenwich Civil Time* is given in Table VII to the nearest minute for each day in the year. This table is a mean table, and it is subject to a maximum variation, at times, of about 2 minutes.

TABLE VII

SIDEREAL TIME FOR 0ʰ GREENWICH CIVIL TIME

Compiled from the American Ephemeris.

Day	Jan.	Feb.	Mar.	Apr.	May	June	July	Aug.	Sept.	Oct.	Nov.	Dec.
1	6ʰ40ᵐ	8ʰ42ᵐ	10ʰ32ᵐ	12ʰ35ᵐ	14ʰ33ᵐ	16ʰ35ᵐ	18ʰ33ᵐ	20ʰ36ᵐ	22ʰ39ᵐ	0ʰ37ᵐ	2ʰ39ᵐ	4ʰ38ᵐ
2	6 44	8 46	10 36	12 39	14 37	16 39	18 37	20 40	22 43	0 41	2 43	4 42
3	6 48	8 50	10 40	12 43	14 41	16 43	18 41	20 44	22 47	0 45	2 47	4 45
4	6 52	8 54	10 44	12 46	14 45	16 47	18 45	20 47	22 51	0 49	2 51	4 49
5	6 56	8 58	10 48	12 50	14 49	16 51	18 49	20 51	22 55	0 53	2 55	4 53
6	7 00	9 02	10 52	12 54	14 53	16 55	18 53	20 55	22 59	0 57	2 59	4 57
7	7 03	9 06	10 56	12 58	14 57	16 59	18 57	20 59	23 02	1 01	3 03	5 01
8	7 07	9 10	11 00	13 02	15 01	17 03	19 01	21 03	23 06	1 05	3 07	5 05
9	7 11	9 14	11 04	13 06	15 04	17 07	19 05	21 07	23 10	1 09	3 11	5 09
10	7 15	9 18	11 08	13 10	15 08	17 11	19 09	21 11	23 14	1 13	3 15	5 13
11	7 19	9 21	11 12	13 14	15 12	17 15	19 13	21 15	23 18	1 17	3 19	5 17
12	7 23	9 25	11 16	13 18	15 16	17 19	19 17	21 19	23 22	1 20	3 23	5 21
13	7 27	9 29	11 20	13 22	15 20	17 22	19 21	21 23	23 26	1 24	3 27	5 25
14	7 31	9 33	11 24	13 26	15 24	17 26	19 25	21 27	23 30	1 28	3 31	5 29
15	7 35	9 37	11 28	13 30	15 28	17 30	19 29	21 31	23 34	1 32	3 35	5 33
16	7 39	9 41	11 32	13 34	15 32	17 34	19 33	21 35	23 38	1 36	3 38	5 37
17	7 43	9 45	11 36	13 38	15 36	17 38	19 37	21 39	23 42	1 40	3 42	5 41
18	7 47	9 49	11 39	13 42	15 40	17 42	19 40	21 43	23 46	1 44	3 46	5 45
19	7 51	9 53	11 43	13 46	15 44	17 46	19 44	21 47	23 50	1 48	3 50	5 49
20	7 55	9 57	11 47	13 50	15 48	17 50	19 48	21 51	23 54	1 52	3 54	5 53
21	7 59	10 01	11 51	13 54	15 52	17 54	19 52	21 55	23 58	1 56	3 58	5 56
22	8 03	10 05	11 55	13 57	15 56	17 58	19 56	21 58	00 02	2 00	4 02	6 00
23	8 07	10 09	11 59	14 01	16 00	18 02	20 00	22 02	00 06	2 04	4 06	6 04
24	8 11	10 13	12 03	14 05	16 04	18 06	20 04	22 06	00 10	2 08	4 10	6 08
25	8 14	10 17	12 07	14 09	16 08	18 10	20 08	22 10	00 13	2 12	4 14	6 12
26	8 18	10 21	12 11	14 13	16 11	18 14	20 12	22 14	00 17	2 16	4 18	6 16
27	8 22	10 25	12 15	14 17	16 15	18 18	20 16	22 18	00 21	2 20	4 22	6 20
28	8 26	10 28	12 19	14 21	16 19	18 22	20 20	22 22	00 25	2 24	4 26	6 24
29	8 30		12 23	14 25	16 23	18 26	20 24	22 26	00 29	2 27	4 30	6 28
30	8 34		12 27	14 29	16 27	18 29	20 28	22 30	00 33	2 31	4 34	6 32
31	8 38		12 31		16 31		20 32	22 34		2 35		6 36

The *correction for Greenwich Civil Time* is given in Table VIII. This correction must be made in order to convert a mean time interval into sidereal time. In the formula, the mean time interval is Greenwich Civil Time—that is, the number of hours that have elapsed since 0^h G.C.T. (midnight).

TABLE VIII

CORRECTION TO BE ADDED TO A MEAN TIME INTERVAL TO CONVERT MEAN SOLAR INTO SIDEREAL TIME

Hours		Minutes						Seconds	
Hrs.	Cor.	Min.	Cor.	Min.	Cor.	Min.	Cor.	Sec.	Cor.
1	0^m 10^s	1	00^s	21^m	3^s	41	7^s	1	$0.^s0$
2	0 20	2	0	22	4	42	7		
3	0 30	3	0	23	4	43	7	t	o
4	0 39	4	1	24	4	44	7		
5	0 49	5	1	25	4	45	7	60	$0.^s2$
6	0 59	6	1	26	4	46	8		
7	1 09	7	1	27	4	47	8		
8	1 19	8	1	28	5	48	8		
9	1 29	9	1	29	5	49	8		
10	1 39	10	2	30	5	50	8		
11	1 48	11	2	31	5	51	8		NOTE:
12	1 58	12	2	32	5	52	9		The correction for seconds
13	2 08	13	2	33	5	53	9		is so small that it
14	2 18	14	2	34	6	54	9		may be disregarded.
15	2 28	15	2	35	6	55	9		
16	2 38	16	3	36	6	56	9		
17	2 48	17	3	37	6	57	9		
18	2 57	18	3	38	6	58	10		
19	3 07	19	3	39	6	59	10		
20	3 17	20	3	40	7	60	10		
21	3 27								
22	3 37								
23	3 47								

Compiled from the Nautical Almanac (Great Britain)

EXAMPLE: If your Greenwich Civil Time happens to be $15^h37^m45^s$, the correction would be 2^m34^s. From Table VIII the correction

for $15^h = 2^m28^s$
for $37^m = 0\ 06$
for $45^s = 0\ 00$
Total correction $= 2^m34^s$

Three examples are given below, showing not only the use of the above formula for finding sidereal time, but also what happens in the computation at different times of day.

You will find it much easier to convert your Standard Time and local mean time into astronomical terminology at the outset. Instead of saying May 15, 9:30 P.M., add 12 hours and call it May 15, 21h30m. Remember that the astronomical day begins at midnight and the hours are numbered consecutively, from 0h to 24h. If you do this, mental work, errors, and worry are lessened, and it is only necessary to deduct 24h at the end of the computation if the required sidereal time is greater than 24h. (See Example 1, below.)

EXAMPLE 1: At 9:30 P.M. E.S.T., May 15, Cambridge, Mass. Find the sidereal time. (Longitude of Cambridge = 71°07′30″ W. or 4h44m30s W.)

Local mean time, at Cambridge, May 15, 21h30m E.S.T.

(9:30 P.M.)	= 21h45m30s
Sidereal time for 0h G.C.T., May 16 (Table VII)	= 15 32
Correction for 2h30m G.C.T. (Table VIII)	= 0 00 25
Sidereal time	= 37h17m55s
Deduct	− 24 00 00
The required sidereal time	= 13h17m55s
or	= 13h18m

EXAMPLE 2: At 1:25 A.M. C.S.T., July 19, Chicago, Ill. Find the sidereal time. (Longitude of Chicago = 87°37′30″ W., or 5h50m30s W.)

Local mean time, at Chicago, July 19, 1h25m C.S.T.

(1:25 A.M.)	= 1h34m30s
Sidereal time for 0h G.C.T. July 19 (Table VII)	= 19 44
Correction for 7h25m G.C.T. (Table VIII)	= 0 01 13
The required sidereal time	= 21h19m43s
or	= 21h20m

EXAMPLE 3: At 6:15 A.M. P.S.T., September 23, at a place whose longitude is 123°10′45″ W. (8h12m43s W). Find the sidereal time.

Local mean time at 123°10′45″ W. longitude, September 23,

6h15m P.S.T. (6:15 A.M.)	= 6h02m17s
Sidereal time for 0h G.C.T. Sept. 23 (Table VII)	= 0 06
Correction for 14h15m G.C.T. (Table VIII)	= 0 02 20
The required sidereal time	= 6h10m37s
or	= 6h11m

There are other ways of finding sidereal time but you will find the method just described as easy as any. Furthermore, if you figure out what the sidereal time will be, say, at 8 P.M. E.S.T., all you have to do is set your watch at 8 P.M. E.S.T. to agree with the corresponding sidereal time. This will serve your purpose throughout the evening. If you want to regulate a watch or an alarm clock to tell sidereal time every day without having to make the above computations each night, you must regulate it to gain 4 minutes each day, over Standard Time. Remember, the sidereal day is only 23^h56^m long.

Now that you know how to obtain sidereal time, what good is it? What are you going to do with it? How are you going to use it in conjunction with your camera or telescope? You will find the answers to these questions if you will turn to Chapter 14 which tells about mechanical drives, and to Chapter 15 which explains the use of the setting circles.

Chapter 14

MOUNTINGS WITH MECHANICAL DRIVES

IN CHAPTER 5 we showed you how to make a simple equatorial
mounting. This was a hand-driven mounting. But if you take
your hobby of shooting the stars seriously, and want to get the most
out of it, you will want to do things "according to Hoyle" in so far
as your means and ability will allow. You will want to emulate the
great observatories and construct fine instruments capable of turning
out professional work. You will want instruments provided with
the necessary accessories that will make it possible for you to carry
out any program in a professional manner. For these reasons we
must delve once more into the subject of mountings. We say you
will want to do all these things because we know what happens when
you get bitten by the skyshooting bug—then the sky's the limit.

Let's first examine a camera used by the astronomer. If you visit
any large observatory you will soon find that all its equipment
is not big and expensive. For an example, look at Figure 50 which
shows a simple camera that astronomers use every clear night. It
does all the things we have suggested you do, and it consists only of
an ordinary camera lens 1½ inches in diameter of 6 inches focal
length, mounted in a metal box about ten inches square, which is
open at one end—a plateholder is attached to the other end.

Notice how the camera box is mounted in a fork, also that the polar
and equatorial axes are clearly visible. Affixed to the axes are two
circles—the one beside the camera box is called the declination circle,
which is divided into 360°, usually in four quadrants, thus: 0°-90°-
0°-90°-0°. The circle mounted on the polar axis, beneath the
camera, is called the right ascension circle. It is usually divided into
24 equal parts or hours, in halves, thus: 0^h-12^h-0^h (or in quadrants,
thus: 0^h-6^h-0^h-6^h-0^h).

In general conversation these two circles are referred to as "dec"
and "hour" (or "R.A."), which terms refer descriptively to their
use. They are adjusted on the mounting so that when the camera

points to the celestial pole the declination circle will read 90° (see Chapter 15).

Right ascension and declination are the two coordinates used to locate objects in the sky in the same manner that latitude and longitude are used to locate places on the earth. Consequently, if you know the R.A. and declination of an object, you can set your camera on the object without the aid of a star chart or looking at the sky. Using circles is the easiest and most efficient method of setting your camera on an object. Chapter 15 explains in detail how you can use these setting circles. We are here more concerned with the mechanical part of the mounting—that part which, once your camera is set, will automatically turn it about the polar axis so you can get clean-cut images without following or guiding by hand. Such a mechanical device is called a "drive."

There are several types of drives, based on two principles, clock drives and motor drives. In the design of clock drives the amateur has made use of about every conceivable type of mechanism from complicated precision clocks down to the lowly alarm clock. For motors the amateur has used everything from the spring motor of a phonograph to synchronous motors.

Making a mechanical drive for your camera is not as difficult as it sounds, nor do you have to worry about the greater weight associated with a large telescope. It is only necessary to add a gear to the polar axis so that a second, or drive, gear will turn the camera from the east toward the west at the same rate as the stars appear to move. There is nothing complicated about the principle involved.

As we explained in Chapter 13, our watches keep time by reference to the sun, but the astronomer keeps time by reference to the stars. The difference between the time of everyday life and "star" (sidereal) time is roughly 3^m56^s per day. A sidereal day is the interval of time between two successive crossings of the Vernal Equinox across any given meridian which amounts to approximately 23^h56^m, therefore a sidereal day is shorter than a mean solar day by about four minutes. Thus the problem of the drive mechanism is one of arranging and adjusting a motor or clockwork, by means of gears, so it will turn your camera one complete revolution about the polar axis in approximately 23^h56^m. Consequently if you want your watch

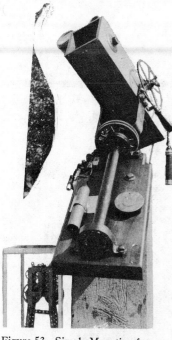

Figure 53. Simple Mounting for a Homemade Camera

An impulse drive is used. (Equipment and photo by William von Arx)

Figure 54. Camera on Telescope

The camera is a Zecanar fitted with $f/4.5$ lens, and mounted on a 6-inch reflecting telescope, as shown. (Equipment and photo by R. Willey)

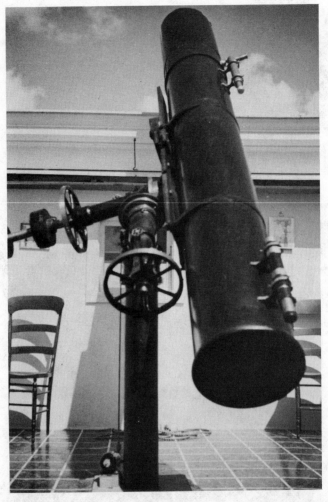

Figure 55. Equatorial Mounting. German Type

The pictures of the moon (Figures 38, 39, 40, and 41) were taken with this homemade 12½-inch reflecting telescope, of 100 inches focal length. Note the setting circles. The small synchronous motor that drives the telescope may be seen on the floor beside the pier. (Equipment and photo by R. G. Stephens)

to show sidereal time you will have to adjust it to gain about four minutes a day.

By this time you are probably aggravated because we have not told you exactly how long a sidereal day really is. Well, here you are: a sidereal day is 23^h56^m 4.091^s of mean solar time (mean time). Is that close enough for you? You will need that figure in order to get the proper gears for your drive.

There are so many different ways to solve the problem of driving your camera that we suggest you consult the two books by Albert G. Ingalls, *Amateur Telescope Making,* 4th Edition, and *Amateur Telescope Making, Advanced.* In these two books you will find many designs, illustrations, and instructions for making all kinds of mechanical drives.

Once more we want to drive home the fact that you should make your mounting heavy rather than light. It is particularly necessary to keep this in mind if you are going to use a mechanical drive, because if your instrument is not smooth working, free from vibration and play, it will not and cannot be expected to give you satisfactory results.

Your camera will not require much power. A $\frac{1}{20}$ horsepower motor is sufficient to drive a fairly heavy instrument. Also, you will find it a great advantage to have ball bearings in the polar axis. You can also use an old alarm clock to provide the drive force by attaching a weighted pulley and wire to the hour spindle of the clock, and an old phonograph spring motor can be utilized by replacing the spring with a wire and a weight. There is really no end to the ingenious devices that have been made to serve as drives for cameras.

The synchronous direct drive motor, however, is coming more and more into use. The general acceptance of the electric clock has made the use of this motor practical. Therefore if your electric clocks keep good time you can be reasonably sure that such a motor can be used in your locality. A complete motor with the proper reduction gears can be purchased at a reasonable price. By buying the parts and putting the drive together yourself, you can keep the cost down to a minimum. The advantage of the synchronous motor is obvious—once adjusted it is only necessary to plug it into the nearest electric outlet and you are ready to go to work. Once your

camera is set to the position desired, it will be driven as long as required, without watching.

It is not hard to fit a mounting with circles and a simple drive mechanism—such things are within the reach of all and they greatly facilitate the use of your camera, broaden its scope, and make possible the enlargement of any program undertaken, as well as allowing exposures of long duration which are necessary to record faint nebulae or to get the best out of star clusters. Each picture you make will have a greater scientific value either for personal research and study or for the use of others.

The size and fineness of your equipment is, of course, governed by your interest, the size of your pocketbook, and your mechanical ability. No matter how fine your instrument, no matter that your mounting is fitted with circles and a drive, you cannot get the most out of your equipment unless you know how to use it efficiently. Chapter 15 will be of aid to you in the efficient operation of your camera.

Chapter 15

HOW TO USE THE SETTING CIRCLES

IF YOU HAVE a simple equatorial hand-driven mounting you can facilitate the finding of objects in the sky by adding two circles, called setting circles—one corresponding to right ascension, the other to declination. If your mounting is driven mechanically you cannot afford to be without these circles. With them you can emulate the professional astronomer who depends entirely upon them and sidereal time (see Chapter 13) to set his instruments. "Sweeping" the sky to locate an object is abolished by the proper use of the setting circles.

The positions of celestial objects are located in a manner similar to that of places on the earth. The location of a place on the earth is determined when its latitude and longitude are known. The astronomer's "latitude" is called declination, and his "longitude" is referred to as right ascension.

The declination circle is so placed that its plane lies perpendicular to the plane of the equator, and each quadrant on its periphery is divided into degrees and minutes of arc from 0° to 90° (See Figure 56). The "hour angle" or right ascension circle is so placed that its plane lies at right angles to the plane of the declination circle and each quadrant is divided into hours and minutes of time from 0^h to 6^h (or each half from 0^h to 12^h).

In this arrangement the declination circle is placed on the equatorial axis and the hour circle is placed on the polar axis. They are adjusted and fixed in place so that each reads zero (0) when your telescope or camera is pointed to the due (true) south point on the celestial equator.

By tipping your camera up and down in a north-south line you can read on the declination circle how many degrees north or south of the celestial equator a star may be as it crosses your meridian. Now set your camera back on the zero points, then move it in an east-west direction—in this way you can read on the right ascension

(hour) circle how many hours a star on the equator is away from
the meridian. Hence the name: hour angle circle.

Therefore, if you want to set your camera on an object invisible
to the eye, all you have to do is to look up the right ascension and
declination of the object, then set your camera to the declination of

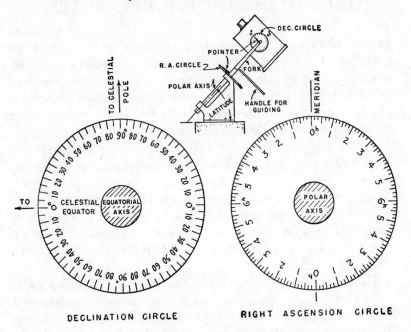

Figure 56. Setting Circles

This is what the right ascension and declination circles look like. The position of the
circles is shown in the inset diagram of the mounting. Either the circle or the pointer may
be stationary.

the object and clamp your camera in that position. Next, find the
hour angle (distance from meridian) of the object and then turn
your camera toward the east or west, as the case may be, so the
reading of the hour circle is equal to the hour angle of the object at
any particular time.

Right away you ask, "How can I find these things?"

The coordinates for hundreds of interesting objects can be found
in most star atlases and in many popular books on astronomy. To
make things even easier for you, we have included the positions of

nearly a hundred selected objects in Tables X, XI, XII, XIII, and XIV.

If you know the sidereal time and the right ascension of an object, you can find its hour angle by just subtracting whichever of the two quantities is the smaller from the larger. Simple, isn't it?

Now all you want to know is whether you should turn your camera east or west of the meridian or, if we have to be technical about it, whether the hour angle is east or west. If the right ascension is the larger quantity, the hour angle is east, and the object in question will not have reached the meridian. If the sidereal time is the greater quantity, the hour angle is west, and the object will have passed the meridian.

Here are two examples to show you how this works:

EXAMPLE 1:

Sidereal time	= 13^h18^m
R.A. of R Ursae Majoris	= 10 40
Hour Angle =	2^h38^m W.

EXAMPLE 2:

R.A. of M13 in Hercules	= 16^h40^m
Sidereal time	= 13 18
Hour Angle =	3^h22^m E.

WARNING! Whenever you look up the position of a star or any other object in the sky, for use in any of the formulas we have given you, be sure the year or date (called the Epoch) of the position given is not more than 10 or 15 years before or after the time for which you do your figuring. More distant Epochs may result in serious error. The reason for this is the fact that the Vernal Equinox does not stay put—it moves a very slight amount each year. All the positions of objects we have listed have been computed for the year (Epoch) 1950. You can bring these positions up-to-date by using the Precession Tables in the Appendix. Where you must be careful is when you are looking at some old star atlas or book containing a list of objects. The *American Ephemeris and Nautical Almanac* lists many stars and other objects, together with their positions. This book is published each year by the Government, and all the positions are computed for the date of the *Ephemeris*.

The methods we have outlined for computing sidereal time (Chapter 13) and for setting your instruments are used by the astronomer. But there are other ways of doing the same things, so now let's do them a different way which, although not so accurate, probably will serve your purpose equally as well.

The sidereal time for a given place is equal to the right ascension of an object when that object is on the meridian of that place. In order to obtain sidereal time, all you have to do is to pick out some bright star (on or near the celestial equator) whose right ascension you know. The way to do it is this: when the star you select is east of and close to the meridian of your place, set your instrument due south and clamp it in declination (that is, the declination of the star selected). Knowing the right ascension of the star (obtained from the current *American Ephemeris*), watch the field of view, and when the star arrives at the center of the field, set a watch or clock to agree with the right ascension of the star, and you will have the correct sidereal time. The accuracy, of course, depends on you. If you use a watch with a dial divided into 12 hours, you will have to deduct 12 from the R.A. when the R.A. is greater than 12, and then set the watch to the remainder, always remembering that 12 hours must be added to the reading of the watch when you use it. All of this figuring you can do mentally.

Another simple method of finding sidereal time is to set your instrument carefully on some easily distinguished bright object such as Sirius, which is not too far removed from the celestial equator and whose R.A. (obtained from the current *American Ephemeris*) is known. When it is in the center of the field of view, the hour circle will show the hour angle of the object, or the time which has elapsed or must elapse since (or before) it crossed your meridian. If the object is *east* of the meridian you can obtain the sidereal time by subtracting the hour angle of the object from its R.A. If the object is *west* of the meridian the sidereal time will be obtained by adding the hour angle to the right ascension.

When you want to set your camera on an object invisible to the eye, there is another method of doing it which does not require the use of sidereal time. First, set your camera or telescope on some well-known bright star whose R.A. is known. Find the difference between the R.A. of the bright star and the object you want to pho-

tograph. Then add or subtract the difference in R.A. to or from the hour angle of the bright star as shown on the hour circle. If the object sought is nearer to your meridian than the bright star, the difference in R.A. is subtracted from the hour angle of the bright star; if the bright star is nearer your meridian, the difference is added. This gives the hour angle of the object sought, and if your instrument is then set to that hour angle and the proper declination, the object should be found approximately in the center of the field of view.

All these things—finding sidereal time, using it, and making use of the setting circles—are just handy pieces of information to remember. They enable you to shoot the stars with the least amount of effort.

Chapter 16

KEEPING RECORDS

I N EVERYDAY photography, it is possible for you to show a friend a picture you took a year ago and describe it to him in great detail—give all the facts about it such as date, state of the weather, where you were, what the scene means, and so on. You might be able to tell your friend what kind of film you used, the aperture-ratio, and the exposure time. There are many reasons why you can do this. In your picture, familiar earthly objects can be associated readily in your mind with certain activities and in this way you remember all the facts associated with the actual taking of an every-day type of photograph. Shooting the stars is quite a bit different and we doubt very much (except under certain conditions) that you could do the same thing with your star pictures. Therefore we stress the real necessity of keeping an accurate record of what you do.

We have outlined what you can do with your camera on various types of mountings. If your camera is mounted on a tripod, it is obvious that only certain information can be known definitely: that part of the sky toward which your camera is pointed, the time of beginning and end of exposure, and the latitude and longitude of your place. However, if your camera is mounted equatorially you can fix definitely the point toward which the center of your camera is pointed, by reading the hour (R.A.) and declination circles. Without an equatorial mounting fitted with circles you must use a star chart, after the picture is made, to determine the position.

The question you will ask is, "What kind of records should I keep?" The answer, of course, depends upon what you are photographing, what kind of mounting you are using, and what kind of work you are doing. We can answer your question a little more definitely by dividing camera mountings into two general types— those with circles and those without circles.

First of all, provide yourself with a sturdily bound book with blank pages, preferably ruled only in the horizontal direction, so the

vertical columns can be ruled any width you desire to receive the data required. Notebooks for this purpose may be bought in any stationery store. Write the words "RECORD BOOK" in large letters on the front cover. This book will be used only for recording data concerning each exposure and nothing else should appear in it.

Certain information is common to both types of camera; therefore, on the first right-hand page of the Record Book, enter your name and address, name of city or town where the photographs are made, together with the latitude and longitude of the place where your camera is set up. Latitude and longitude may be derived by direct observation, or by locating your observing position on a United States Geological Survey topographic map of your locality. Such a map will enable you to obtain a more accurate determination of your terrestrial coordinates than by any other method, except by direct observation.

This fixes your position with respect to the rest of the world and the universe in general—necessary data that apply to all observations. If you have more than one camera in use, a separate Record Book should be kept for each instrument to avoid any misinterpretation. Other specific information such as the focal length of your lens and its diameter, kind of camera, and so forth should also be written on this first page, for all such information remains the same regardless of the mounting you use. Once you have recorded this information it is done forever as long as the particular instrument to which it refers is in service.

Before continuing, one word of caution. Remember that the basis of notemaking is that all notes should be written with the idea that someone else, not you, must read and interpret them. Careless, sloppy notes are inexcusable and they frequently result in worthless labor. Enter all facts in your notebook carefully and neatly so anyone can read what you have written.

Use both the left- and right-hand pages of your notebook in laying out the vertical columns for the records. For mountings without circles, the following layout will serve your purpose:

1. If only one camera is used the "Instrument" may be omitted at the top of the left-hand page. When you have several cameras in service the repetition of the instrument used helps avoid errors made by placing

the data in the wrong book, because the name of the instrument will be always before you, on each page.

2. The date is usually written in this manner: July 1-2, 1941, not as July 1, 1941, because you begin work in the evening of one day and you may end it in the wee morning hours of the following day.

3. Every plate should have a number which corresponds to the number in the Record Book.

INSTRUMENT:							DATE:
NO. OF PLATE	REGION	DETERMINED POSITION		BEGIN EXP.	END EXP.	SKY	REMARKS
		R. A.	DEC.				

Figure 57. Record Data for Mountings Without Circles

4. The "region" is the approximate position toward which your camera is pointed. If your camera is pointed toward Arcturus (the star whose light opened the Century of Progress exposition in Chicago), that word can be entered in the "region" column, or its technical name, Alpha Boötes, may be entered.

5. The "Determined Position" cannot be filled in until after you have developed the plate or film and compared it with a star chart, from which the R.A. and declination of the center of the plate can be obtained.

6. Probably you will enter the beginning and end of exposure in Standard Time, but sidereal time may be used as well. Whichever you use should be clearly noted.

7. The column marked "Sky" refers to the condition of the sky, such as cloudy, clear, clear?, hazy, or any notation that will indicate the condition existing at the beginning of the exposure.

8. Other pertinent data, such as stopping the instrument by closing the shutter because of clouds, should be entered under "Remarks."

If you are using several instruments the plate number should be preceded by a symbol or letter which will signify the plate was taken with a certain camera. For example: C84 might mean it is the 84th plate to be taken with a 1-inch Cooke lens. If separate books are used for each instrument the key letter or symbol can be placed on the front cover beneath the words "Record Book," and only those plates made with the "C" instrument would be entered in the "C"

book. The symbol or key letter would of necessity be placed on the plate and on the envelope in which the plate is filed.

When setting circles are used the page layout remains the same except for the coordinates, which are known at the beginning and do not have to be determined after the plate has been developed. The time of beginning and end of exposure is generally listed in sidereal time where circles are used, instead of in Standard Time. If your equipment is fitted with circles you will no doubt use them in the manner explained in Chapter 15, in which case the sidereal time would be known.

If you make any exposures with any aperture other than full, enter that fact in the "Remarks" column, otherwise its omission will imply "wide open."

Always enter something in the columns. If there is nothing to be set down use a dash to show that it wasn't forgotten. Never write anything before the proper time to do it; for instance, don't make a record of starting the exposure until you have done so and then do not delay in entering that fact. Some interruption may cause a delay in starting.

Do not make erasures in the Record Book. If an error is made draw a single line through the notation and enter the correction above it, so the original record can be read. You may find the original notation was the correct one after all.

If other entries are made at some later date, a colored pencil or some other medium should be used to distinguish them from entries made at the time of the exposure.

Figure 58 shows a Record Book page layout that will serve every purpose, regardless of the mounting used. This layout is based on Record Books pretty generally used in observatories. Two observations have been entered as a guide.

1. "Class" refers to the type of plate being taken. In the example, a chart plate was made—one on a selected region and the other as a part of a general meteor program.

2. The "Observed Hour Angle" is the angle obtained by reading the R.A. circle at the time of setting. It should be equal to the difference between the sidereal time and the R.A. of the object, or center of the field.

3. "Tel. E. or W." refers to the mounting of German type where the telescope tube or camera may be set either on the east or the west side of the polar axis.

4. The "Load" column serves as a record of the number of grams weight placed on the pendulum shelf of a precision clock to retard or increase the speed of rotation of the polar axis. Unless you use such a clock this column is unnecessary.

INSTRUMENT: 1½" COOKE ('C')

NO. OF PLATE	CLASS	OBJECT	R.A.	DEC.	STARTED	OBSERVED HOUR ANGLE	OBSERVED DEC.	TEL. E. or W.	LOAD	FOCUS	PRISM
799	Chart	FF Aquilae	18ᵗ 56ᵐ	+17° 00'	18ʰ-43ᵐ	0ʰ-13ᵐE	+17°00'	—	—	—	—
800	Chart	Meteor Patrol	18-00	+35-00	20-01	2-01 W	+35-00	—	—	—	—

LEFT HAND PAGE

DATE *Sat.-Sun. Aug. 24-25, 1940*

SKY AT START	STOPPED	EXPOSURE	CLOUDS	OBSERVER	REMARKS
0?	19ᵗ 56ᵐ	00ₐ₇₃	0	M.M	Cramer Hi-Speed special
0	21-00	59ᵐ	0	"	" " " "

RIGHT HAND PAGE

Figure 58. Record Book

This is a sample page from a record book. The parenthetical "C" is the code letter assigned to the instrument when several cameras are used.

5. The "Focus" column provides for a record of the setting of an adjustable plateholder. Weather changes may affect the focus.

6. Details about a prism, if used, are recorded in the column reserved for that purpose.

7. An error was made in recording Observation 799, where the exposure was found by subtracting the R.A. instead of the "started" time from the "stopping" time. Note how the correction was entered.

FILING PLATES AND FILMS

All your photographs should be filed in neat order away from harm, dust, and dirt. Never file plates together side by side without protection of some sort between them. Each plate or film should be placed in a suitable envelope so marked or numbered that it can be

found easily. There are many filing systems, one as good as another, but we shall describe one system with the hope it will remove some worry from your shoulders.

Do not mix plates taken with different instruments. Where separate Record Books are kept for each instrument, the numbers, together with the identifying letter or symbol, can run consecutively from 1 for each instrument.

R.A. $18^h 56^m$		DEC. $+17°00'$	
EXP. 73 min.		NO. C 799	
DATE August 24-25, 1940			
REMARKS Variable FF aquilae.			
Excellent images			

Figure 59. Index Card

The sample shows what data are brought forward from the Record Book. See Figure 58.

If you use roll film or film pack your own identifying number will have to be added to the finished (dried) negative by writing in ink on the emulsion side. If you use cut film or glass plates you can add your own identifying number, in a dark room before development (after exposure) by pulling out the slide in the plateholder a little way to allow room near the edge to write on the emulsion side with a hard pencil or stylus.

It is necessary to write only the number of the plate (obtained from the Record Book), with its identifying mark, in the upper right-hand corner of the envelope in which it is placed. The rest of the information is put on standard library index cards.

The cards should have sufficient data to make possible ready reference to the plates of any region, together with the salient facts about each plate, so that it is unnecessary to refer to the Record Books. Figure 59 shows the layout for the filing cards.

The cards are filed in the order of increasing right ascension. If two cards have the same R.A., place the one having the greatest northern declination first, and so on.

All information on the cards is obtained from the Record Book, and the operation of this system entails a minimum amount of work. However, if you have the time and the inclination you will find it of value to have the same information on the plate envelopes that appears on the cards.

This method of filing facilitates reference to all the plates of the same region—for they will be together in the card file.

Chapter 17

MORE ABOUT
CAMERAS, FILMS, AND DEVELOPING

T ODAY ALMOST everyone has a miniature (35mm) camera, and many of these are of the SLR (single lens reflex) type. SLR cameras are particularly well adapted for use in conjunction with almost any kind of external optics—telescopes, field glasses, binoculars, monoculars, and telephoto lenses.

For example, excellent pictures can be made with a SLR camera held at the eyepiece of a telescope by hand, or rigidly attached to binoculars or a monocular. There are many attachments available for this purpose. SLR cameras can be obtained in a variety of shapes and sizes, with between the lens shutters and focal plane shutters.

Most SLR cameras produce some vibration, which can be annoying. Focal plane shutters will produce the least vibration; return mirrors the most. If you can, get a camera with a shutter that releases the mirror soon enough to avoid vibration, or one capable of being operated with the mirror locked up. This is a fine point, but do not let vibration deter you from skyshooting.

The cameras most frequently used by the amateur are Cannon, Contaflex, Contarex, Exacta, Leica, Leicaflex, Miranda, and Nikon. Of course there are a host of other similar cameras. The order given here is alphabetical and is not intended to suggest order of preference. All are excellent cameras.

The accessories for mounting these cameras are numerous today. Some amateurs have shown a unique ingenuity in devising their own mountings. Firms such as Edmund (Edmund Scientific Co., Barrington, N. J. 08007) have many useful accessories and instruments listed in their catalog. The United Scientific Co. (66 Needham St., Newton Highlands, Mass. 02161) is another outlet for telescopes, accessories, and cameras. There are other similar firms, but these two are mentioned because they are well established and their relation with the amateur has been excellent. They are dependable. In

all your dealings with suppliers, stick to the well established firms. Don't go looking for bargains—there aren't any.

One other camera that deserves to be mentioned is the Polaroid, which is a unique camera using a very high speed emulsion. Much can be done with it, both in black and white and in color. This camera with its fast film presents new and interesting possibilities. Excellent photos of the constellations have been made in 5 seconds at $f/4.5$, and the stars are shown down to the limit of those seen by the un-aided eye. Star trails and artificial satellites are good examples for this camera, and with the new Polaroid color film, interesting effects may be obtained. If you hitch it to your telescope you can go on to other fields. Of course you only have one picture, but you can see the results right away.

FILMS

There has been a great change in the type of films being used today. They vary from very slow to very high speed emulsions—as much as 1000 ASA and more. In general, the slower the speed the less grain. Previous chapters indicate the type of film which will give good results, but sometimes you may want to try something faster or slower. For example, you may want to use a very slow film on the moon, one with very little grain, for details are what you are after. A good film for this purpose is Panatomic-X, or High Contrast Copy, that has practically no grain. But if you need speed, films like Tri-X and Royal-X Pan can be used.

Each film manufacturer makes a variety of emulsions from which to choose. Eastman Kodak has made an effort to place in the hands of the amateur useful information about its films, particularly in regard to astrophotography. A table of their films is reproduced to help guide you in a selection (see page 156).

Other manufacturers such as Ansco and Agfa make comparable black and white, and color films, which will be found satisfactory. Unless you are going into specialized fields, do not change from the film, or maker, that you have been using.

DEVELOPING

Developing your negatives is still a problem. In general, commercial developing is not good for astronomical photographs. In the large cities you may find someone who will give your negative special care, and use the developers required. This costs a little more but

it is worth it. However, it is much better to do it yourself. You can control temperature and time of development, and get much more satisfaction in the doing.

In addition to the developers mentioned elsewhere, there are D-76, DK-50, D-11, and D-19. Developer D-76 is an exceedingly good developer producing high definition, sharpness, and detail. DK-50 is a general purpose developer producing good negatives. D-11 and D-19 are high contrast developers.

These are excellent developers, but we repeat, use the developer specified for the film you are using. Color films are best done by the manufacturer. Color processing is fast.

The following table is a suggested guide for the developer to use with various Eastman films:

Developer	Film
D-76	Verichrome Pan, Tri-X, Plus-X Pan, Panatomic-X
DK-50	Royal-X Pan, Tri-X
D-11	High Contrast Copy
D-19	High Contrast Copy

The black and white Eastman films offered in rolls, their relative ASA ratings, and characteristics are given below:

Verichrome Pan (ASA 125) medium speed, extremely fine grain, panchromatic, ideal for general work.

Plus-X Pan (ASA 125) medium speed, extremely fine grain, high definition.

Panatomic-X (ASA 40) extremely fine grain, low speed, moderate contrast.

Panatomic-X (ASA-32) extremely fine grain, sharp, moderate speed and contrast.

Tri-X (ASA 400) high speed, fine grain.

Royal-X Pan (ASA 1250) extremely fast, coarse grain.

High Contrast Copy (Tungsten 64) high contrast, panchromatic, extremely fine grain, extremely high resolving power.

For specialized film such as 103a-O and 103a-E write to Astronomy Aids, Eastman Kodak Co., Box 1004, Canoga Park, Calif., 91304. These films are particularly adapted to long exposures.

For useful information and details of films and developers write to Consumer Markets Division, Eastman Kodak Co., 343 State St., Rochester, N. Y., 14650.

KODAK FILMS – ROLL AND SHEET

	ROLL FILMS	ASA SPEED	35mm FILMS	ASA SPEED	SHEET FILMS	ASA SPEED
B&W	PANATOMIC-X (120 only)	40	PANATOMIC-X	32	PANATOMIC-X	64
	VERICHROME Pan	125	PLUS-X Pan	125	PLUS-X Pan (ESTAR Thick Base)	125
					SUPER-XX Pan	200
	TRI-X Pan	400	TRI-X Pan	400	Super Panchro-Press, Type B	250
	ROYAL-X Pan (120 only)	1250	High Contrast Copy	—		
					TRI-X Pan (ESTAR Thick Base)	320
			Infrared	—	ROYAL Pan	400
					RS Pan	650
					ROYAL-X Pan	1250
COLOR	KODACOLOR-X	64	KODACHROME II	25	EKTACHROME, Daylight	50
	EKTACHROME-X	64	KODACHROME-X	64	EKTACOLOR Professional, Type L	50
	EKTACHROME Professional (120 and 620 only)	50	KODACOLOR-X	64		
	High Speed EKTACHROME, Daylight (120 only)	160	EKTACHROME-X	64		
			High Speed EKTACHROME, Daylight	160		

(Reproduced, with permission, from Kodak pamphlet "Astrophotography with your Camera")

Chapter 18

FOR THE SOPHISTICATED SKYSHOOTER

THE PHOTOGRAPHS in this book, for the most part, have been taken with simple equipment using ordinary films. This equipment can be made or purchased by anyone at little expense. As you get better acquainted with skyshooting you may want to purchase more sophisticated equipment and films, thereby enabling you to probe deeper into the universe. Recent advances in photography and equipment have placed in the hands of the amateur instrumentation that is on a par with that of the professionals.

Barlow lenses, catadioptric telescopes, and finely machined accessories are available to the amateur. The Barlow lens will increase magnification. The catadioptric telescope is particularly useful because of its smallness and portability, yet is able to do fine photographic work.

One of the finest and most versatile of the small telescopes is the "Questar" (Questar Corp., New Hope, Pa. 18938). The optics are of the catadioptric type, which allows a full-sized 3.5-inch telescope of 7-foot focal length to be compressed by optical folding into a tube only 8 inches long, weighing only 7 pounds! Here is a unique and compact instrument for the sophisticated skyshooter. He no longer has to carry around a large and bulky piece of equipment.

One of the Questar's advantages is that it can be focused all the way down from infinity to 7 feet, thereby making it not only a celestial instrument of great power, but also a terrestrial one. The skyshooter often is interested in other things of nature. In addition to his work at night he may use his Questar during the day to photograph animals and birds.

It is easy to take pictures with the Questar. All you do is attach a 35mm single lens reflex camera body, without lens, just behind the control box. Questar becomes the lens. Check the focus in the SLR's finder, and expose. That's all!

The Questar is equivalent to a powerful telephoto lens. We have

included several photographs taken with this instrument. They tell more of its versatility than we could tell in an entire chapter. Since all skyshooters are lovers of nature, we have included the photograph of the bird to show what can be done with wildlife.

You can also get spectacular pictures of the sun or moon rising or setting among the trees, or above buildings. The longer the focal length the larger the sun or moon. But an ordinary telephoto attached to the lens of your camera is all that you need for this type of picture. A 135mm telephoto is the shortest lens that will give good results. With a lens of 400mm or longer the moon or sun becomes the main subject. With color film speed of ASA 32 an exposure of 1/25 second at $f/8$ is sufficient for the moon. But when the moon is on or near the horizon a longer exposure is necessary. One of the best times to take lunar pictures of this type is one or two days before the full moon, when it is above the horizon as the sun sets.

Another trick is to take a double exposure by shooting the foreground landscape at twilight. Then wait until the moon has risen and make a second exposure for the moon. Similar pictures of the sun can be made.

All cameras with focal plane shutters produce some vibration and those with return mirrors produce the most. This is nothing to worry about when taking pictures of landscapes and people; but when the camera is attached to the high power of telescopes you want to get rid of as much vibration as possible. This is even true of the telescope. It must have a good mounting and be stable. Vibration in the telescope will cause blurry images. Questar has given a great deal of study to this problem of vibration and they have found two cameras that are virtually free of vibration from recoil. They are the Pentacon and Nikon.

The Pentacon camera is a Zeiss product and is fitted with a self-timer that can release the mirror soon enough to avoid fully its recoil effect during exposure. The Nikon is so constructed that its shutter can be operated alone, with locked up mirror, when desired; and it was found to have the least recoil of any tested. Probably some of the other fine cameras will have this feature in the future. Vibration can be a disturbing factor when trying to do fine work, therefore it is desirable—in the camera and the telescope—to reduce vibration to a minimum.

Figure 60. Questar Fitted with Nikon F Camera, Close-Coupled
(Courtesy Questar Corporation)

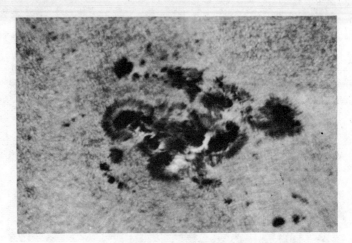

Figure 61. Sunspot Group Showing Tracery of "Bridges"
(Photo by Ralph Davis, Courtesy Questar Corporation)

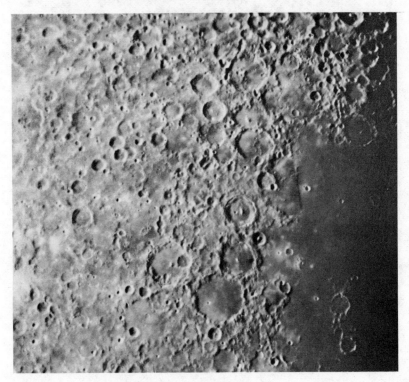

Figure 62. Surface of the Moon
This beautiful photograph shows the detail as seen by the Questar.
(Photo by Ralph Davis, Courtesy Questar Corporation)

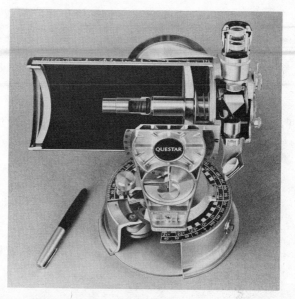

Figure 63. Cutaway View Showing the Internal
Construction of the Questar

(Courtesy Questar Corporation)

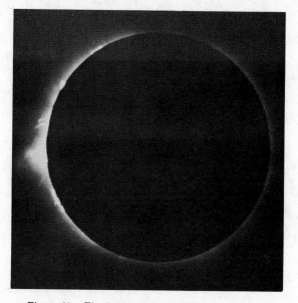

Figure 64. The Solar Eclipse at Lae, New Guinea,
February 5, 1962

(Photo by John W. Firor, Taken with a Questar, Courtesy High Altitude
Observatory, Boulder, Colorado)

Figure 65. Nature Photography
with the Questar

This picture shows the Questar in position to
take a picture of an Anhinga perched on a
branch some distance away. The inset shows
the bird as seen by the Questar. Taken on
35-mm Tri-X film at 1/250 second; the sprocket
holes are reproduced to show the size of the
image. (Photo by Ralph Davis, Courtesy
Questar Corporation)

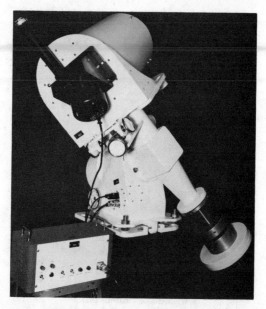

Figure 66. The 16-inch Telescope

This general purpose 16-inch reflector is fitted with complete
electronic settings and drive. A planet camera for use with a
projected image is shown. (Courtesy Optical Division,
Competition Associates)

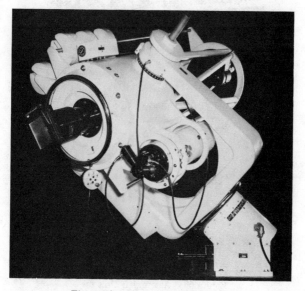

Figure 67. The 12-inch Telescope

12-inch telescope designed to accommodate about 200 lbs. of extra
equipment. It is small and compact. Solid state controls are at lower
left. It has Sychro (remote) readout for RA and Dec. There are no setting
circles. (Courtesy Optical Division, Competition Associates)

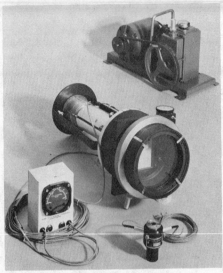

Figure 68. Equipment for Photography
with Cooled Emulsions

The disassembled unit is shown here. The camera
(center), the vacuum pump (top), and the tempera-
ture readout (bottom) are included. Liquid nitrogen
is used for cooling. (Courtesy Optical Division,
Competition Associates)

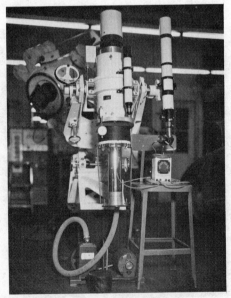

Figure 69. Assembled Unit for
Photography with Cooled Emulsions

Here the camera, vacuum pump, and temperature read-
out are in position at the cassegrainian focus of a 12-
inch telescope, which is designed to run on a 12 volt
DC, or 115 volt AC. (Courtesy Optical Division,
Competition Associates)

The amateur, in the past 20 years, has come a long way. Not only is his approach more sophisticated, but the same sophistication is reflected in the type of equipment he uses—and money is not always the criterion that guides his purchase. Also he has become interested in emulsions, such as: What effect does cooling the emulsion have? What effect does baking the emulsion have? In his experiments with emulsions he must have special equipment. Fortunately, the equipment is within his reach.

Such equipment is being produced by the Optical Division of Competition Associates (32-38 Boylston St., Cambridge, Mass. 02138). They have developed a camera to be used with a refractor, or at the Cassegrainian focus of a reflector, that provides for cooling of the plate. It seems that cooling the film increases the emulsion sensitivity. For example, tests show that Kodak Royal-X Pan Sheet Film has a sensitivity gain of about 10 times when cooled to $-50°C$, and exposed for 15 minutes. In other words, by the use of cooled emulsions an increase of as much as 2 magnitudes can be obtained.

Although this may seem technical and complicated, some amateurs are carrying out experiments in the cooling of and baking of emulsions. One amateur is working with baked film—baking for 96 hours at $49°C$ before exposure. Tri-X, Super Panchro Press, and Royal-X Pan are some of the general films used in this work.

A 2-magnitude increase was obtained by cooling High Speed Ektachrome from $9°C$ to $-78°C$; this also resulted in greater color balance. With Super Anscochrome Film, the color balance was found superior when cooled from normal temperatures to $-65°C$.

It is well established that cooling the emulsion increases the effective speed of the film or plate. We are referring here to the effect on ordinary commercial film, not spectroscopic and other special plates made especially for astronomical purposes.

Those who wish to investigate this field should refer to the magazine *Sky and Telescope*, where numerous articles have been published on the subject. Those of E. A. Harlan, March 1964; A. A. Hoag, December 1964; E. Kreimer, December 1965; and E. Kreimer, August 1966, will be found most helpful.

This can be an interesting field of experimentation for those with the money, instrumentation, and time to engage in it. Today, sophisticated equipment is not beyond the reach of the amateur.

Chapter 19

A DAY IN THE SUN

ALTHOUGH the night sky is a fascinating place to use either black and white, or color film, there is also much to be found during daylight—subjects that are more unusual, and require a sharp eye. Then too there are the more obvious, such as rainbows.

Rainbows are formed by light playing on drops of water. The colors are sometimes faint and at other times they may be fairly brilliant. They may be photographed in black and white, and in color. Try it with panchromatic film with a yellow filter at a speed of 1/10 second at $f/16$. In color it is best to use $\frac{1}{2}$ to 1 stop less than the normal stop; but it is possible to shoot the rainbow at the normal stop and still get color. For example, if your normal exposure calls for $f/8$, stop down 1 stop to $f/11$ for the rainbow.

From the ground a rainbow is always part of a circle, reaching a semicircle at sunset. But from an airplane it becomes a full circle (See Fig. 70). Sometimes the shadow of the plane will be found in the center (See Fig. 71). Whenever you are traveling by air, look for this phenomenon, and if you have your camera handy, try to photograph it.

Sometimes there is a secondary rainbow in conjunction with the primary rainbow, but usually it is very difficult to see. Rarely, the secondary bow may be almost as bright as the primary bow. The order of colors in a rainbow is red, orange, yellow, green, blue, violet —red being on the outside. The order of colors in the secondary bow is the reverse of that in the primary bow. The relative width and brightness of the different colors vary greatly.

Rainbows do not occur only in rain storms; they may also be seen elsewhere. Look for them at waterfalls, fountains, and other places where mist or droplets rise. Another phenomenon you might look for is the reflected rainbow on still water.

Another peculiar phenomenon arises in the rainbow at or near sunset. All the colors seem to fade, except the red.

Figure 70. Circular Rainbow on a Cloud
(M. W. Mayall)

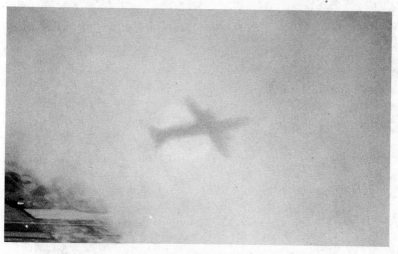

Figure 71. Shadow of an Airplane in a Circular Rainbow
(M. W. Mayall)

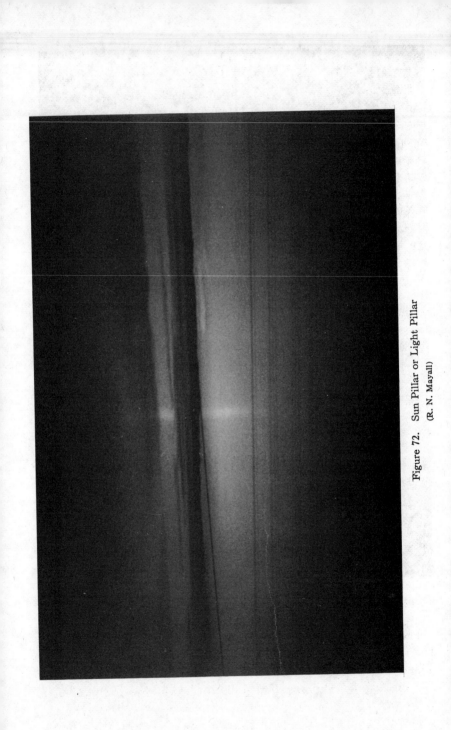

Figure 72. Sun Pillar or Light Pillar
(R. N. Mayall)

There are "fog bows" that may be observed in the fog, and "dew bows" that may be observed on a lawn, on a pond with an oily surface, on a lake, or on the sea early in the morning. There is also the moon rainbow that may be seen only when the moon is full and is visible in the part of the sky opposite the moon. Moon bows are seldom colored. They are not to be confused with haloes.

Just as we see haloes around the moon so too can we see haloes around the sun. When the sky becomes milky white, made opalescent by thin veils of clouds, the sun seems to shine through ground glass, and its outline is no longer sharp. Under such conditions you may see a bright ring around the sun, having a radius of about 22°. The best way to see it is to stand in the shade and block out the sun with your hand. This is only the small halo—other haloes are on a much larger scale having a radius of about 46°. They occur fairly often and are interesting to watch for and photograph.

Sometimes two spots or concentrations of light called "parhelia" or mock suns, commonly referred to as "sun dogs," appear on the small halo.

Another fascinating phenomenon is the light-pillar or sun-pillar (See Fig. 72). This vertical pilar of light occurs at the time of the rising or setting of the sun. It is colorless, but when the setting or rising sun is yellow, orange, or red, the pillar takes on the same color. Beautiful color pictures can be made of this without filter and no change in normal exposure.

From an airplane, another phenomenon may be observed—the sun reflected on a cloud. Also, if you are at sea or on top of a hill, you can observe, and maybe photograph, the "green flash" or "green ray" which occurs just as the upper edge of the sun slips below the horizon. And don't forget the clouds—thunderheads, cumulus, mammatocumulus, and so forth—for they make dramatic photographs. Tornadoes, cyclones, dust devils, and water spouts at sea—all make interesting and exciting subjects for your camera.

Try photographing the rising moon, if you have a telephoto lens. The moon rising through the trees, or seen against an interesting skyline can produce a spectacular effect, particularly at full moon. The sun may be similarly photographed, but *use great care and do not forget the neutral density filter.*

There are other natural phenomena to be observed such as distor-

tions of the sun and moon at sunrise and sunset, and moonrise and moonset. These distortions of the sun and moon are frequent and often fantastic.

A day in the sun can be an interesting and fruitful day for your camera. Remember, color film can be used as well as black and white. Then too, sometimes a photograph is enhanced if taken in black and white rather than in color.

APPENDIX

THE GREEK ALPHABET

You should become familiar with the letters of the Greek alphabet, because many of the stars on a star chart are identified by them.

Letter	Name	Letter	Name	Letter	Name
α	Alpha	ι	Iota	ρ or ϱ	Rho
β	Beta	κ	Kappa	σ or ς	Sigma
γ	Gamma	λ	Lambda	τ	Tau
δ	Delta	μ	Mu	υ	Upsilon
ε	Epsilon	ν	Nu	φ	Phi
ζ	Zeta	ξ	Xi	χ	Chi
η	Eta	ο	Omicron	ψ	Psi
θ	Theta	π or ϖ	Pi	ω	Omega

AMATEUR ASTRONOMICAL ORGANIZATIONS AND PLANETARIA

The great metropolitan areas and many other cities and towns have one or more amateur astronomical organizations of one kind or another. These are active groups with memberships totaling well up into the thousands. But there are equally as many persons, if not more, who are isolated and therefore cannot participate in the activities of a local group. For such persons there are national organizations whose meetings are less frequent (once or twice a year), but whose members enjoy as much cooperation and fraternal spirit as is found in local groups.

The American Meteor Society (AMS) 512 North Wynnewood Avenue, Narberth, Pennsylvania 19702 stresses visual and telescopic observations of meteors. New members who are willing to take an active part in a meteor program will be welcomed.

The Association of Lunar and Planetary Observers (ALPO), University Park, New Mexico 88001, is an informal group, international in scope, which studies the moon, planets, and so forth. Members make drawings and photographs. Section Recorders supervise

systematic work. Its magazine *The Strolling Astronomer* is a well-known source of information.

The American Association of Variable Star Observers (AAVSO), 187 Concord Avenue, Cambridge, Massachusetts 02138 has an international membership. It is the largest group of amateurs doing serious work. The members' observations of variable stars are processed and made available to astronomers throughout the world. The Association has supplied astronomers with more valuable data than any other single organization. It was founded in 1911. It provides the American Sunspot Numbers and operates a Solar Flare patrol; it has an active occultation division and a division in Photoelectric Photometry (PEP). It publishes a monthly Solar Bulletin, Quarterly Reports of variable star observations, Annual Predictions for maxima and minima of long period variables, and Information Sheets for Eclipsing Binaries, in addition to a Manual for Photoelectric Photometry and one for Observing Variable Stars. There is also a Nova Search division.

For those "down under" there is the Royal Astronomical Society of New Zealand (RASNZ) c/o Carter Observatory, P.O. Box 2909, Wellington C.1, New Zealand. This organization has sections that do variable star observing, telescope making, lunar and planetary observing, and computing.

A list of all local organizations would be too long and require constant change; therefore we omit them here. Wherever observatories or planetaria abound, there you will undoubtedly find an enthusiastic and active group of amateur astronomers. Information about local activities in your area usually can be obtained from the nearest observatory or planetarium. Also *Sky and Telescope* magazine each year publishes a list of all amateur groups and planetaria. We suggest you consult your library for copies of this magazine.

PLANETARIA

The United States is planetarium-minded. Today even small towns may have some sort of instrument. Those fortunate enough to live in or near the large cities will find well-equipped planetaria that sponsor amateur activities as part of their educational programs. Many of them have exhibition halls, and they set apart space for optical work-

shops where the amateur may grind a mirror, construct a telescope, and make exhibits. In addition there are other smaller ones that are satisfying a great need, such as the one in the Natural History Museum in Springfield, Massachusetts, and the numerous Spitz and Goto planetaria that are being erected by many cities, towns, and schools.

Canada is also becoming planetarium-minded. There are now large planetaria in Montreal and in Calgary, to be followed by Winnipeg, Toronto, and Vancouver. Other smaller ones will be built in Hamilton, Ontario, Halifax, Nova Scotia, and Edmonton, Alberta.

OBSERVATORIES

It may come as a surprise to many to learn there are more than a hundred active observatories in the United States. The *American Ephemeris and Nautical Almanac,* a yearly publication obtained from the Superintendent of Documents, Washington, D.C., lists observatories all over the world, and gives their latitude and longitude. Here you can find if there is an observatory near you. Then, too, there are many other observatories in colleges both large and small, and there are still others owned by amateurs that are well equipped and doing serious work.

We suggest you inquire at your local library as to whether or not there is an observatory near you.

Many amateurs have excellent observatories. Some use them for visual work, some for photographic work, and some serve their community. It was through the efforts of a group in Lima, Ohio that the Schoonover Observatory was erected complete with telescope, library, meeting room, and hall for public lectures. The Aldrich Astronomical Society of Worcester, Massachusetts has built a similar building in the country.

One of the more recent private observatories is the Ford Observatory on Mt. Peltier, near Los Angeles, California. It is equipped with an 18-inch telescope, photoelectric equipment and numerous other accessories. It has been designed to do special work, tied in with the professional astronomers and the American Association of Variable Star Observers.

The motto may be: If there isn't one near you—build it.

PRECESSION FOR FIFTY YEARS
TABLE IXa

North RA		0°	10°	20°	30°	40°	50°	55°	60°	65°	70°	75°	80°
h m	h m	m	m	m	m	m	m	m	m	m	m	m	m
6 0	6 0	+2.6	+2.8	+3.0	+3.2	+3.5	+3.9	+4.2	+4.5	+5.0	+5,6	+6.8	+8.9
6 30	5 30	2.6	2.8	3.0	3.2	3.5	3.9	4.2	4.5	4.9	5.6	6.8	8.8
7 0	5 0	2.6	2.8	3.0	3.2	3.5	3.8	4.1	4.4	4.9	5.6	6.6	8.7
7 30	4 30	2.6	2.8	2.9	3.1	3.4	3.8	4.0	4.3	4.8	5.4	6.4	8.4
8 0	4 0	2.6	2.8	2.9	3.1	3.4	3.7	3.9	4.2	4.7	5.2	6.2	8.0
8 30	3 30	2.6	2.7	2.9	3.1	3.3	3.6	3.8	4.1	4.5	5.0	5.9	7.6
9 0	3 0	2.6	2.7	2.8	3.0	3.3	3.6	3.8	3.9	4.3	4.8	5.5	7.1
9 30	2 30	2.6	2.6	2.8	3.0	3.2	3.5	3.7	3.8	4.0	4.5	5.1	6.5
10 0	2 0	2.6	2.6	2.8	2.9	3.1	3.3	3.5	3.6	3.8	4.2	4.7	5.8
10 30	1 30	2.6	2.6	2.7	2.9	2.9	3.1	3.2	3.3	3.5	3.8	4.2	5.0
11 0	1 0	2.6	2.6	2.7	2.8	2.8	2.9	3.0	3.1	3.2	3.4	3.7	4.2
11 30	0 30	2.6	2.6	2.7	2.7	2.7	2.8	2.8	2.8	2.9	3.0	3.1	3.4
12 0	0 0	2.6	2.6	2.6	2.6	2.6	2.6	2.6	2.6	2.6	2.6	2.6	2.6
12 30	23 30	2.6	2.6	2.6	2.5	2.5	2.4	2.4	2.3	2.3	2.2	2.1	1.8
13 0	23 0	2.6	2.6	2.5	2.4	2.4	2.3	2.2	2.1	2.0	1.8	1.5	0.9
13 30	22 30	2.6	2.5	2.4	2.3	2.3	2.1	2.0	1.9	1.7	1.4	1.0	+0.1
14 0	22 0	2.6	2.5	2.4	2.3	2.1	1.9	1.8	1.6	1.4	1.0	0.5	−0.6
14 30	21 30	2.6	2.5	2.3	2.2	2.0	1.8	1.6	1.4	1.1	0.7	+0.1	1.3
15 0	21 0	2.6	2.5	2.3	2.1	1.9	1.7	1.4	1.2	0.9	0.4	−0.3	1.9
15 30	20 30	2.6	2.4	2.3	2.1	1.9	1.5	1.2	1.1	0.7	+0.1	0.7	2.4
16 0	20 0	2.6	2.4	2.2	2.0	1.8	1.4	1.2	0.9	0.5	−0.1	1.0	2.9
16 30	19 30	2.6	2.4	2.2	2.0	1.8	1.3	1.2	0.8	0.4	0.2	1.2	3.3
17 0	19 0	2.6	2.4	2.2	2.0	1.7	1.3	1.1	0.8	0.3	0.3	1.4	3.5
17 30	18 30	2.6	2.4	2.2	1.9	1.7	1.3	1.0	0.7	0.2	0.4	1.5	3.7
18 0	18 0	+2.6	+2.4	+2.2	+1.9	+1.6	+1.3	+1.0	+0.7	+0.2	−0.5	−1.6	−3.8
										+	−		

For precession in RA, use left-hand hours in Table IXa for north declination; use right-hand hours for south declination.

For precession in declination, use Table IXb.

PRECESSION FOR FIFTY YEARS

TABLE IXa (*Continued*)

82°	84°	86°	87°	88°	89°	South RA	
m	*m*	*m*	*m*	*m*	*m*	*h m*	*h m*
+10.5	+13.2	+18.5	+23.8	+34.5	+66.4	18 0	18 0
10.4	13.1	18.3	23.6	34.2	65.9	17 30	18 30
10.3	12.9	17.9	23.1	33.3	64.3	17 0	19 0
9.9	12.5	17.3	22.3	32.0	61.6	16 30	19 30
9.4	11.8	16.3	21.3	30.2	57.8	16 0	20 0
8.9	11.0	15.2	19.7	27.9	53.1	15 30	20 30
8.2	10.1	13.8	17.6	25.1	47.6	15 0	21 0
7.4	9.1	12.3	15.4	22.0	41.4	14 30	21 30
6.6	7.9	10.6	13.3	18.5	34.4	14 0	22 0
5.8	6.6	8.7	10.8	14.8	27.0	13 30	22 30
4.7	5.3	6.7	8.1	10.8	19.1	13 0	23 0
3.6	4.0	4.7	5.3	6.8	10.9	12 30	23 30
2.6	2.6	2.6	+ 2.6	+ 2.6	+ 2.6	12 0	24 0
1.6	+ 1.2	+ 0.5	— 0.2	— 1.6	— 5.9	11 30	0 30
+ 0.5	— 0.2	— 1.5	2.9	5.7	13.9	11 0	1 0
— 0.5	1.4	3.5	5.6	9.6	21.8	10 30	1 30
1.4	2.8	5.3	8.1	13.3	29.3	10 0	2 0
2.2	3.9	7.1	10.4	16.8	36.3	9 30	2 30
3.0	4.9	8.7	12.4	19.9	42.6	9 0	3 0
3.7	5.8	10.1	14.3	22.8	48.0	8 30	3 30
4.3	6.6	11.2	15.8	25.0	52.6	8 0	4 0
4.8	7.2	12.1	17.1	26.8	56.3	7 30	4 30
5.1	7.6	12.8	17.9	28.2	59.0	7 0	5 0
5.3	7.9	13.2	18.3	29.0	60.6	6 30	5 30
— 5.4	— 8.0	--13.3	—18.7	--29.3	—61.2	6 0	6 00

TABLE IXb

Declination RA		
h m	*h m*	
0 0	24 0	+16.7
0 30	23 30	16.6
1 0	23 0	16.2
1 30	22 30	15.4
2 0	22 0	14.5
2 30	21 30	13.3
3 0	21 0	12.0
3 30	20 30	10.2
4 0	20 0	8.3
4 30	19 30	6.4
5 0	19 0	4.3
5 30	18 30	+ 2.2
6 0	18	0.0
6 30	17 30	— 2.2
7	17	4.3
7 30	16 30	6.4
8 0	16 0	8.3
8 30	15 30	10.2
9 0	15 0	12.0
9 30	14 30	13.3
10 0	14 0	14.5
10 30	13 30	15.4
11 0	13 0	16.2
11 30	12 30	16.6
12 0	12 0	— 16.7

LIST OF OBJECTS

The objects given in the following lists have been selected for their interest, and all positions have been reduced to the Epoch 1950.

TABLE X

LIST OF OBJECTS—VARIABLE STARS

Name	R.A. (1950)	Dec. (1950)	Magnitude Max.	Magnitude Min.	Period (Days)	Type (See definitions below)
R Andromedae	00ʰ21.4ᵐ	+38°17′	5.0	15.3	409	Long period
T Aquarii	20 47.3	—05 20	6.7	14.0	202	Long period
η Aquilae	19 49.9	+00 52	3.7	4.4	7.2	Cepheid
TU Cassiopeiae ...	00 23.6	+54 36	7.5	8.7	2.1	Cepheid
T Centauri	13 38.9	—33 21	5.2	10.0	90.7	Long period
δ Cephei	22 27.3	+58 10	3.8	4.6	5.4	Cepheid
U Cephei	00 57.6	+81 37	6.7	9.8	2.5	Eclipsing
o Ceti (Mira)	02 16.8	—03 12	2.0	10.1	331.5	Long period
RR Ceti	01 29.6	+01 05	9.2	10.3	0.6	Cluster
R Coronae Borealis	15 46.5	+28 18	5.8	13.8	Irregular
χ Cygni	19 48.6	+32 47	2.3	14.3	406.7	Long period
W Cygni	21 34.1	+45 09	5.0	7.6	130.6	Semiregular
SS Cygni	21 40.7	+43 21	8.2	12.1	Irregular
XX Cygni	20 02.3	+58 49	11.4	12.5	0.1	Cluster
η Geminorum	06 11.9	+22 32	3.1	3.9	234	Long period
R Geminorum	07 04.3	+22 46	5.9	14.1	370.1	Long period
U Geminorum	07 52.1	+22 08	8.8	13.8	Irregular
α Herculis	17 12.3	+14 27	3.0	4.0	Irregular
VX Herculis	16 28.4	+18 28	9.6	10.8	0.5	Cluster
R Hydrae	13 27.0	—23 01	3.5	10.9	387	Long period
R Leonis	09 44.9	+11 39	4.4	11.6	313.1	Long period
RR Leonis	10 04.9	+24 14	10.6	11.5	0.5	Cluster
U Orionis	05 52.8	+20 10	5.2	12.9	373.2	Long period
β Persei (Algol) ..	03 05.0	+40 45	2.3	3.5	2.9	Eclipsing
R Sagittae	20 11.3	+16 34	9.0	11.5	70.8	Semiregular
R Scuti	18 44.8	—05 46	5.0	8.4	144.0	Semiregular
RV Tauri	04 44.0	+26 05	9.8	13.3	78.6	Semiregular
SU Tauri	05 46.1	+19 03	9.5	16.0	Irregular

Cluster Type: Continuous variation in periods of less than one day.
Cepheid Type: Continuous variation in periods from one to about 100 days.
Eclipsing Type: Variation caused by two revolving stars alternately eclipsing each other.
Long Period Type: Period usually greater than 100 days.

TABLE XI

LIST OF OBJECTS—CLUSTERS

Name	R.A. (1950)	Dec. (1950)	Description
47 Toucani	00h22.8m	−72°14′	Globular. Visible to naked eye
h and χ Persei	02 17.4	+56 56	A double cluster
M45 (The Pleiades)	03 44.5	+23 58	Open. 6 or 7 bright stars visible to naked eye and surrounded with nebulosity
M37 Aurigae	05 49.1	+32 38	Open. Several hundred stars
M35 Geminorum ...	06 10.1	+24 21	Open. Visible to naked eye
2 Monocerotis	06 29.6	+04 54	Beautiful cluster of bright stars
M50 Monocerotis ...	07 00.6	−08 16	Open. Bright
M44 Cancri	08 37.2	+20 10	Open. "Praesepe" (The Beehive). Visible to the naked eye
265Δ Carinae	09 10.6	−64 37	Globular. Large. Stars 13-15 magnitude
κ Crucis	12 51.2	−60 05	Open. "Jewel Box." Bright stars of various colors
ω Centauri	13 23.8	−47 03	Globular. Large
M13 Herculis	16 39.9	+36 33	Globular. A fine example. Visible to naked eye
M19 Ophiuchi	17 00.1	−26 02	Globular
M23 Ophiuchi	17 53.9	+19 00	Open
M22 Sagittarii	18 32.8	−23 57	Globular
M11 Aquilae	18 48.2	−06 21	Open. Barely visible to naked eye
M39 Cygni	21 30.4	+48 13	Open
M2 Aquarii	21 30.9	−01 03	Globular
75 Lacertae	22 13.2	+49 39	Good field
30 Cassiopeiae	23 54.5	+56 25	Good field

TABLE XII

LIST OF OBJECTS—NEBULAE

(See also Rich Star Fields)

Name	R.A. (1950)	Dec. (1950)	Description
M45 (The Pleiades)	03h44.5m	+23°58′	Naked eye cluster of 6 or 7 stars surrounded by nebulosity
M1 Tauri	05 31.5	+22 03	Diffuse. "The Crab Nebula"
M42 Orionis	05 32.9	—05 21	Diffuse. "Great Nebula in Orion." Bright. May be seen in 2½-inch telescope
30 Doradus	05 38.8	—69 09	Diffuse. Form of loop. Large and bright
27 Hydrae	10 22.4	—18 24	Planetary. Elliptical shape
M97 Ursae Majoris .	11 11.9	+55 18	Planetary. "The Owl Nebula"
37 Draconis	17 59.0	+66 35	Planetary. Elliptical. Bluish
M20 Sagittarii	17 59.3	—23 02	Diffuse. "Trifid Nebula"
M8 Sagittarii	18 00.7	—24 23	"Lagoon Nebula"
M17 Sagittarii	18 17.9	—16 12	Diffuse. "Horseshoe Nebula"
M57 Lyrae	18 51.6	+32 58	Planetary. "Ring Nebula." Form may be seen in 2½-inch telescope
M27 Vulpeculae	19 55.5	+22 35	Planetary. "Dumb-bell Nebula"
Cygnus	20 53	+43 40	Diffuse. "North American Nebula"
Cygnus	20 53	+31 24	Diffuse. "Lacework Nebula"

TABLE XIII

LIST OF OBJECTS—ISLAND UNIVERSES

(Extragalactic Nebulae)

Name	R.A. (1950)	Dec. (1950)	Description
M31 Andromedae ...	00h40.0m	+41°00′	Spiral. "Great Nebula." Large and bright
M33 Triangulum ...	01 31.0	+30 24	Spiral
M51 Canum Venati-corum	13 27.8	+47 27	Spiral. "Whirlpool Nebula." Large
NGC 55 Sculptoris .	00 12.5	—39 30	Edgewise spiral
NGC 598 Androme-dae	00 31.1	+30 24	Large faint spiral with central condensation
NGC 3031 Draconis .	09 51.5	+69 18	Elliptical spiral with bright center
NGC 4594 Corvi ...	12 37.3	—11 21	Spiral, nearly edgewise
NGC 4649 Virginis .	12 41.1	+11 49	Faint double spiral
NGC 5128 Centauri .	13 22.4	—42 45	Large, bright oval
NGC 5194, 5 Canum Venaticorum	13 27.8	+47 27	Great double spiral

TABLE XIV

LIST OF OBJECTS—RICH STAR FIELDS

Region	R.A. (1950)	Dec. (1950)	Description
Taurus	04h14m	+28°00′	Prominent dark streaks
π & δ Scorpii	15 46	—25 00	Diffuse nebulosity evident
ν Scorpii	16 06	—19 13	Large areas of diffuse and dark nebulosity
ρ Ophiuchi	16 18	—23 18	Five patches diffuse nebulosity and many dark streaks. Also a globular cluster
Ophiuchus	16 44	—22 30	Dark lanes in very rich field
S Nebula	17 16	—23 30	Small, but prominent dark nebulosity in form of S
Sagittarius	17 55	—29 00	"Star Cloud" of Sagittarius
M8 Sagittarii	17 56	—24 23	Diffuse nebula
Scutum	18 12	—15 00	Part of star cloud with M16 and M17 (diffuse nebulae)
Scutum	18 45	—07 00	"The Great Star Cloud" in Scutum
North American Nebula	20 53	+43 40	Diffuse and dark nebulosity outlines North and Central America

TABLE XV

100 Selected Stars

Positions for Epoch 1950—Magnitudes, Visual and Photographic—Spectral Classes

Name and Constellation	R.A.	Dec.	M_{vis}	M_{pg}	Sp.
— Cephei	00^h06^m	$+79°26'$	6.2	6.3	A3
— Piscium	00 33	+12 46	6.4	6.8	F5
— Andromedae	00 34	+44 13	5.4	6.6	K5
— Ceti	00 34	−15 15	6.6	7.6	K0
— Andromedae	01 31	+36 59	5.8	5.8	B9
— Ceti	01 31	−07 17	5.9	6.4	G0
τ Sculptoris	01 34	−30 10	5.7	6.0	F0
— Cassiopeiae	01 35	+57 43	5.7	6.7	K0
α Ursae Minoris	01 49	+89 02	2.1	2.6	F8
29 Arietis	02 30	+14 49	6.1	6.5	F5
σ Ceti	02 30	−15 28	4.8	5.2	F5
— Persei	02 40	+48 03	6.6	7.3	G5
— Cassiopeiae	03 06	+74 12	4.9	5.0	A2
— Fornacis	03 32	−31 15	6.2	6.6	F5
10 Tauri	03 34	+00 15	4.4	5.2	G5
— Camelopardalis	03 38	+63 03	5.3	6.7	M0
11 Tauri	03 38	+25 10	6.2	6.2	A0
57 Persei	04 30	+42 58	6.1	6.4	F0
89 Tauri	04 35	+15 56	5.8	6.1	F0
53 Eridani	04 36	−14 24	4.0	5.0	K0
— Columbae	05 33	−33 07	5.7	6.7	K0
— Aurigae	05 34	+33 32	6.4	7.4	K0
ϵ Orionis	05 34	−01 14	1.8	1.5	B0
— Camelopardalis	05 37	+65 40	5.8	6.8	K0
— Camelopardalis	05 58	+75 35	6.5	7.7	K5
μ Canis Majoris	06 34	−19 13	4.1	5.1	K0
γ Geminorum	06 35	+16 27	1.9	1.9	A0
ψ^2 Aurigae	06 36	+42 32	5.1	5.9	G5
51 Cephei	07 18	+87 08	5.3	6.6	M0
9 Canis Minoris	07 32	+03 29	5.8	5.8	A0
υ Geminorum	07 33	+27 01	4.2	5.4	K5
ρ Puppis	07 33	−28 16	4.6	4.5	B8
23 Lyncis	07 37	+57 12	6.2	7.2	K0
— Cancri	08 33	+15 29	6.3	6.4	A5
6 Hydrae	08 38	−12 18	5.2	6.2	K2
— Lyncis	08 40	+47 05	6.2	7.0	G5
— Ursae Minoris	08 46	+88 46	7.0	7.0	A0
— Ursae Majoris	09 11	+73 09	5.9	6.0	A2
ζ^2 Antliae	09 29	−31 39	6.0	6.2	F0
— Leonis	09 34	+31 23	5.7	7.1	M0
2 Sextantis	09 36	+04 53	4.8	5.8	K0
— Ursae Majoris	09 38	+69 28	5.7	6.7	K0
30 Camelopardalis	10 25	+82 49	5.3	5.7	F2
— Ursae Majoris	10 30	+40 41	4.8	5.0	A5
46 Leonis	10 30	+14 24	5.7	7.1	M0
ϕ Hydrae	10 36	−16 37	5.1	6.1	K0
— Ursae Majoris	11 30	+61 22	5.5	5.9	F5
18 Hydrae	11 30	−30 49	5.2	6.6	M0
— Leonis	11 34	+28 03	5.8	5.9	A3
υ Leonis	11 34	−00 33	4.5	5.5	K0

TABLE XV (*Continued*)

100 SELECTED STARS

Positions for Epoch 1950—Magnitudes, Visual and Photographic—Spectral Classes

Name and Constellation	R.A.	Dec.	M_{vis}	M_{pg}	Sp.
— Draconis	12h03m	+77°11′	6.0	7.0	K0
η Corvi	12 30	−15 55	4.4	4.7	F0
8 Canum Venaticorum	12 31	+41 38	4.3	4.9	G0
25 Comae Berenices	12 34	+17 22	5.8	6.8	K2
81 Ursae Majoris	13 32	+55 36	5.5	5.5	A0
ζ Virginis	13 32	−00 20	3.4	3.5	A2
— Hydrae	13 34	−26 14	5.5	5.6	A2
— Comae Berenices	13 35	+24 52	5.9	7.2	M0
— Librae	14 34	−12 06	6.2	6.7	F8
— Boötis	14 36	+43 51	5.9	6.9	K0
— Boötis	14 36	+18 31	6.0	7.0	K0
9 Ursae Minoris	15 00	+71 59	6.7	7.2	G0
— Draconis	15 28	+62 16	6.5	7.7	K5
θ Coronae Borealis	15 31	+31 32	4.2	4.0	B5
— Lupi	15 33	−32 56	6.3	6.3	B9
14 Serpentis	15 34	−00 24	6.5	6.9	F5
φ Ophiuchi	16 28	−16 30	4.4	5.4	K0
σ Herculis	16 32	+42 32	4.2	4.2	A0
— Herculis	16 34	+15 36	6.3	6.3	A0
ε Ursae Minoris	16 51	+82 07	4.4	5.2	G5
— Ophiuchi	17 29	+02 46	5.6	6.2	G0
— Draconis	17 30	+11 58	6.5	7.6	K2
— Herculis	17 35	+30 49	5.8	5.8	A2
— Scorpii	17 40	−33 02	6.5	7.8	M0
δ Ursae Minoris	17 48	+86 37	4.4	4.4	A0
— Ursae Minoris	17 56	+75 11	6.4	7.4	K0
λ Ursae Minoris	18 21	+89 03	6.6	8.0	M3
— Scuti	18 31	−14 54	5.7	5.7	A0
— Herculis	18 34	+16 56	6.2	6.7	G0
— Lyrae	18 35	+43 11	6.3	6.4	A5
— Draconis	19 32	+60 03	6.4	7.6	K5
51 Sagittarii	19 33	−24 50	5.7	5.8	A3
ι Aquilae	19 34	−01 24	4.3	4.2	B5
— Cygni	19 35	+29 13	6.3	6.1	B5
— Cygni	20 31	+43 01	6.4	6.2	B3
η Delphini	20 32	+12 51	5.2	5.3	A2
— Capricorni	20 33	−16 42	6.2	6.3	A5
— Cephei	20 55	+75 44	6.2	7.0	G5
— Cephei	21 30	+60 14	5.5	5.3	B0
— Piscis Austrini	21 32	−29 55	6.6	6.5	B8
— Cygni	21 34	+29 50	6.5	7.5	K0
— Aquarii	21 35	−00 37	6.3	6.3	A2
56 Aquarii	22 28	−14 51	6.4	6.4	A0
— Pegasi	22 35	+12 19	6.5	7.7	K5
— Lacertae	22 36	+44 55	6.4	7.0	F8
— Cephei	23 28	+87 02	5.6	5.9	F0
— Cassiopeiae	23 29	+58 53	6.8	7.8	K0
— Pegasi	23 34	+32 38	6.3	6.8	F5
16 Piscium	23 34	+01 49	5.6	6.1	F5
— Sculptoris	23 34	−32 09	6.5	7.5	K0

CONSTELLATIONS

There are 88 constellations in the sky—each has an astronomical name and a common name, just as the plants and flowers in your garden have botanical and common names. When the astronomer speaks of a certain object he says, for example, "Beta Lyrae" not "Beta Lyra." In other words, when he speaks of the constellation he would say "Lyra," but when he couples it with the identifying letter or number of a particular object he then reverts to the Latin genitive case of the constellation name, thus: "Beta Lyrae," which can be translated as "Beta of the constellation Lyra."

In 1922, the International Astronomical Union adopted the standard list of three-letter abbreviations we give here.

Sometime you may want to know whether a certain constellation is high up in the sky. For that reason we have given, in the last column, the approximate date when (in the northern hemisphere) each constellation will be overhead or due south, early in the evening. The zodiacal constellations are preceded by an asterisk.

TABLE XVI

LIST OF CONSTELLATIONS

Astronomical Name	Common Name	Genitive Case	Abbreviation	Approx. Date on Meridian
Andromeda	Andromeda	Andromedae	And	Nov. 10
Antlia	The Pump, or the Air Pump	Antliae	Ant	Apr. 5
Apus	The Bird of Paradise	Apodis	Aps	June 30
* Aquarius	The Waterbearer	Aquarii	Aqr	Oct. 10
Aquila	The Eagle	Aquilae	Aql	Aug. 30
Ara	The Altar	Arae	Ara	July 20
* Aries	The Ram	Arietis	Ari	Dec. 10
Auriga	The Charioteer	Aurigae	Aur	Jan. 30
Boötes	Boötes, or the Herdsman	Boötis	Boo	June 15
Caelum	The Burin, or Graving-tool	Caeli	Cae	Jan. 15
Camelopardalis .	The Giraffe	Camelopardalis	Cam	Feb. 1
* Cancer	The Crab	Cancri	Cnc	Mar. 15
Canes Venatici .	The Hunting Dogs	Canum Venaticorum	CVn	May 20
Canis Major ...	The Great Dog	Canis Majoris	CMa	Feb. 15
Canis Minor ...	The Little Dog	Canis Minoris	CMi	Mar. 1
* Capricornus ..	The Goat, or the Sea Goat	Capricorni	Cap	Sept. 20
Carina	The Keel (of the ship Argo, which is no longer a constellation)	Carinae	Car	Mar. 15

TABLE XVI (*Continued*)

LIST OF CONSTELLATIONS

Astronomical Name	Common Name	Genitive Case	Abbreviation	Approx. Date on Meridian
Cassiopeia	Cassiopeia	Cassiopeiae	Cas	Nov. 20
Centaurus	The Centaur	Centauri	Cen	May 20
Cepheus	Cepheus, or the Monarch	Cephei	Cep	Oct. 15
Cetus	The Whale	Ceti	Cet	Nov. 30
Chamaeleon ...	Chamaeleon	Chamaeleontis	Cha	Apr. 15
Circinus	The Compasses	Circini	Cir	June 15
Columba	The Dove	Columbae	Col	Jan. 30
Coma Berenices.	Berenice's Hair	Comae Berenices	Com	May 15
Corona Australis	Southern Crown	Coronae Australis	CrA	Aug. 15
Corona Borealis.	Northern Crown	Coronae Borealis	CrB	June 30
Corvus	The Crow, or The Raven	Corvi	Crv	May 10
Crater	Crater, or the Cup	Crateris	Crt	Apr. 25
Crux	The Cross	Crucis	Cru	May 10
Cygnus	The Swan	Cygni	Cyg	Sept. 10
Delphinus	The Dolphin	Delphini	Del	Sept. 15
Dorado	The Goldfish	Doradus	Dor	Jan. 20
Draco	The Dragon	Draconis	Dra	July 20
Equuleus	The Colt, or Little Horse	Equulei	Equ	Sept. 20
Eridanus	Eridanus, or the River	Eridani	Eri	Jan. 5
Fornax	The Furnace	Fornacis	For	Dec. 15
* Gemini	The Twins	Geminorum	Gem	Feb. 20
Grus	The Crane	Gruis	Gru	Oct. 10
Hercules	Hercules	Herculis	Her	July 25
Horologium ...	The Clock	Horologii	Hor	Dec. 25
Hydra	The Sea Serpent	Hydrae	Hya	Apr. 20
Hydrus	Hydrus	Hydri	Hyi	Dec. 10
Indus	The Indian	Indi	Ind	Sept. 25
Lacerta	The Lizard	Lacertae	Lac	Oct. 10
* Leo	The Lion	Leonis	Leo	Apr. 10
Leo Minor	The Little Lion	Leonis Minoris	LMi	Apr. 10
Lepus	The Hare	Leporis	Lep	Jan. 25
* Libra	The Balance, or The Scales	Librae	Lib	June 20
Lupus	The Wolf	Lupi	Lup	June 20
Lynx	The Lynx	Lyncis	Lyn	Mar. 5
Lyra	The Lyre	Lyrae	Lyr	Aug. 15
Mensa	The Table Mountain	Mensae	Men	Jan. 30
Microscopium ..	The Microscope	Microscopii	Mic	Sept. 20
Monoceros	The Unicorn	Monocerotis	Mon	Feb. 20
Musca	The Fly	Muscae	Mus	May 10
Norma	The Level	Normae	Nor	July 5
Octans	The Octant	Octantis	Oct	Sept. 20

TABLE XVI (*Continued*)

List of Constellations

Astronomical Name	Common Name	Genitive Case	Abbre-viation	Approx. Date on Meridian
Ophiuchus	Ophiuchus, or the Serpent Bearer	Ophiuchi	Oph	July 25
Orion	Orion	Orionis	Ori	Jan. 25
Pavo	The Peacock	Pavonis	Pav	Aug. 25
Pegasus	Pegasus, or the Flying Horse	Pegasi	Peg	Oct. 20
Perseus	Perseus	Persei	Per	Dec. 25
Phoenix	The Phoenix	Phoenicis	Phe	Nov. 20
Pictor	The Painter, or the Easel	Pictoris	Pic	Jan. 20
* Pisces	The Fishes	Piscium	Psc	Nov. 10
Piscis **Austrinus**	The Southern Fish	Piscis Austrini	PsA	Oct. 10
Puppis	The Stern (of the ship Argo, which is no longer a constellation)	Puppis	Pup	Feb. 25
Pyxis·	The Compass	Pyxidis	Pyx	Mar. 15
Reticulum	The Net	Reticuli	Ret	Dec. 30
Sagitta	The Arrow	Sagittae	Sge	Aug. 30
* Sagittarius ...	The Archer	Sagittarii	Sgr	Aug. 20
* Scorpius	The Scorpion	Scorpii	Sco	July 20
Sculptor	Sculptor	Sculptoris	Scl	Nov. 10
Scutum	The Shield	Scuti	Sct	Aug. 15
Serpens (Caput) (Cauda)	The Serpent (Head) (Tail)	Serpentis	Ser	June 30 Aug. 5
Sextans	The Sextant	Sextantis	Sex	Apr. 5
* Taurus	The Bull	Tauri	Tau	Jan. 15
Telescopium ...	The Telescope	Telescopii	Tel	Aug. 25
Triangulum	The Triangle	Trianguli	Tri	Dec. 5
Triangulum Australe	The Southern Triangle	Trianguli Australis	TrA	July 5
Tucana	The Toucan	Tucanae	Tuc	Nov. 5
Ursa Major ...	The Great Bear, or The Big Dipper	Ursae Majoris	UMa	Apr. 20
Ursa Minor ...	The Little Bear, or The Little Dipper	Ursae Minoris	UMi	June 25
Vela	The Sails (of the ship Argo, which is no longer a constellation)	Velorum	Vel	Mar. 25
* Virgo	The Virgin	Virginis	Vir	May 25
Volans	The Flying Fish	Volantis	Vol	Mar. 1
Vulpecula	The Fox	Vulpeculae	Vul	Sept. 10

TABLE XVII

Conversion of Time to Arc

m	0^h	1^h	2^h	3^h	4^h	5^h
0	0°00′	15°00′	30°00′	45°00′	60°00′	75°00′
1	0 15	15 15	30 15	45 15	60 15	75 15
2	0 30	15 30	30 30	45 30	60 30	75 30
3	0 45	15 45	30 45	45 45	60 45	75 45
4	1 00	16 00	31 00	46 00	61 00	76 00
5	1 15	16 15	31 15	46 15	61 15	76 15
6	1 30	16 30	31 30	46 30	61 30	76 30
7	1 45	16 45	31 45	46 45	61 45	76 45
8	2 00	17 00	32 00	47 00	62 00	77 00
9	2 15	17 15	32 15	47 15	62 15	77 15
10	2 30	17 30	32 30	47 30	62 30	77 30
11	2 45	17 45	32 45	47 45	62 45	77 45
12	3 00	18 00	33 00	48 00	63 00	78 00
13	3 15	18 15	33 15	48 15	63 15	78 15
14	3 30	18 30	33 30	48 30	63 30	78 30
15	3 45	18 45	33 45	48 45	63 45	78 45
16	4 00	19 00	34 00	49 00	64 00	79 00
17	4 15	19 15	34 15	49 15	64 15	79 15
18	4 30	19 30	34 30	49 30	64 30	79 30
19	4 45	19 45	34 45	49 45	64 45	79 45
20	5 00	20 00	35 00	50 00	65 00	80 00
21	5 15	20 15	35 15	50 15	65 15	80 15
22	5 30	20 30	35 30	50 30	65 30	80 30
23	5 45	20 45	35 45	50 45	65 45	80 45
24	6 00	21 00	36 00	51 00	66 00	81 00
25	6 15	21 15	36 15	51 15	66 15	81 15
26	6 30	21 30	36 30	51 30	66 30	81 30
27	6 45	21 45	36 45	51 45	66 45	81 45
28	7 00	22 00	37 00	52 00	67 00	82 00
29	7 15	22 15	37 15	52 15	67 15	82 15
30	7 30	22 30	37 30	52 30	67 30	82 30
31	7 45	22 45	37 45	52 45	67 45	82 45
32	8 00	23 00	38 00	53 00	68 00	83 00
33	8 15	23 15	38 15	53 15	68 15	83 15
34	8 30	23 30	38 30	53 30	68 30	83 30
35	8 45	23 45	38 45	53 45	68 45	83 45
36	9 00	24 00	39 00	54 00	69 00	84 00
37	9 15	24 15	39 15	54 15	69 15	84 15
38	9 30	24 30	39 30	54 30	69 30	84 30
39	9 45	24 45	39 45	54 45	69 45	84 45
40	10 00	25 00	40 00	55 00	70 00	85 00
41	10 15	25 15	40 15	55 15	70 15	85 15
42	10 30	25 30	40 30	55 30	70 30	85 30
43	10 45	25 45	40 45	55 45	70 45	85 45
44	11 00	26 00	41 00	56 00	71 00	86 00
45	11 15	26 15	41 15	56 15	71 15	86 15
46	11 30	26 30	41 30	56 30	71 30	86 30
47	11 45	26 45	41 45	56 45	71 45	86 45
48	12 00	27 00	42 00	57 00	72 00	87 00
49	12 15	27 15	42 15	57 15	72 15	87 15
50	12 30	27 30	42 30	57 30	72 30	87 30
51	12 45	27 45	42 45	57 45	72 45	87 45
52	13 00	28 00	43 00	58 00	73 00	88 00
53	13 15	28 15	43 15	58 15	73 15	88 15
54	13 30	28 30	43 30	58 30	73 30	88 30
55	13 45	28 45	43 45	58 45	73 45	88 45
56	14 00	29 00	44 00	59 00	74 00	89 00
57	14 15	29 15	44 15	59 15	74 15	89 15
58	14 30	29 30	44 30	59 30	74 30	89 30
59	14 45	29 45	44 45	59 45	74 45	89 45

Seconds

0^s	$0′\,00″$	0.00^s	$0.00″$	0.50^s	$7.50″$
0	0′00″	0.00	0.00	0.50	7.50
1	0 15	.01	0.15	.51	7.65
2	0 30	.02	0.30	.52	7.80
3	0 45	.03	0.45	.53	7.95
4	1 00	.04	0.60	.54	8.10
5	1 15	0.05	0.75	0.55	8.25
6	1 30	.06	0.90	.56	8.40
7	1 45	.07	1.05	.57	8.55
8	2 00	.08	1.20	.58	8.70
9	2 15	.09	1.35	.59	8.85
10	2 30	0.10	1.50	0.60	9.00
11	2 45	.11	1.65	.61	9.15
12	3 00	.12	1.80	.62	9.30
13	3 15	.13	1.95	.63	9.45
14	3 30	.14	2.10	.64	9.60
15	3 45	0.15	2.25	0.65	9.75
16	4 00	.16	2.40	.66	9.90
17	4 15	.17	2.55	.67	10.05
18	4 30	.18	2.70	.68	10.20
19	4 45	.19	2.85	.69	10.35
20	5 00	0.20	3.00	0.70	10.50
21	5 15	.21	3.15	.71	10.65
22	5 30	.22	3.30	.72	10.80
23	5 45	.23	3.45	.73	10.95
24	6 00	.24	3.60	.74	11.10
25	6 15	0.25	3.75	0.75	11.25
26	6 30	.26	3.90	.76	11.40
27	6 45	.27	4.05	.77	11.55
28	7 00	.28	4.20	.78	11.70
29	7 15	.29	4.35	.79	11.85
30	7 30	0.30	4.50	0.80	12.00
31	7 45	.31	4.65	.81	12.15
32	8 00	.32	4.80	.82	12.30
33	8 15	.33	4.95	.83	12.45
34	8 30	.34	5.10	.84	12.60
35	8 45	0.35	5.25	0.85	12.75
36	9 00	.36	5.40	.86	12.90
37	9 15	.37	5.55	.87	13.05
38	9 30	.38	5.70	.88	13.20
39	9 45	.39	5.85	.89	13.35
40	10 00	0.40	6.00	0.90	13.50
41	10 15	.41	6.15	.91	13.65
42	10 30	.42	6.30	.92	13.80
43	10 45	.43	6.45	.93	13.95
44	11 00	.44	6.60	.94	14.10
45	11 15	0.45	6.75	0.95	14.25
46	11 30	.46	6.90	.96	14.40
47	11 45	.47	7.05	.97	14.55
48	12 00	.48	7.20	.98	14.70
49	12 15	.49	7.35	.99	14.85
50	12 30	0.50	7.50	1.00	15.00
51	12 45				
52	13 00				
53	13 15				
54	13 30				
55	13 45				
56	14 00				
57	14 15				
58	14 30				
59	14 45				

$6^h = 90°$
$12 = 180$
$18 = 270$

Compiled from The Nautical Almanac (Great Britain).

The Library

Any collector or hobbyist acquires those books and magazines that are necessary to the attainment of his desire. We list below a few books and several magazines that will be invaluable to you sky-shooters, together with a longer list of selected books for general reading. All titles listed can be obtained in bookstores, unless otherwise noted, and most of them will be found in the public libraries.

Valuable Books to Have Around

American Ephemeris and Nautical Almanac. An annual government publication containing valuable data about the sun, moon, and planets, together with accurate positions, magnitude, etc., of several hundred stars. Procure from the Superintendent of Documents, Washington, D. C.

Observers' Handbook of the Royal Astronomical Society of Canada. An exceedingly helpful annual guide for the layman. It contains up-to-the-minute data and information about various phases of astronomy, together with a long list of selected objects. Procure from Royal Astronomical Society of Canada, Toronto, Canada.

Amateur Telescope Making (4th ed.) and *Amateur Telescope Making—Advanced.* Three volumes compiled by Albert G. Ingalls for the layman who wishes to build a telescope. They should be in every library. The design and construction of mountings, together with instructions for making many accessories, are fully described and illustrated.

Norton's Star Atlas and Telescopic Handbook. Shows nearly all the visual stars on 16 sectional maps. Nebulae are noted on the maps. There are many pages of general information, together with a list of double stars, clusters, nebulae, and variable stars.

Schurig's *Himmelsatlas.* A group of sectional star maps showing nearly all the visual stars. Variable stars and nebulae are located on the maps. A valuable atlas without text. It also contains an excellent map of the moon. Text in German.

Skalnate Pleso, Atlas of the Heavens, by A. Becvar. Charts of entire sky show stars to 7.75 magnitude, with clusters, nebulae, double stars, and variables. Also *Atlases Eclipticalis, Borealis* and *Australis,* showing stars to 9th magnitude. Purchase all from Sky Publishing Corporation, 49 Bay State Road, Cambridge, Mass. 02138.

MAGAZINES

Each of the magazines listed below contains authoritative material written for the layman by authors eminent in their respective fields.

Review of Popular Astronomy. An excellent magazine for the amateur. It emphasizes the use of binoculars and small telescopes, and contains articles, news, and departments. Well illustrated. Subscribe from the publisher: Sky Map Publications, Inc., 111 South Meramec, St. Louis, Missouri 63105.

Sky and Telescope. The foremost popular magazine on astronomy. It is designed to reach the general reader as well as those who have a definite interest in astronomy. Well illustrated, news notes, departments, articles. Subscribe from Sky Publishing Corp., 49 Bay State Road, Cambridge, Massachusetts 02138.

The Strolling Astronomer. The journal of the Association of Lunar and Planetary Observers. It contains articles on planets, moon, etc., with many drawings and photographs. Obtain from Walter Haas, University Park, New Mexico 88001.

FOR GENERAL READING

Baker, Robert H. *Astronomy.* 8th ed. Princeton: D. Van Nostrand Co., 1964.
————. *Introduction to Astronomy.* 6th ed. Princeton: D. Van Nostrand Co., 1960.

Duncan, John C. *Astronomy.* 5th ed. New York: Harper & Row, 1955.

Eddington, Arthur S. *The Expanding Universe.* Ann Arbor: University of Michigan, 1958.

Fanning, A. E. *Planets, Stars and Galaxies.* New York: Dover Publications, 1967.

Jeans, James H. *The Universe Around Us.* New York: Cambridge University Press, 1960.

Larousse. *Encyclopedia of Astronomy.* 2nd rev. ed. New York: G. P. Putnam's Sons, 1959.

Ley, Willy. *Conquest of Space.* New York: Viking Press, 1949.

Martin, Martha E. *The Friendly Stars.* 2nd rev. ed. New York: Dover Publications, 1964.

Mayall, R. Newton and Margaret W. *Beginner's Guide to the Skies.* New York: G. P. Putnam's Sons, 1960.

Mayall, R. Newton, and others. *Sky Observer's Guide.* New York: Golden Press.

Menzel, Donald H. *Field Guide to the Stars and Planets.* Boston: Houghton Mifflin Co., 1963.

Olcott, William, and others. *Field Book of the Skies.* 4th rev. ed. New York: G. P. Putnam's Sons.

Pendray, Edward. *Men, Mirrors, and Stars.* 2nd rev. ed. New York: Harper & Row, 1946.

Phillips, T. E. R., and Steavenson, W. H., eds. *Hutchinson's Splendour of the Heavens; A Popular Authoritative Astronomy.* 24 parts in 2 vol. London: Hutchinson & Co., 1923.

Shapley, Harlow. *Flights from Chaos; A Survey of Material Systems From Atoms to Galaxies, Adapted from Lectures at the College of the City of New York, Class of 1872 Foundation.* New York: Whittlesey House, McGraw-Hill Book Co., 1930.

————. Of Stars and Men. New York: Washington Square Press, 1958.

Sternes, Mabel, comp. *Directory of Astronomical Observatories in the U. S. A.* Ann Arbor: J. W. Edwards.

Struve, Otto, and Velta Zebergs. *Astronomy of the 20th Century.* New York: Macmillan Co., 1962.

Struve, Otto, and others. *Elementary Astronomy.* New York: Oxford University Press, 1959.

For General Reading in Special Fields

Abetti, Giorgio. *The Sun.* Translated by J. B. Sidgwick. New York: Macmillan Co., 1957.

Bok, Bart J. and Priscilla F. *The Milky Way.* 3rd ed. Cambridge: Harvard University Press, 1957.

Campbell, Leon, and L. G. Jacchia. *The Story of Variable Stars.* Philadelphia: Blakiston Co., 1941.

Howard, Neale E. *Standard Handbook for Telescope Making.* New York: Thomas Y. Crowell Co., 1959.

Keene, George T. *Star Gazing with Telescope and Camera.* Philadelphia: Chilton Books, 1962.

Mayall, R. Newton and Margaret L. *Sundials—How to Know, Use and Make Them.* Newton Centre, Mass.: Charles T. Branford Co.

Menzel, Donald H. *Our Sun.* Cambridge: Harvard University Press, 1959.

Merrill, Paul W. *The Nature of Variable Stars.* New York: Macmillan Co., 1938.

Miczaika, Gerhard R., and William M. Sinton. *Tools of the Astronomer.* Cambridge: Harvard University Press, 1961.

Mitchell, Samuel A. *Eclipses of the Sun.* 5th ed. New York: Columbia University Press, 1951.

Neal, Harry E. *The Telescope.* New York: Julian Messner, 1958.

Olivier, Charles P. *Meteors.* Baltimore: Williams and Wilkins Co., 1925.

Page, Lou Williams and Thornton Page. *The Macmillan Sky and Telescope Library of Astronomy,* Vol. I: *Wanderers in the Sky;* Vol. II: *Neighbors of the Earth;* Vol. III: *Origin of the Solar System;* Vol. IV: *Telescopes: How to Make Them and Use Them.* New York: Macmillan Co., 1965.

Paul, Henry E. *Outer Space Photography for Amateurs.* New York: Hastings House Publishers, 1960.

————. *Telescopes for Skygazing.* Philadelphia: Chilton Books, 1965.

Shapley, Harlow, ed. *Source Book in Astronomy, 1900–1950.* Cambridge: Harvard University Press, 1960.

Vaucouleurs, Gérard de. *Astronomical Photography.* New York: Macmillan Co., 1961.

Watson, Fletcher G. *Between the Planets.* New York: Doubleday and Co.

Webb, T. W. *Celestial Objects for Common Telescopes.* Edited and revised by Margaret W. Mayall. 2 vols. New York: Dover Publications, 1962.

Whipple, Fred L. *Earth, Moon and Planets.* Cambridge: Harvard University Press, 1963.

Suppliers and Information

Eastman Kodak Co., 343 State St., Rochester, N.Y. 14650.
 Information and data on films.
Edmund Scientific Co., Barrington, N.J. 08007.
 Optics, telescopes, accessories.
A. Jaegers, 6915 Merrick Rd., Lynnbrook, N.Y. 11563.
 Optics, telescopes, accessories.
Optical Division, Competition Associates, 32 Boylston St., Cambridge, Mass. 02138.
 Specialized equipment, cameras and other equipment made to order.
Questar Corporation, New Hope, Pa. 18938.
 Questar telescope (catadioptric), cameras.
United Scientific Co., 66 Needham St., Newton Highlands, Mass. 02161.
 Unitron telescopes, cameras, accessories.

Note on Table 4, Page 58

Table IV on page 58 is based on the following formula:

$$m = 8.8 + 5 \operatorname{Log} D$$

where $m =$ magnitude, and $D =$ diameter of objective.

This is based on *average* seeing. However, under extremely good seeing conditions some amateurs find the magnitude is much fainter than that shown in the table—probably:

$$m = 10.0 + 5 \operatorname{Log} D$$

Sometime you may want to see what your telescope will do, or what you should expect of it. One of the best objects to use is a double star—two stars very close together. A good telescope should resolve close doubles—how close is determined by a formula known as "Dawe's Limit," as follows:

$$L = \frac{4.56}{A}$$

where $L =$ the minimum separation in seconds, and $A =$ aperture of the objective in inches.

Example: How close a double should a 6-inch telescope resolve? According to the formula

$$\frac{4.56}{6} = 0.\,''76$$

Your telescope should separate two stars only 0.″76 apart! That is, if it is a 6-inch telescope.

INDEX

A CATALOGUE OF SELECTED DOVER BOOKS
IN ALL FIELDS OF INTEREST

A CATALOGUE OF SELECTED DOVER BOOKS
IN ALL FIELDS OF INTEREST

AMERICA'S OLD MASTERS, James T. Flexner. Four men emerged unexpectedly from provincial 18th century America to leadership in European art: Benjamin West, J. S. Copley, C. R. Peale, Gilbert Stuart. Brilliant coverage of lives and contributions. Revised, 1967 edition. 69 plates. 365pp. of text.
21806-6 Paperbound $3.00

FIRST FLOWERS OF OUR WILDERNESS: AMERICAN PAINTING, THE COLONIAL PERIOD, James T. Flexner. Painters, and regional painting traditions from earliest Colonial times up to the emergence of Copley, West and Peale Sr., Foster, Gustavus Hesselius, Feke, John Smibert and many anonymous painters in the primitive manner. Engaging presentation, with 162 illustrations. xxii + 368pp.
22180-6 Paperbound $3.50

THE LIGHT OF DISTANT SKIES: AMERICAN PAINTING, 1760-1835, James T. Flexner. The great generation of early American painters goes to Europe to learn and to teach: West, Copley, Gilbert Stuart and others. Allston, Trumbull, Morse; also contemporary American painters—primitives, derivatives, academics—who remained in America. 102 illustrations. xiii + 306pp. 22179-2 Paperbound $3.50

A HISTORY OF THE RISE AND PROGRESS OF THE ARTS OF DESIGN IN THE UNITED STATES, William Dunlap. Much the richest mine of information on early American painters, sculptors, architects, engravers, miniaturists, etc. The only source of information for scores of artists, the major primary source for many others. Unabridged reprint of rare original 1834 edition, with new introduction by James T. Flexner, and 394 new illustrations. Edited by Rita Weiss. 6⅝ x 9⅝.
21695-0, 21696-9, 21697-7 Three volumes, Paperbound $15.00

EPOCHS OF CHINESE AND JAPANESE ART, Ernest F. Fenollosa. From primitive Chinese art to the 20th century, thorough history, explanation of every important art period and form, including Japanese woodcuts; main stress on China and Japan, but Tibet, Korea also included. Still unexcelled for its detailed, rich coverage of cultural background, aesthetic elements, diffusion studies, particularly of the historical period. 2nd, 1913 edition. 242 illustrations. lii + 439pp. of text.
20364-6, 20365-4 Two volumes, Paperbound $6.00

THE GENTLE ART OF MAKING ENEMIES, James A. M. Whistler. Greatest wit of his day deflates Oscar Wilde, Ruskin, Swinburne; strikes back at inane critics, exhibitions, art journalism; aesthetics of impressionist revolution in most striking form. Highly readable classic by great painter. Reproduction of edition designed by Whistler. Introduction by Alfred Werner. xxxvi + 334pp.
21875-9 Paperbound $3.00

VISUAL ILLUSIONS: THEIR CAUSES, CHARACTERISTICS, AND APPLICATIONS, Matthew Luckiesh. Thorough description and discussion of optical illusion, geometric and perspective, particularly; size and shape distortions, illusions of color, of motion; natural illusions; use of illusion in art and magic, industry, etc. Most useful today with op art, also for classical art. Scores of effects illustrated. Introduction by William H. Ittleson. 100 illustrations. xxi + 252pp.

21530-X Paperbound $2.00

A HANDBOOK OF ANATOMY FOR ART STUDENTS, Arthur Thomson. Thorough, virtually exhaustive coverage of skeletal structure, musculature, etc. Full text, supplemented by anatomical diagrams and drawings and by photographs of undraped figures. Unique in its comparison of male and female forms, pointing out differences of contour, texture, form. 211 figures, 40 drawings, 86 photographs. xx + 459pp. 5⅜ x 8⅜.

21163-0 Paperbound $3.50

150 MASTERPIECES OF DRAWING, Selected by Anthony Toney. Full page reproductions of drawings from the early 16th to the end of the 18th century, all beautifully reproduced: Rembrandt, Michelangelo, Dürer, Fragonard, Urs, Graf, Wouwerman, many others. First-rate browsing book, model book for artists. xviii + 150pp. 8⅜ x 11¼.

21032-4 Paperbound $3.50

THE LATER WORK OF AUBREY BEARDSLEY, Aubrey Beardsley. Exotic, erotic, ironic masterpieces in full maturity: Comedy Ballet, Venus and Tannhauser, Pierrot, Lysistrata, Rape of the Lock, Savoy material, Ali Baba, Volpone, etc. This material revolutionized the art world, and is still powerful, fresh, brilliant. With *The Early Work,* all Beardsley's finest work. 174 plates, 2 in color. xiv + 176pp. 8⅛ x 11.

21817-1 Paperbound $3.75

DRAWINGS OF REMBRANDT, Rembrandt van Rijn. Complete reproduction of fabulously rare edition by Lippmann and Hofstede de Groot, completely reedited, updated, improved by Prof. Seymour Slive, Fogg Museum. Portraits, Biblical sketches, landscapes, Oriental types, nudes, episodes from classical mythology—All Rembrandt's fertile genius. Also selection of drawings by his pupils and followers. "Stunning volumes," *Saturday Review.* 550 illustrations. lxxviii + 552pp. 9⅛ x 12¼.

21485-0, 21486-9 Two volumes, Paperbound $10.00

THE DISASTERS OF WAR, Francisco Goya. One of the masterpieces of Western civilization—83 etchings that record Goya's shattering, bitter reaction to the Napoleonic war that swept through Spain after the insurrection of 1808 and to war in general. Reprint of the first edition, with three additional plates from Boston's Museum of Fine Arts. All plates facsimile size. Introduction by Philip Hofer, Fogg Museum. v + 97pp. 9⅜ x 8¼.

21872-4 Paperbound $2.50

GRAPHIC WORKS OF ODILON REDON. Largest collection of Redon's graphic works ever assembled: 172 lithographs, 28 etchings and engravings, 9 drawings. These include some of his most famous works. All the plates from *Odilon Redon: oeuvre graphique complet,* plus additional plates. New introduction and caption translations by Alfred Werner. 209 illustrations. xxvii + 209pp. 9⅛ x 12¼.

21966-8 Paperbound $5.00

DESIGN BY ACCIDENT; A BOOK OF "ACCIDENTAL EFFECTS" FOR ARTISTS AND DESIGNERS, James F. O'Brien. Create your own unique, striking, imaginative effects by "controlled accident" interaction of materials: paints and lacquers, oil and water based paints, splatter, crackling materials, shatter, similar items. Everything you do will be different; first book on this limitless art, so useful to both fine artist and commercial artist. Full instructions. 192 plates showing "accidents," 8 in color. viii + 215pp. 8⅜ x 11¼. 21942-9 Paperbound $3.75

THE BOOK OF SIGNS, Rudolf Koch. Famed German type designer draws 493 beautiful symbols: religious, mystical, alchemical, imperial, property marks, runes, etc. Remarkable fusion of traditional and modern. Good for suggestions of timelessness, smartness, modernity. Text. vi + 104pp. 6⅛ x 9¼.
20162-7 Paperbound $1.25

HISTORY OF INDIAN AND INDONESIAN ART, Ananda K. Coomaraswamy. An unabridged republication of one of the finest books by a great scholar in Eastern art. Rich in descriptive material, history, social backgrounds; Sunga reliefs, Rajput paintings, Gupta temples, Burmese frescoes, textiles, jewelry, sculpture, etc. 400 photos. viii + 423pp. 6⅜ x 9¾. 21436-2 Paperbound $5.00

PRIMITIVE ART, Franz Boas. America's foremost anthropologist surveys textiles, ceramics, woodcarving, basketry, metalwork, etc.; patterns, technology, creation of symbols, style origins. All areas of world, but very full on Northwest Coast Indians. More than 350 illustrations of baskets, boxes, totem poles, weapons, etc. 378 pp.
20025-6 Paperbound $3.00

THE GENTLEMAN AND CABINET MAKER'S DIRECTOR, Thomas Chippendale. Full reprint (third edition, 1762) of most influential furniture book of all time, by master cabinetmaker. 200 plates, illustrating chairs, sofas, mirrors, tables, cabinets, plus 24 photographs of surviving pieces. Biographical introduction by N. Bienenstock. vi + 249pp. 9⅞ x 12¾. 21601-2 Paperbound $4.00

AMERICAN ANTIQUE FURNITURE, Edgar G. Miller, Jr. The basic coverage of all American furniture before 1840. Individual chapters cover type of furniture— clocks, tables, sideboards, etc.—chronologically, with inexhaustible wealth of data. More than 2100 photographs, all identified, commented on. Essential to all early American collectors. Introduction by H. E. Keyes. vi + 1106pp. 7⅞ x 10¾.
21599-7, 21600-4 Two volumes, Paperbound $11.00

PENNSYLVANIA DUTCH AMERICAN FOLK ART, Henry J. Kauffman. 279 photos, 28 drawings of tulipware, Fraktur script, painted tinware, toys, flowered furniture, quilts, samplers, hex signs, house interiors, etc. Full descriptive text. Excellent for tourist, rewarding for designer, collector. Map. 146pp. 7⅞ x 10¾.
21205-X Paperbound $2.50

EARLY NEW ENGLAND GRAVESTONE RUBBINGS, Edmund V. Gillon, Jr. 43 photographs, 226 carefully reproduced rubbings show heavily symbolic, sometimes macabre early gravestones, up to early 19th century. Remarkable early American primitive art, occasionally strikingly beautiful; always powerful. Text. xxvi + 207pp. 8⅜ x 11¼. 21380-3 Paperbound $3.50

ALPHABETS AND ORNAMENTS, Ernst Lehner. Well-known pictorial source for decorative alphabets, script examples, cartouches, frames, decorative title pages, calligraphic initials, borders, similar material. 14th to 19th century, mostly European. Useful in almost any graphic arts designing, varied styles. 750 illustrations. 256pp. 7 x 10. 21905-4 Paperbound $4.00

PAINTING: A CREATIVE APPROACH, Norman Colquhoun. For the beginner simple guide provides an instructive approach to painting: major stumbling blocks for beginner; overcoming them, technical points; paints and pigments; oil painting; watercolor and other media and color. New section on "plastic" paints. Glossary. Formerly *Paint Your Own Pictures.* 221pp. 22000-1 Paperbound $1.75

THE ENJOYMENT AND USE OF COLOR, Walter Sargent. Explanation of the relations between colors themselves and between colors in nature and art, including hundreds of little-known facts about color values, intensities, effects of high and low illumination, complementary colors. Many practical hints for painters, references to great masters. 7 color plates, 29 illustrations. x + 274pp.
 20944-X Paperbound $2.75

THE NOTEBOOKS OF LEONARDO DA VINCI, compiled and edited by Jean Paul Richter. 1566 extracts from original manuscripts reveal the full range of Leonardo's versatile genius: all his writings on painting, sculpture, architecture, anatomy, astronomy, geography, topography, physiology, mining, music, etc., in both Italian and English, with 186 plates of manuscript pages and more than 500 additional drawings. Includes studies for the Last Supper, the lost Sforza monument, and other works. Total of xlvii + 866pp. 7⅞ x 10¾.
 22572-0, 22573-9 Two volumes, Paperbound $11.00

MONTGOMERY WARD CATALOGUE OF 1895. Tea gowns, yards of flannel and pillow-case lace, stereoscopes, books of gospel hymns, the New Improved Singer Sewing Machine, side saddles, milk skimmers, straight-edged razors, high-button shoes, spittoons, and on and on . . . listing some 25,000 items, practically all illustrated. Essential to the shoppers of the 1890's, it is our truest record of the spirit of the period. Unaltered reprint of Issue No. 57, Spring and Summer 1895. Introduction by Boris Emmet. Innumerable illustrations. xiii + 624pp. 8½ x 11⅝.
 22377-9 Paperbound $6.95

THE CRYSTAL PALACE EXHIBITION ILLUSTRATED CATALOGUE (LONDON, 1851). One of the wonders of the modern world—the Crystal Palace Exhibition in which all the nations of the civilized world exhibited their achievements in the arts and sciences—presented in an equally important illustrated catalogue. More than 1700 items pictured with accompanying text—ceramics, textiles, cast-iron work, carpets, pianos, sleds, razors, wall-papers, billiard tables, beehives, silverware and hundreds of other artifacts—represent the focal point of Victorian culture in the Western World. Probably the largest collection of Victorian decorative art ever assembled— indispensable for antiquarians and designers. Unabridged republication of the Art-Journal Catalogue of the Great Exhibition of 1851, with all terminal essays. New introduction by John Gloag, F.S.A. xxxiv + 426pp. 9 x 12.
 22503-8 Paperbound $5.00

A History of Costume, Carl Köhler. Definitive history, based on surviving pieces of clothing primarily, and paintings, statues, etc. secondarily. Highly readable text, supplemented by 594 illustrations of costumes of the ancient Mediterranean peoples, Greece and Rome, the Teutonic prehistoric period; costumes of the Middle Ages, Renaissance, Baroque, 18th and 19th centuries. Clear, measured patterns are provided for many clothing articles. Approach is practical throughout. Enlarged by Emma von Sichart. 464pp. 21030-8 Paperbound $3.50

Oriental Rugs, Antique and Modern, Walter A. Hawley. A complete and authoritative treatise on the Oriental rug—where they are made, by whom and how, designs and symbols, characteristics in detail of the six major groups, how to distinguish them and how to buy them. Detailed technical data is provided on periods, weaves, warps, wefts, textures, sides, ends and knots, although no technical background is required for an understanding. 11 color plates, 80 halftones, 4 maps. vi + 320pp. 6⅛ x 9⅛. 22366-3 Paperbound $5.00

Ten Books on Architecture, Vitruvius. By any standards the most important book on architecture ever written. Early Roman discussion of aesthetics of building, construction methods, orders, sites, and every other aspect of architecture has inspired, instructed architecture for about 2,000 years. Stands behind Palladio, Michelangelo, Bramante, Wren, countless others. Definitive Morris H. Morgan translation. 68 illustrations. xii + 331pp. 20645-9 Paperbound $3.00

The Four Books of Architecture, Andrea Palladio. Translated into every major Western European language in the two centuries following its publication in 1570, this has been one of the most influential books in the history of architecture. Complete reprint of the 1738 Isaac Ware edition. New introduction by Adolf Placzek, Columbia Univ. 216 plates. xxii + 110pp. of text. 9½ x 12¾.
 21308-0 Clothbound $12.50

Sticks and Stones: A Study of American Architecture and Civilization, Lewis Mumford.One of the great classics of American cultural history. American architecture from the medieval-inspired earliest forms to the early 20th century; evolution of structure and style, and reciprocal influences on environment. 21 photographic illustrations. 238pp. 20202-X Paperbound $2.00

The American Builder's Companion, Asher Benjamin. The most widely used early 19th century architectural style and source book, for colonial up into Greek Revival periods. Extensive development of geometry of carpentering, construction of sashes, frames, doors, stairs; plans and elevations of domestic and other buildings. Hundreds of thousands of houses were built according to this book, now invaluable to historians, architects, restorers, etc. 1827 edition. 59 plates. 114pp. 7⅞ x 10¾.
 22236-5 Paperbound $3.50

Dutch Houses in the Hudson Valley Before 1776, Helen Wilkinson Reynolds. The standard survey of the Dutch colonial house and outbuildings, with constructional features, decoration, and local history associated with individual homesteads. Introduction by Franklin D. Roosevelt. Map. 150 illustrations. 469pp. 6⅝ x 9¼. 21469-9 Paperbound $5.00

THE ARCHITECTURE OF COUNTRY HOUSES, Andrew J. Downing. Together with Vaux's *Villas and Cottages* this is the basic book for Hudson River Gothic architecture of the middle Victorian period. Full, sound discussions of general aspects of housing, architecture, style, decoration, furnishing, together with scores of detailed house plans, illustrations of specific buildings, accompanied by full text. Perhaps the most influential single American architectural book. 1850 edition. Introduction by J. Stewart Johnson. 321 figures, 34 architectural designs. xvi + 560pp.
22003-6 Paperbound $4.00

LOST EXAMPLES OF COLONIAL ARCHITECTURE, John Mead Howells. Full-page photographs of buildings that have disappeared or been so altered as to be denatured, including many designed by major early American architects. 245 plates. xvii + 248pp. 7⅞ x 10¾.
21143-6 Paperbound $3.50

DOMESTIC ARCHITECTURE OF THE AMERICAN COLONIES AND OF THE EARLY REPUBLIC, Fiske Kimball. Foremost architect and restorer of Williamsburg and Monticello covers nearly 200 homes between 1620-1825. Architectural details, construction, style features, special fixtures, floor plans, etc. Generally considered finest work in its area. 219 illustrations of houses, doorways, windows, capital mantels. xx + 314pp. 7⅞ x 10¾.
21743-4 Paperbound $4.00

EARLY AMERICAN ROOMS: 1650-1858, edited by Russell Hawes Kettell. Tour of 12 rooms, each representative of a different era in American history and each furnished, decorated, designed and occupied in the style of the era. 72 plans and elevations, 8-page color section, etc., show fabrics, wall papers, arrangements, etc. Full descriptive text. xvii + 200pp. of text. 8⅜ x 11¼.
21633-0 Paperbound $5.00

THE FITZWILLIAM VIRGINAL BOOK, edited by J. Fuller Maitland and W. B. Squire. Full modern printing of famous early 17th-century ms. volume of 300 works by Morley, Byrd, Bull, Gibbons, etc. For piano or other modern keyboard instrument; easy to read format. xxxvi + 938pp. 8⅜ x 11.
21068-5, 21069-3 Two volumes, Paperbound $10.00

KEYBOARD MUSIC, Johann Sebastian Bach. Bach Gesellschaft edition. A rich selection of Bach's masterpieces for the harpsichord: the six English Suites, six French Suites, the six Partitas (Clavierübung part I), the Goldberg Variations (Clavierübung part IV), the fifteen Two-Part Inventions and the fifteen Three-Part Sinfonias. Clearly reproduced on large sheets with ample margins; eminently playable. vi + 312pp. 8⅛ x 11.
22360-4 Paperbound $5.00

THE MUSIC OF BACH: AN INTRODUCTION, Charles Sanford Terry. A fine, nontechnical introduction to Bach's music, both instrumental and vocal. Covers organ music, chamber music, passion music, other types. Analyzes themes, developments, innovations. x + 114pp.
21075-8 Paperbound $1.50

BEETHOVEN AND HIS NINE SYMPHONIES, Sir George Grove. Noted British musicologist provides best history, analysis, commentary on symphonies. Very thorough, rigorously accurate; necessary to both advanced student and amateur music lover. 436 musical passages. vii + 407 pp.
20334-4 Paperbound $2.75

JOHANN SEBASTIAN BACH, Philipp Spitta. One of the great classics of musicology, this definitive analysis of Bach's music (and life) has never been surpassed. Lucid, nontechnical analyses of hundreds of pieces (30 pages devoted to St. Matthew Passion, 26 to B Minor Mass). Also includes major analysis of 18th-century music. 450 musical examples. 40-page musical supplement. Total of xx + 1799pp.
(EUK) 22278-0, 22279-9 Two volumes, Clothbound $17.50

MOZART AND HIS PIANO CONCERTOS, Cuthbert Girdlestone. The only full-length study of an important area of Mozart's creativity. Provides detailed analyses of all 23 concertos, traces inspirational sources. 417 musical examples. Second edition. 509pp.
21271-8 Paperbound $3.50

THE PERFECT WAGNERITE: A COMMENTARY ON THE NIBLUNG'S RING, George Bernard Shaw. Brilliant and still relevant criticism in remarkable essays on Wagner's Ring cycle, Shaw's ideas on political and social ideology behind the plots, role of Leitmotifs, vocal requisites, etc. Prefaces. xxi + 136pp.
(USO) 21707-8 Paperbound $1.75

DON GIOVANNI, W. A. Mozart. Complete libretto, modern English translation; biographies of composer and librettist; accounts of early performances and critical reaction. Lavishly illustrated. All the material you need to understand and appreciate this great work. Dover Opera Guide and Libretto Series; translated and introduced by Ellen Bleiler. 92 illustrations. 209pp.
21134-7 Paperbound $2.00

BASIC ELECTRICITY, U. S. Bureau of Naval Personel. Originally a training course, best non-technical coverage of basic theory of electricity and its applications. Fundamental concepts, batteries, circuits, conductors and wiring techniques, AC and DC, inductance and capacitance, generators, motors, transformers, magnetic amplifiers, synchros, servomechanisms, etc. Also covers blue-prints, electrical diagrams, etc. Many questions, with answers. 349 illustrations. x + 448pp. 6½ x 9¼.
20973-3 Paperbound $3.50

REPRODUCTION OF SOUND, Edgar Villchur. Thorough coverage for laymen of high fidelity systems, reproducing systems in general, needles, amplifiers, preamps, loudspeakers, feedback, explaining physical background. "A rare talent for making technicalities vividly comprehensible," R. Darrell, *High Fidelity*. 69 figures. iv + 92pp.
21515-6 Paperbound $1.35

HEAR ME TALKIN' TO YA: THE STORY OF JAZZ AS TOLD BY THE MEN WHO MADE IT, Nat Shapiro and Nat Hentoff. Louis Armstrong, Fats Waller, Jo Jones, Clarence Williams, Billy Holiday, Duke Ellington, Jelly Roll Morton and dozens of other jazz greats tell how it was in Chicago's South Side, New Orleans, depression Harlem and the modern West Coast as jazz was born and grew. xvi + 429pp.
21726-4 Paperbound $3.00

FABLES OF AESOP, translated by Sir Roger L'Estrange. A reproduction of the very rare 1931 Paris edition; a selection of the most interesting fables, together with 50 imaginative drawings by Alexander Calder. v + 128pp. 6½x9¼.
21780-9 Paperbound $1.50

AGAINST THE GRAIN (A REBOURS), Joris K. Huysmans. Filled with weird images, evidences of a bizarre imagination, exotic experiments with hallucinatory drugs, rich tastes and smells and the diversions of its sybarite hero Duc Jean des Esseintes, this classic novel pushed 19th-century literary decadence to its limits. Full unabridged edition. Do not confuse this with abridged editions generally sold. Introduction by Havelock Ellis. xlix + 206pp. 22190-3 Paperbound $2.50

VARIORUM SHAKESPEARE: HAMLET. Edited by Horace H. Furness; a landmark of American scholarship. Exhaustive footnotes and appendices treat all doubtful words and phrases, as well as suggested critical emendations throughout the play's history. First volume contains editor's own text, collated with all Quartos and Folios. Second volume contains full first Quarto, translations of Shakespeare's sources (Belleforest, and Saxo Grammaticus), Der Bestrafte Brudermord, and many essays on critical and historical points of interest by major authorities of past and present. Includes details of staging and costuming over the years. By far the best edition available for serious students of Shakespeare. Total of xx + 905pp. 21004-9, 21005-7, 2 volumes, Paperbound $7.00

A LIFE OF WILLIAM SHAKESPEARE, Sir Sidney Lee. This is the standard life of Shakespeare, summarizing everything known about Shakespeare and his plays. Incredibly rich in material, broad in coverage, clear and judicious, it has served thousands as the best introduction to Shakespeare. 1931 edition. 9 plates. xxix + 792pp. 21967-4 Paperbound $4.50

MASTERS OF THE DRAMA, John Gassner. Most comprehensive history of the drama in print, covering every tradition from Greeks to modern Europe and America, including India, Far East, etc. Covers more than 800 dramatists, 2000 plays, with biographical material, plot summaries, theatre history, criticism, etc. "Best of its kind in English," *New Republic*. 77 illustrations. xxii + 890pp. 20100-7 Clothbound $10.00

THE EVOLUTION OF THE ENGLISH LANGUAGE, George McKnight. The growth of English, from the 14th century to the present. Unusual, non-technical account presents basic information in very interesting form: sound shifts, change in grammar and syntax, vocabulary growth, similar topics. Abundantly illustrated with quotations. Formerly *Modern English in the Making*. xii + 590pp. 21932-1 Paperbound $4.00

AN ETYMOLOGICAL DICTIONARY OF MODERN ENGLISH, Ernest Weekley. Fullest, richest work of its sort, by foremost British lexicographer. Detailed word histories, including many colloquial and archaic words; extensive quotations. Do not confuse this with the Concise Etymological Dictionary, which is much abridged. Total of xxvii + 830pp. 6½ x 9¼. 21873-2, 21874-0 Two volumes, Paperbound $7.90

FLATLAND: A ROMANCE OF MANY DIMENSIONS, E. A. Abbott. Classic of science-fiction explores ramifications of life in a two-dimensional world, and what happens when a three-dimensional being intrudes. Amusing reading, but also useful as introduction to thought about hyperspace. Introduction by Banesh Hoffmann. 16 illustrations. xx + 103pp. 20001-9 Paperbound $1.25

POEMS OF ANNE BRADSTREET, edited with an introduction by Robert Hutchinson. A new selection of poems by America's first poet and perhaps the first significant woman poet in the English language. 48 poems display her development in works of considerable variety—love poems, domestic poems, religious meditations, formal elegies, "quaternions," etc. Notes, bibliography. viii + 222pp.

22160-1 Paperbound $2.50

THREE GOTHIC NOVELS: THE CASTLE OF OTRANTO BY HORACE WALPOLE; VATHEK BY WILLIAM BECKFORD; THE VAMPYRE BY JOHN POLIDORI, WITH FRAGMENT OF A NOVEL BY LORD BYRON, edited by E. F. Bleiler. The first Gothic novel, by Walpole; the finest Oriental tale in English, by Beckford; powerful Romantic supernatural story in versions by Polidori and Byron. All extremely important in history of literature; all still exciting, packed with supernatural thrills, ghosts, haunted castles, magic, etc. xl + 291pp.

21232-7 Paperbound $2.50

THE BEST TALES OF HOFFMANN, E. T. A. Hoffmann. 10 of Hoffmann's most important stories, in modern re-editings of standard translations: Nutcracker and the King of Mice, Signor Formica, Automata, The Sandman, Rath Krespel, The Golden Flowerpot, Master Martin the Cooper, The Mines of Falun, The King's Betrothed, A New Year's Eve Adventure. 7 illustrations by Hoffmann. Edited by E. F. Bleiler. xxxix + 419pp. 21793-0 Paperbound $3.00

GHOST AND HORROR STORIES OF AMBROSE BIERCE, Ambrose Bierce. 23 strikingly modern stories of the horrors latent in the human mind: The Eyes of the Panther, The Damned Thing, An Occurrence at Owl Creek Bridge, An Inhabitant of Carcosa, etc., plus the dream-essay, Visions of the Night. Edited by E. F. Bleiler. xxii + 199pp. 20767-6 Paperbound $1.50

BEST GHOST STORIES OF J. S. LEFANU, J. Sheridan LeFanu. Finest stories by Victorian master often considered greatest supernatural writer of all. Carmilla, Green Tea, The Haunted Baronet, The Familiar, and 12 others. Most never before available in the U. S. A. Edited by E. F. Bleiler. 8 illustrations from Victorian publications. xvii + 467pp. 20415-4 Paperbound $3.00

MATHEMATICAL FOUNDATIONS OF INFORMATION THEORY, A. I. Khinchin. Comprehensive introduction to work of Shannon, McMillan, Feinstein and Khinchin, placing these investigations on a rigorous mathematical basis. Covers entropy concept in probability theory, uniqueness theorem, Shannon's inequality, ergodic sources, the E property, martingale concept, noise, Feinstein's fundamental lemma, Shanon's first and second theorems. Translated by R. A. Silverman and M. D. Friedman. iii + 120pp. 60434-9 Paperbound $2.00

SEVEN SCIENCE FICTION NOVELS, H. G. Wells. The standard collection of the great novels. Complete, unabridged. *First Men in the Moon, Island of Dr. Moreau, War of the Worlds, Food of the Gods, Invisible Man, Time Machine, In the Days of the Comet.* Not only science fiction fans, but every educated person owes it to himself to read these novels. 1015pp. (USO) 20264-X Clothbound $6.00

LAST AND FIRST MEN AND STAR MAKER, TWO SCIENCE FICTION NOVELS, Olaf Stapledon. Greatest future histories in science fiction. In the first, human intelligence is the "hero," through strange paths of evolution, interplanetary invasions, incredible technologies, near extinctions and reemergences. Star Maker describes the quest of a band of star rovers for intelligence itself, through time and space: weird inhuman civilizations, crustacean minds, symbiotic worlds, etc. Complete, unabridged. v + 438pp. (USO) 21962-3 Paperbound $2.50

THREE PROPHETIC NOVELS, H. G. WELLS. Stages of a consistently planned future for mankind. *When the Sleeper Wakes*, and *A Story of the Days to Come*, anticipate *Brave New World* and *1984*, in the 21st Century; *The Time Machine*, only complete version in print, shows farther future and the end of mankind. All show Wells's greatest gifts as storyteller and novelist. Edited by E. F. Bleiler. x + 335pp. (USO) 20605-X Paperbound $2.50

THE DEVIL'S DICTIONARY, Ambrose Bierce. America's own Oscar Wilde— Ambrose Bierce—offers his barbed iconoclastic wisdom in over 1,000 definitions hailed by H. L. Mencken as "some of the most gorgeous witticisms in the English language." 145pp. 20487-1 Paperbound $1.25

MAX AND MORITZ, Wilhelm Busch. Great children's classic, father of comic strip, of two bad boys, Max and Moritz. Also Ker and Plunk (Plisch und Plumm), Cat and Mouse, Deceitful Henry, Ice-Peter, The Boy and the Pipe, and five other pieces. Original German, with English translation. Edited by H. Arthur Klein; translations by various hands and H. Arthur Klein. vi + 216pp. 20181-3 Paperbound $2.00

PIGS IS PIGS AND OTHER FAVORITES, Ellis Parker Butler. The title story is one of the best humor short stories, as Mike Flannery obfuscates biology and English. Also included, That Pup of Murchison's, The Great American Pie Company, and Perkins of Portland. 14 illustrations. v + 109pp. 21532-6 Paperbound $1.25

THE PETERKIN PAPERS, Lucretia P. Hale. It takes genius to be as stupidly mad as the Peterkins, as they decide to become wise, celebrate the "Fourth," keep a cow, and otherwise strain the resources of the Lady from Philadelphia. Basic book of American humor. 153 illustrations. 219pp. 20794-3 Paperbound $2.00

PERRAULT'S FAIRY TALES, translated by A. E. Johnson and S. R. Littlewood, with 34 full-page illustrations by Gustave Doré. All the original Perrault stories— Cinderella, Sleeping Beauty, Bluebeard, Little Red Riding Hood, Puss in Boots, Tom Thumb, etc.—with their witty verse morals and the magnificent illustrations of Doré. One of the five or six great books of European fairy tales. viii + 117pp. 8⅛ x 11. 22311-6 Paperbound $2.00

OLD HUNGARIAN FAIRY TALES, Baroness Orczy. Favorites translated and adapted by author of the *Scarlet Pimpernel*. Eight fairy tales include "The Suitors of Princess Fire-Fly," "The Twin Hunchbacks," "Mr. Cuttlefish's Love Story," and "The Enchanted Cat." This little volume of magic and adventure will captivate children as it has for generations. 90 drawings by Montagu Barstow. 96pp. (USO) 22293-4 Paperbound $1.95

THE RED FAIRY BOOK, Andrew Lang. Lang's color fairy books have long been children's favorites. This volume includes Rapunzel, Jack and the Bean-stalk and 35 other stories, familiar and unfamiliar. 4 plates, 93 illustrations x + 367pp.
21673-X Paperbound $2.50

THE BLUE FAIRY BOOK, Andrew Lang. Lang's tales come from all countries and all times. Here are 37 tales from Grimm, the Arabian Nights, Greek Mythology, and other fascinating sources. 8 plates, 130 illustrations. xi + 390pp.
21437-0 Paperbound $2.75

HOUSEHOLD STORIES BY THE BROTHERS GRIMM. Classic English-language edition of the well-known tales — Rumpelstiltskin, Snow White, Hansel and Gretel, The Twelve Brothers, Faithful John, Rapunzel, Tom Thumb (52 stories in all). Translated into simple, straightforward English by Lucy Crane. Ornamented with head-pieces, vignettes, elaborate decorative initials and a dozen full-page illustrations by Walter Crane. x + 269pp.
21080-4 Paperbound **$2.00**

THE MERRY ADVENTURES OF ROBIN HOOD, Howard Pyle. The finest modern versions of the traditional ballads and tales about the great English outlaw. Howard Pyle's complete prose version, with every word, every illustration of the first edition. Do not confuse this facsimile of the original (1883) with modern editions that change text or illustrations. 23 plates plus many page decorations. xxii + 296pp.
22043-5 Paperbound $2.75

THE STORY OF KING ARTHUR AND HIS KNIGHTS, Howard Pyle. The finest children's version of the life of King Arthur; brilliantly retold by Pyle, with 48 of his most imaginative illustrations. xviii + 313pp. 6⅛ x 9¼.
21445-1 Paperbound $2.50

THE WONDERFUL WIZARD OF OZ, L. Frank Baum. America's finest children's book in facsimile of first edition with all Denslow illustrations in full color. The edition a child should have. Introduction by Martin Gardner. 23 color plates, scores of drawings. iv + 267pp.
20691-2 Paperbound $2.50

THE MARVELOUS LAND OF OZ, L. Frank Baum. The second Oz book, every bit as imaginative as the Wizard. The hero is a boy named Tip, but the Scarecrow and the Tin Woodman are back, as is the Oz magic. 16 color plates, 120 drawings by John R. Neill. 287pp.
20692-0 Paperbound $2.50

THE MAGICAL MONARCH OF MO, L. Frank Baum. Remarkable adventures in a land even stranger than Oz. The best of Baum's books not in the Oz series. 15 color plates and dozens of drawings by Frank Verbeck. xviii + 237pp.
21892-9 Paperbound $2.25

THE BAD CHILD'S BOOK OF BEASTS, MORE BEASTS FOR WORSE CHILDREN, A MORAL ALPHABET, Hilaire Belloc. Three complete humor classics in one volume. Be kind to the frog, and do not call him names . . . and 28 other whimsical animals. Familiar favorites and some not so well known. Illustrated by Basil Blackwell. 156pp.
(USO) 20749-8 Paperbound $1.50

EAST O' THE SUN AND WEST O' THE MOON, George W. Dasent. Considered the best of all translations of these Norwegian folk tales, this collection has been enjoyed by generations of children (and folklorists too). Includes True and Untrue, Why the Sea is Salt, East O' the Sun and West O' the Moon, Why the Bear is Stumpy-Tailed, Boots and the Troll, The Cock and the Hen, Rich Peter the Pedlar, and 52 more. The only edition with all 59 tales. 77 illustrations by Erik Werenskiold and Theodor Kittelsen. xv + 418pp. 22521-6 Paperbound $3.50

GOOPS AND HOW TO BE THEM, Gelett Burgess. Classic of tongue-in-cheek humor, masquerading as etiquette book. 87 verses, twice as many cartoons, show mischievous Goops as they demonstrate to children virtues of table manners, neatness, courtesy, etc. Favorite for generations. viii + 88pp. 6½ x 9¼. 22233-0 Paperbound $1.50

ALICE'S ADVENTURES UNDER GROUND, Lewis Carroll. The first version, quite different from the final *Alice in Wonderland*, printed out by Carroll himself with his own illustrations. Complete facsimile of the "million dollar" manuscript Carroll gave to Alice Liddell in 1864. Introduction by Martin Gardner. viii + 96pp. Title and dedication pages in color. 21482-6 Paperbound $1.25

THE BROWNIES, THEIR BOOK, Palmer Cox. Small as mice, cunning as foxes, exuberant and full of mischief, the Brownies go to the zoo, toy shop, seashore, circus, etc., in 24 verse adventures and 266 illustrations. Long a favorite, since their first appearance in St. Nicholas Magazine. xi + 144pp. 6⅝ x 9¼. 21265-3 Paperbound $1.75

SONGS OF CHILDHOOD, Walter De La Mare. Published (under the pseudonym Walter Ramal) when De La Mare was only 29, this charming collection has long been a favorite children's book. A facsimile of the first edition in paper, the 47 poems capture the simplicity of the nursery rhyme and the ballad, including such lyrics as I Met Eve, Tartary, The Silver Penny. vii + 106pp. (USO) 21972-0 Paperbound $2.00

THE COMPLETE NONSENSE OF EDWARD LEAR, Edward Lear. The finest 19th-century humorist-cartoonist in full: all nonsense limericks, zany alphabets, Owl and Pussycat, songs, nonsense botany, and more than 500 illustrations by Lear himself. Edited by Holbrook Jackson. xxix + 287pp. (USO) 20167-8 Paperbound $2.00

BILLY WHISKERS: THE AUTOBIOGRAPHY OF A GOAT, Frances Trego Montgomery. A favorite of children since the early 20th century, here are the escapades of that rambunctious, irresistible and mischievous goat—Billy Whiskers. Much in the spirit of *Peck's Bad Boy,* this is a book that children never tire of reading or hearing. All the original familiar illustrations by W. H. Fry are included: 6 color plates, 18 black and white drawings. 159pp. 22345-0 Paperbound $2.00

MOTHER GOOSE MELODIES. Faithful republication of the fabulously rare Munroe and Francis "copyright 1833" Boston edition—the most important Mother Goose collection, usually referred to as the "original." Familiar rhymes plus many rare ones, with wonderful old woodcut illustrations. Edited by E. F. Bleiler. 128pp. 4½ x 6⅜. 22577-1 Paperbound $1.00

TWO LITTLE SAVAGES; BEING THE ADVENTURES OF TWO BOYS WHO LIVED AS INDIANS AND WHAT THEY LEARNED, Ernest Thompson Seton. Great classic of nature and boyhood provides a vast range of woodlore in most palatable form, a genuinely entertaining story. Two farm boys build a teepee in woods and live in it for a month, working out Indian solutions to living problems, star lore, birds and animals, plants, etc. 293 illustrations. vii + 286pp.

20985-7 Paperbound $2.50

PETER PIPER'S PRACTICAL PRINCIPLES OF PLAIN & PERFECT PRONUNCIATION. Alliterative jingles and tongue-twisters of surprising charm, that made their first appearance in America about 1830. Republished in full with the spirited woodcut illustrations from this earliest American edition. 32pp. $4\frac{1}{2}$ x $6\frac{3}{8}$.

22560-7 Paperbound $1.00

SCIENCE EXPERIMENTS AND AMUSEMENTS FOR CHILDREN, Charles Vivian. 73 easy experiments, requiring only materials found at home or easily available, such as candles, coins, steel wool, etc.; illustrate basic phenomena like vacuum, simple chemical reaction, etc. All safe. Modern, well-planned. Formerly Science Games for Children. 102 photos, numerous drawings. 96pp. $6\frac{1}{8}$ x $9\frac{1}{4}$.

21856-2 Paperbound $1.25

AN INTRODUCTION TO CHESS MOVES AND TACTICS SIMPLY EXPLAINED, Leonard Barden. Informal intermediate introduction, quite strong in explaining reasons for moves. Covers basic material, tactics, important openings, traps, positional play in middle game, end game. Attempts to isolate patterns and recurrent configurations. Formerly Chess. 58 figures. 102pp. (USO) 21210-6 Paperbound $1.25

LASKER'S MANUAL OF CHESS, Dr. Emanuel Lasker. Lasker was not only one of the five great World Champions, he was also one of the ablest expositors, theorists, and analysts. In many ways, his Manual, permeated with his philosophy of battle, filled with keen insights, is one of the greatest works ever written on chess. Filled with analyzed games by the great players. A single-volume library that will profit almost any chess player, beginner or master. 308 diagrams. xli x 349pp.

20640-8 Paperbound $2.75

THE MASTER BOOK OF MATHEMATICAL RECREATIONS, Fred Schuh. In opinion of many the finest work ever prepared on mathematical puzzles, stunts, recreations; exhaustively thorough explanations of mathematics involved, analysis of effects, citation of puzzles and games. Mathematics involved is elementary. Translated by F. Göbel. 194 figures. xxiv + 430pp. 22134-2 Paperbound $3.50

MATHEMATICS, MAGIC AND MYSTERY, Martin Gardner. Puzzle editor for Scientific American explains mathematics behind various mystifying tricks: card tricks, stage "mind reading," coin and match tricks, counting out games, geometric dissections, etc. Probability sets, theory of numbers clearly explained. Also provides more than 400 tricks, guaranteed to work, that you can do. 135 illustrations. xii + 176pp.

20335-2 Paperbound $1.75

MATHEMATICAL PUZZLES FOR BEGINNERS AND ENTHUSIASTS, Geoffrey Mott-Smith. 189 puzzles from easy to difficult—involving arithmetic, logic, algebra, properties of digits, probability, etc.—for enjoyment and mental stimulus. Explanation of mathematical principles behind the puzzles. 135 illustrations. viii + 248pp.
20198-8 Paperbound $1.75

PAPER FOLDING FOR BEGINNERS, William D. Murray and Francis J. Rigney. Easiest book on the market, clearest instructions on making interesting, beautiful origami. Sail boats, cups, roosters, frogs that move legs, bonbon boxes, standing birds, etc. 40 projects; more than 275 diagrams and photographs. 94pp.
20713-7 Paperbound $1.00

TRICKS AND GAMES ON THE POOL TABLE, Fred Herrmann. 79 tricks and games—some solitaires, some for two or more players, some competitive games—to entertain you between formal games. Mystifying shots and throws, unusual caroms, tricks involving such props as cork, coins, a hat, etc. Formerly *Fun on the Pool Table*. 77 figures. 95pp.
21814-7 Paperbound $1.25

HAND SHADOWS TO BE THROWN UPON THE WALL: A SERIES OF NOVEL AND AMUSING FIGURES FORMED BY THE HAND, Henry Bursill. Delightful picturebook from great-grandfather's day shows how to make 18 different hand shadows: a bird that flies, duck that quacks, dog that wags his tail, camel, goose, deer, boy, turtle, etc. Only book of its sort. vi + 33pp. 6½ x 9¼. 21779-5 Paperbound $1.00

WHITTLING AND WOODCARVING, E. J. Tangerman. 18th printing of best book on market. "If you can cut a potato you can carve" toys and puzzles, chains, chessmen, caricatures, masks, frames, woodcut blocks, surface patterns, much more. Information on tools, woods, techniques. Also goes into serious wood sculpture from Middle Ages to present, East and West. 464 photos, figures. x + 293pp.
20965-2 Paperbound $2.00

HISTORY OF PHILOSOPHY, Julián Marias. Possibly the clearest, most easily followed, best planned, most useful one-volume history of philosophy on the market; neither skimpy nor overfull. Full details on system of every major philosopher and dozens of less important thinkers from pre-Socratics up to Existentialism and later. Strong on many European figures usually omitted. Has gone through dozens of editions in Europe. 1966 edition, translated by Stanley Appelbaum and Clarence Strowbridge. xviii + 505pp. 21739-6 Paperbound $3.50

YOGA: A SCIENTIFIC EVALUATION, Kovoor T. Behanan. Scientific but non-technical study of physiological results of yoga exercises; done under auspices of Yale U. Relations to Indian thought, to psychoanalysis, etc. 16 photos. xxiii + 270pp.
20505-3 Paperbound $2.50

Prices subject to change without notice.
Available at your book dealer or write for free catalogue to Dept. GI, Dover Publications, Inc., 180 Varick St., N.Y., N.Y. 10014. Dover publishes more than 150 books each year on science, elementary and advanced mathematics, biology, music, art, literary history, social sciences and other areas.